Birger Sandzén

Portrait of Birger Sandzén
by Margaret Sandzén
Greenough
(1947) oil on canvas
32 × 25³/₄ inches
Greenough Collection

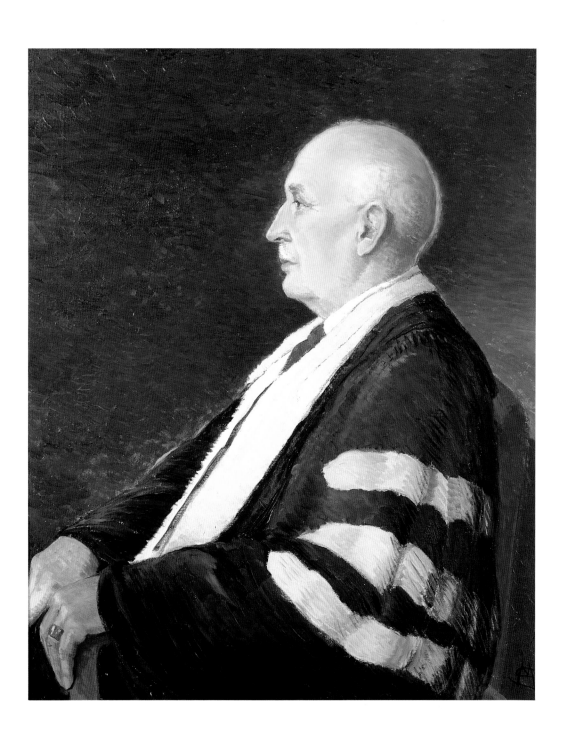

Birger Sandzén: An Illustrated Biography

Emory Lindquist

Foreword by William H. Gerdts

Published for The Birger Sandzén Memorial Foundation
by the University Press of Kansas

Published by the University Press of Kansas (Lawrence, Kansas 66049), which was organized by the Kansas
Board of Regents and is operated and funded by Emporia State University, Fort Hays State University,
Kansas State University, Pittsburg State University, the University of Kansas, and Wichita State University

Library of Congress Cataloging-in-Publication Data
Lindquist, Emory Kempton, 1908–1992
 Birger Sandzén : an illustrated biography / Emory Lindquist ;
foreword by William H. Gerdts.
 p. cm.
 ISBN 0-7006-0575-4
 1. Sandzén, Birger, 1871–1954. 2. Swedish American artists—
Kansas—Biography. 3. West (U.S.) in art. I. Sandzén, Birger,
1871–1954. II. Title.
N6537.S317L56 1993
760'.092—dc20
 [B] 92-23467

British Library Cataloguing in Publication Data is available.

Printed in Hong Kong
10 9 8 7 6 5 4 3 2

The paper used in this publication meets the minimum requirements of the American National
Standard for Permanence of Paper for Printed Library Materials Z39.48-1984.

Contents

Illustrations

Black and White Figures

Foreword

The Art of Birger Sandzén

In the late 1980s, in preparation for my study of regional American painting, *Art Across America,* I visited communities in the state of Kansas—Lawrence, Topeka, Lindsborg, and Wichita. Without question, the revelation that I sustained upon entering the Birger Sandzén Memorial Gallery in Lindsborg was not only the most extraordinary artistic encounter of that expedition but one of the most amazing and splendid firsthand experiences occasioned by the research involved with the work.

It is intriguing to think back upon that moment, to try to recall and analyze the sensations I experienced. That revelation was not triggered simply by the appearance of Sandzén's pictures; I was already familiar with them through some of the literature I had accumulated and from a group of slides that ensured I had some idea of the artist's bold colorism—perhaps the major feature of his mature painting, as Emory Lindquist so properly emphasizes in this volume. Nevertheless, I was still unprepared to find such exceptional work in a little gallery associated with a relatively rural college located in a small town in the middle of prairie land. Additional factors in the intense impression made by this display included the originality of the artist's aesthetic strategies, partly the stylistic consistency, and certainly the high level of professional quality. But I think the intensity resulted at least partially and perhaps primarily from the sense of scale of the large pictures that had been hung in one of the major rooms in the gallery.

Sandzén's graphic work was on view also, and these prints, especially his woodcuts, are probably as phenomenal as his oils. The lithographs reflect especially the strong calligraphic manipulation of form seen in his oils, and the block prints amazingly incorporate into black and white the equivalence of the artist's color and light, which I find contemporaneously, perhaps, only in the woodcuts of the Buffalo artist, J. J. Lankes. Sandzén's block prints otherwise are quite individual for their time in America, when the primary emphasis was in the application and expression of prismatic color. Sandzén's work instead recalls the dramatic black-and-white graphics of contemporary Germans of the movement *Die Brücke,* though those artists concentrated upon figural and urban imagery instead of on the landscape that so fascinated Sandzén. But I shall focus here upon the artist's oil paintings.

As I recall, many of the works were landscapes, dramatic mountainscapes of the Rockies, and prairie scenes of Sandzén's adopted Kansas. The artist's daughter narrated a story about her father's attraction to the local scenery, which Nina Stawski quotes in her admirable Master's thesis on Sandzén's graphic work: "He himself documented his attraction to the colorism of the local landscape." Emory Lindquist quotes the artist's own description

of "the brilliant yellow and red along the creeks, gold buffalo grass on the prairie and large, bright sunflowers," but of course Sandzén's paintings are hardly transcriptive statements. And we can recognize in Sandzén's art the ultimate impact of impressionism, which the artist claimed was "the first sign of recovery. Color will no longer be an unimportant element in painting, but an essential feature." Yet Sandzén was not an impressionist, a movement long accepted in both Europe and America by the time he achieved his artistic maturity. He was very much a modern artist.

There was, certainly, a time-honored tradition in America for the theme of the mountain landscape, beginning with the paintings created by Albert Bierstadt after his first western trip of 1859 and continuing throughout the work he did during his subsequent journeys. The theme is found also in the pictures created by many other painters from both the East Coast and Chicago—most notably, perhaps, in Thomas Moran's work—as well as in those works produced in the second half of the nineteenth century by resident western painters. Nevertheless, though Bierstadt painted almost until his death in 1902 and Moran continued to produce variations of his earlier western subjects into the 1920s, the tradition that their work represented had been more or less discarded and critically denigrated even in the last decade or two of the nineteenth century, condemned as bombastic and grandiose on the one hand and too detailed and specific on the other. Such pictures were viewed as blatantly commercial and as too naive and characterless for a nation that, after the Civil War, had entered into a new phase of cultural cosmopolitanism.

The sometimes exaggeratedly monumental (theoretically though not actually transcriptive) scenes of the Rocky Mountains were largely abandoned in favor of more poetic and even spiritual evocations of nature, in which temporal and seasonal concerns replaced the sense of place so emphasized in those earlier pictures. The generation of landscape painters led by George Inness was generally uncomfortable with mountain scenery and seldom painted it, and their successors, the impressionists, shied away from scenes of grandeur, too. The principal exception—the paintings produced by John Twachtman in the Grand Canyon of the Yellowstone in September 1895—actually proves the rule, for these atypical works were never considered by critics to be the equal of the intimate landscapes that Twachtman painted in the neighborhood of his Connecticut home.

The early twentieth century, in fact, witnessed a revival of interest in mountain art, and Sandzén, though somewhat isolated from other developments in the art world and painting in a manner distinct from other practitioners, should be seen in this context. This revival occurred not at the hands of eastern visitors but of native artists—painters such as John Hafen and James Harwood, who depicted the Wasatch Mountains of Utah at the turn of the century, and especially the large group of southern California painters of the Sierra Nevada, such as William Wendt, Edgar Payne, Jack Wilkinson Smith, Hanson Puthuff, Paul Lauritz, Benjamin Chambers Brown, and Leland Curtis.

The Utah painters worked primarily in an impressionist-related mode. So did some of the Californians, notably Brown, but for the most part they evolved a rather distinct aesthetic based upon broad, often somewhat rectangular and thickly applied brush strokes, which yield a strong, structural emphasis. The inspiration for this rather different California approach to monumental mountain scenery would seem to be the work of Paul Cézanne (although few of Cézanne's paintings were to be seen in California at the beginning of the twentieth century) and even of the cubists. Such a posited relationship is reinforced by the emphasis in the work of some of these painters—Wendt, Smith, Payne, Puthuff, and Lauritz—upon the earth colors of greens and browns and in a turning away from the high key of impressionism that otherwise dominated southern California painting.

Birger Sandzén's western paintings thus share with the work of some of his California contemporaries such qualities as a strong structural sense and a vivid facture of paint and brush stroke, but his work differs from

theirs also, notably in the rich, inventive, high-key colorism, a trademark of his mature style. This began around 1909 and 1910 with the works he created in a pointillist style, which, like those works that succeeded them, have few parallels in American art at all, let alone in a regional context.

Sandzén is supposed to have been impressed by pointillist works and even to have worked in that manner during his six months in France in 1894. Although Swedish writers have emphasized Sandzén's pointillist affiliations, they appear to have been of short duration. Nevertheless, a number of other Americans, like Sandzén, went through a brief period of neoimpressionist divisionism, adopting the dotlike application of paint pioneered by Georges Seurat and continued by Paul Signac, who perhaps exercised specific influence on some of the Americans.

This aspect of neoimpressionism appears first in the work of a few Americans associated with the art colony in Giverny, France, in the early 1890s—Thomas Meteyard and Philip Leslie Hale—though their pointillist works seem to have been created elsewhere during the 1890s as well, Hale's in Matunuck, Rhode Island, and Meteyard's in Venice and then in Scituate, Massachusetts, where he settled in 1894. Pointillism appeared again, although only briefly, around 1910 in the work of a number of younger American artists besides Sandzén, including Oscar Bluemner, Joseph Stella, Thomas Hart Benton, B. J. O. Nordfeldt, and Joseph Raphael, an expatriot living in Holland and Belgium. But pointillism did not remain a dominant mode for any of these artists for long.

One would like to see this issue as cohesive, with these painters investigating the aesthetics of pointillism together, but in fact they were a wildly diverse group. Bluemner and Stella were both in New York City, but the former's involvement with pointillism, only a brief one in 1909, was of too short a duration to suggest any relationship with other Americans. There is little indication that Bluemner and Stella had any close association, though their works appeared together in a number of later avant-garde exhibitions. In any case, Stella's pointillism, which appeared only around 1912–1913, was perhaps the latest among these artists, and it derived from the painting of the Italian futurist Gino Severini. Nordfeldt was a Chicago painter, but his short flirtation with pointillism appears to have occurred in 1910 during a visit to Europe; this approach appears in his work painted in Venice. Benton's brief pointillist period also took place in 1910 but in the French countryside; at about the same time Raphael developed his neoimpressionist manner in the Low Countries. Raphael was, in fact, the only American to produce a sustained body of pointillist-related work, though by 1916 his art had become quite expressionistic.

The only one of these artists with whom Sandzén shared a relationship was the Swedish-born Nordfeldt, whom he visited in 1919 in Santa Fe; whether they were previously acquainted has not been documented. Curiously, one can trace an indirect relationship between Sandzén and Nordfeldt as well. When the latter returned to Chicago, he met the young art student Raymond Jonson in a class at the Chicago Academy of Fine Art. Nordfeldt became an immediate influence on Jonson, and both men produced a series of vivid, full-length figure and portrait studies during the 1910s. Pointillism is not at all a factor in these paintings, though some aspects of the style do appear in Jonson's *Violet Light* of 1918. This may be because of an inspirational trip he took the previous summer to the Colorado Rockies, where he was tremendously impressed by both the physicality of mountain structure and the brilliance of western light, both of which Jonson captured in his *Light,* painted subsequently in 1917; it also incorporates pointillist qualities.

In turn, Jonson, also of Swedish descent, became a close friend of Sandzén. Emory Lindquist suggests that they met in Santa Fe in 1918, but they surely would have known of one another earlier since Jonson's work was included in Carl Smalley's Midwest traveling exhibition beginning in 1916. Contacts among Sandzén, Smalley, and Jonson may have developed even earlier, in 1914, when Jonson's western sketching trip took him to Kansas.

Although four of his pictures were shown at the Museum of New Mexico in Santa Fe in 1918, Jonson himself was not there that year; rather, he was touring in the Midwest and the Far West with a theater company presenting Ibsen's plays early in 1918, and he then spent the spring in Utah and again in Colorado. Jonson did not settle permanently in Santa Fe until 1924.

Although Sandzén would have abandoned his brief involvement with pointillism by the time he and Jonson met, their firm friendship must certainly have been nurtured by their mutual love of western mountain scenery. During the 1920s, Jonson's paintings, under the influence of the art of Wassili Kandinsky, became increasingly abstract, but a number of them still shared with Sandzén a devotion to mountain grandeur. Meanwhile, Sandzén had evolved his mature modernist manner by 1914 if not earlier; his *Wheat Stacks, McPherson County* of that period suggests a Monet subject painted by Cézanne.

Another mutual feeling shared by Sandzén and Jonson was their love of brilliant color. Critics have continually likened Sandzén's paintings to those of Vincent van Gogh, and it is true that the earliest one-artist show of van Gogh's work took place at the Modern Gallery in New York City, roughly at the time that Sandzén developed his mature style. It is also true that the waving, curvilinear forms that Sandzén imposed especially on his cottonwood trees along the Kansas creeks do mirror the expressivity of van Gogh's treatment of foliage as does Sandzén's use of thick, heavy paint impastos, another stylistic trademark of both painters. Although a few Americans, such as the writer Cecilia Waern, had expressed both knowledge and admiration for van Gogh's art even earlier, it seems to me that Sandzén's painting is much more related to fauvism and in fact may be viewed as an alliance between the structural concerns of Cézanne and the coloristic intensity of Matisse and the fauves.

In that, Sandzén was not alone. Matisse's work was exhibited in this country as early as April 1908 at Alfred Stieglitz's 291 Gallery in New York City. A number of American painters in Paris at the end of the first decade of the century, such as Patrick Henry Bruce, Arthur Dove, John Marin, Alfred Maurer, and Max Weber, worked under the immediate influence of Matisse and were informed of Cézanne's work through the great memorial show held in the French capital in 1907. All but Bruce subsequently returned to New York City as confirmed modernists. During the early 1910s in Philadelphia, Carl Newman and H. Lyman Sayen practiced a form of fauvism in Philadelphia; Arthur B. Carles was also working there in a manner that combined the influences of Cézanne and Matisse, though his subject matter was still lifes, portraits, and later nudes, and the results were strikingly different from those of Sandzén. And the American painter Jerome Blum was exhibiting works reflecting fauve colorism in Chicago in 1911.

But the work of neither these Americans nor their French artistic forbears was readily viewable in the American heartland. Certainly many artists as well as members of the general public became especially aware of the post-impressionists—including van Gogh, Cézanne, and Matisse—through their appearance in the controversial study *The Post-Impressionists* by C. Lewis Hind, published in 1912 and much reviewed and discussed in the periodical press. It remains undetermined where and how Sandzén developed his distinct manner of landscape interpretation about this time.

An obvious source might have been the famous Armory Show, which opened in New York City in February 1913 and subsequently went on to Chicago and Boston, as it included a substantial group of paintings by Cézanne, van Gogh, and Matisse. Sandzén was certainly not averse to traveling to view major art shows—he was a visitor at the Panama-Pacific International Exposition held in San Francisco only two years later—but no documentation exists that Sandzén visited the Armory Show at one or another of its venues. Had he done so, it is virtually certain that reference to such a visit would appear in his correspondence. Still, Sandzén must have been aware of some of the innovative art displayed because of the overwhelming amount of criticism and the number of reviews generated by the exhibit, but the assumption that the Armory Show

was a source for Sandzén's artistic maturation must remain speculative at this point. Interestingly, Stuart Davis, one of the artists whose work of the later 1910s stylistically (though seldom thematically) resembles that of Sandzén, unequivocally developed his modernist stance as a result of the impact of the Armory Show.

In addition to his western-landscape imagery, Sandzén's other major scenic focus was on the landscape of his adopted state. The Great Plains have never drawn the hoards of artists that have been attracted to the more overtly spectacular scenery of either the eastern mountain regions—the White and Green mountains, the Catskills, the Adirondacks, the Alleghenies, and the Smokies—or the striking western scenery of the Rockies and the Sierra Nevada, undoubtedly because of the flatter and more even prairie landscape. In addition, the landscapists active in those midwestern states that border the great rivers—the Mississippi and the Missouri—often tended to concentrate upon those waterways. Thus, although occasional artists painted prairie scenery on their journeys west, there have been only a few specialists and these painted in regions where the river scenery was less spectacular. Interestingly, those artists who come to mind were all active roughly at the same time, during the early twentieth century. This group includes the quite celebrated artist of the Canadian Midwest, Charles Jeffreys, and the South Dakota painter, Charles Greener, who resided in Faulkton in the north-central part of the state, as well as Kansas painters such as Sandzén and George Melville Stone.

The landscapes of both Jeffreys and Greener emphasize the great sweep of the prairie, its seeming endlessness and its even surface. The illimitable scenery in their paintings appears to embody a sense of optimism and the promise of growth, qualities often enhanced by brilliant light and color as well as the suggestion of rich agricultural production. Although this last feature appears in some of the Kansas landscapes of Sandzén, it would seem unlikely that any contact occurred between him and either Jeffreys or Greener or even that there was mutual knowledge of each other's work. Sandzén's prairie scenes are far more coloristically intense than theirs. Margaret Sandzén Greenough noted that her father's bright canvases were at variance with the usual regionalist imagery depicting a drab, gray, desolate land. She proposed that he incorporate a little "dust" into some of his work, to which Sandzén replied, "It'll rain again."

Sandzén's Kansas landscapes naturally lack the spectacular scenery of his views of the Rockies and the Southwest, but they depart from the paintings of his contemporaries by emphasizing more broken features of the Kansas landscape. Working both in Graham County in northwestern Kansas and along the Smoky Valley just west of Lindsborg, he found and recorded in his thickly rendered, coloristic style the creeks and low cliffs that monumentalize the low-lying landscape, the colorful, varied riverbank vegetation, and the swaying trees that break the horizon of his scenes along Wild Horse Creek and Red Rock Canyon. Nina Stawski perceptively speculates that Sandzén was so attracted to the Smoky Hill River and Wild Horse Creek because he had come from a land where lakes and streams were abundant to a place where water was exceptional. But at the same time, the formations at these creek beds when dry in summer prepared him, in miniature, for the canyon and mountain forms he found in Colorado and the Southwest.

Sandzén was not alone among Kansas artists of the early twentieth century in his respect for and devotion to the local scenery. The preferred subject matter of George Melville Stone was also the prairie landscape, though he was particularly concerned with it as a setting for farm activity—hence his appellation as the "Millet of the Prairies." Sandzén, too, did not ignore such themes, as his *Wheat Stacks, McPherson County* attests (quite likely a homage to Claude Monet's *Grain Stacks* series, to some degree). And John Noble—"Wichita Bill" as he was nicknamed—carried with him during his expatriation in Paris and his later residency in New York City and Provincetown a sense of the endless sweep of the Kansas landscape, which served specifically as the setting for great herds of wild buffalo in his late masterwork, *The Big Herd*.

Sandzén's artistic impact was felt by many students, those who studied with him in Lindsborg and those whom he instructed at other schools during the 1920s. Sandzén was unusual in that at these institutions he undoubtedly exerted greater influence on his pupils than the settings of those schools offered him. He was already a painter of the Rockies, and no perceptible change appears in his painting during his Broadmoor Art Academy experiences during the summers of 1923 and 1924. This is in contrast to Robert Reid, John F. Carlson (whom Sandzén replaced as the landscape-painting instructor), and later Ernest Lawson, other instructors during the decade whose only paintings of mountain scenery reflect their experiences in Colorado Springs. Sandzén's impact on his students at the Broadmoor Art Academy can be seen in the work of Donna Sumner, who won the Birger Sandzén prize in landscape painting in 1923 and who remained associated with Colorado Springs throughout her career, and in the art of Ada Caldwell, probably the most influential painter in South Dakota in the first half of the twentieth century.

Sandzén's influence seems to have been even greater during his years in Logan, where he represented a unique force of modernism from outside the Utah art community. He was hired as the first of a series of visiting artists-in-residence to offer an alternative to the traditional instruction that had previously characterized art education in Utah. This impact, however, is more difficult to document, since the historical research of art in Utah has concentrated so greatly on development in and around Salt Lake City and on the relationship of the state's artistic community with the Mormon church. Nevertheless, a modernist "Logan School" appears to have developed during the 1920s, characterized by simplification of form and the introduction of strong, prismatic colors heretofore almost unknown in Utah painting.

The dark, dramatic work of Alma Brockerman Wright, also an art instructor in Logan, gave way to a new colorism about this time. John Henri Moser, who had studied with Wright in Logan from 1906 to 1908, returned there, first for one year in 1911 and again in 1929 for two decades, working in a strongly coloristic and expressionistic mode. The relationships among these artists in that northern Utah city remains to be explored. Sandzén's direct influence can be seen in the work of the Utah painter, Philip Henry Barkdull, who studied with Sandzén in 1928 and 1929.

But Birger Sandzén's significance is greater than his role as an important influence on other artists or even upon the artistic and cultural development of his adopted Kansas, as detailed in Emory Lindquist's study. The artist should be recognized, I believe, as a significant figure in the development of modernism in America in the early decades of the twentieth century. He was a painter whose perceptions of the power and dynamics of color ally him with those other Americans who have rightly been recognized as leaders in the introduction of postimpressionism in America—artists such as Arthur Dove, John Marin, Alfred Maurer, Marsden Hartley, Max Weber, and others.

Sandzén's paintings would have qualified in style and stature for inclusion in the major exhibition held in 1986 at the High Museum of Art in Atlanta, The Advent of Modernism. I suspect his omission was owing to the relative unfamiliarity of his painting, a result of Sandzén's isolation in the American heartland and the limited spread of his influence within a regional rather than a national configuration. His absence was an oversight at the time of the show, and it appears more so now that Emory Lindquist has defined Sandzén so well, his life and his art. Ultimately, Sandzén's greatest and most enduring contribution is his marvelous, inimitable art.

William H. Gerdts
May 27, 1992

Preface

When twenty-three-year-old Birger Sandzén (1871–1954) left Sweden in 1894 for Lindsborg, Kansas, a whole new world opened up for him, and he was to be a part of that world until his earthly pilgrimage came to an end in 1954. In the course of his years in Kansas, he received national recognition as an artist, he gained the esteem of students and colleagues as a teacher, and his avid promotion of art enriched the lives of individuals and communities.

Sandzén brought to his new world abundant personal resources. A friendly parental home was always a source of great strength, and his early studies with Olof Erlandsson, a fine art teacher, had given him a good background in the basic principles of drawing and painting. Three years in Stockholm as a student of Anders Zorn and Richard Bergh, famous Swedish painters in the newly founded Konstnärsförbundet (Artists' League), were decisive because of their deep concern for freedom and individuality. His study in Paris with Edmond-François Aman-Jean and other teachers had introduced him to impressionism and a lively new approach to painting; his visits to museums and galleries in Europe had broadened his understanding of the changes and developments in the world of art. In deciding to emigrate to the United States, Sandzén viewed the challenge there: "A free, new country. It should be heaven for a painter. Out there in the West a painter could develop a style of his own to fit the country."

Although environmental circumstances do not necessarily determine the future of creative activity, their impact, supported by unique individual talent and resources, may be substantial. Sandzén, as a landscape painter, soon realized that the prairies with their broad horizons and bright light were quite different from the variegated terrain and the subdued light of his homeland, and in 1908 he first saw the Rocky Mountains with their great masses of shale and rock, rugged mountain peaks piercing the horizon, and penetrating light and deep shadows. The new milieu of wide prairie and rugged mountains gave Sandzén an insight into beauty that produced a striking response in his use of color and painting technique. There was adaptation and learning as this sensitive painter conveyed his feeling and perception on canvases, at first, according to some critics, too boldly. He modified and enriched his style with the passing of the years.

The life and work of Birger Sandzén are known best by the people whose memories of him continue to be an inspiration and through his paintings and prints, and in this book I trace his story and the development of his work through his own words, those of his associates, and the reviews of art critics. His artistic development is further shown in the reproduction of selected oil paintings, water colors, and prints. The road to success was not easy, but it was attained in gratifying dimensions. Critics generally praised his distinctive technique, use of color, effective drawing, and the decisive form and strength of his paintings and graphic work.

There was something of the Renaissance man in Birger Sandzén. Although his primary occupation was painting and printmaking, he was a competent musician; a literary person who wrote biography and short stories as well as about art and art history; a gifted linguist and a translator of books and articles, especially from Swedish to English; and a student of oriental history and culture with a special competence in Chinese art.

A study of Birger Sandzén must seek to place in perspective his personal qualities. There are many remembrances and evidences of his strong character; his religious commitment; his concern for right and justice; his tolerance of and consideration for others; his keen sense of humor; his congenial spirit, except when prejudice and shabbiness were involved; and his optimism, which did not always reveal his inner concern and discontent—all of these factors and others are identifiable characteristics. So also is his unfailing loyalty to teaching and to Bethany College and Lindsborg.

Acknowledgments

My gratitude is great for the assistance and support I have received from many people in preparing this biography of Birger Sandzén. The manuscript owes more to Margaret and Pelham Greenough, Sandzén's daughter and son-in-law, than I am able to express in words. Letters, personal items, interviews, copies of Margaret's notes, and articles on the life of her father constitute basic elements in this study. Pelham Greenough's fine book, *The Graphic Work of Birger Sandzén* (1952), his research on exhibitions in which Sandzén participated, and his unpublished catalog of the paintings of Sandzén furnished invaluable assistance.

The Swedish aspects of the life and career of Birger Sandzén are important, and I am indebted to several people in that country. Birgitta Sjöholm, Vänersborg, a niece of Sandzén, and Dr. Carl-Gustaf Sandzén, Alingsås, a nephew of the artist, provided both materials from the extensive Sandzén family archives and many constructive suggestions. Rektor Arne Palmqvist, Skara Läroverk; Ola Christensson, Göteborg University Library; Karin Stenfors, Stockholm; and personnel of the National Museum, Stockholm, made available helpful information. I recall also a rewarding conference with Folke Holmér, a Stockholm art historian and former curator of the National Museum.

Various aspects of the study required the help of personnel in art museums, galleries, and libraries in the United States. Among those for whose help I am especially appreciative are the Art Institute of Chicago; Bethany College Library, Lindsborg, Kansas; the Brooklyn Museum; the Fine Arts Museum of San Francisco; the Franklin Murphy Library of Art and Architecture, the University of Kansas, Lawrence; the Kansas City Art Institute, Kansas City, Missouri; the Library of Congress, Washington, D.C.; the Los Angeles County Museum of Art; the Nelson-Atkins Museum of Art, Kansas City, Missouri; the New Mexico Museum of Art, Santa Fe; the New York Public Library; the Pennsylvania Academy of the Fine Arts, Philadelphia; the Raymond Jonson Gallery, University of New Mexico, Albuquerque; the Spencer Museum of Art, the University of Kansas, Lawrence; and Wichita State University Library, Wichita, Kansas. Librarians and registrars of other museums and galleries were also helpful.

The research by Nina Stawski on the drawings and notebooks of Birger Sandzén as presented in her master's thesis at the University of Missouri, Columbia, provided valuable new material on this important aspect of Sandzén's career, and the beautifully printed catalog of the "Sandzén Retrospective Exhibition" at the Wichita Art Museum, May 4–June 9, 1985, not only contains representative reproductions of Sandzén's paintings but also includes informative annotations by Howard DaLee Spencer, curator of collections and exhibitions. Several individuals also enriched the manuscript by sharing their knowledge and insight during various stages. C. Louis Hafermehl, Zona Wheeler, Carl Wm. Peterson, and Ray Stapp had been students of Sandzén at Bethany College, and Ray Stapp read the manuscript at various stages, made helpful suggestions relative to its organization and content, and rendered other important services.

Since reproductions of paintings and prints by Sandzén are a central feature of this volume, I wish to express hearty thanks to Larry Griffis, director, and Carl Wm. Peterson, former co-director, of the Birger Sandzén

Memorial Gallery. They devoted much time and thought in selecting the works of Sandzén for reproduction in the volume, assisted by Margaret Greenough, and I am deeply grateful for their contributions. I also greatly appreciate the fine support of Dee Swensson, Naomi Carpenter, and Beth Lindquist for their expertise and cooperation in preparing the manuscript for publication. The final copy profited from careful reading by Emmet and Marion Eklund.

Action by the board of directors of The Birger Sandzén Memorial Foundation initiated this project, and I appreciate the support and encouragement its members gave me; I especially thank Gene Larson, president, for his generous and helpful participation throughout the entire project. The encouragement and support of Bethany College through Dr. Peter Ristuben, president until his death in 1989, of Academic Dean Richard Torgerson, and of Dr. Joel McKean, president since 1990, were most helpful. I am exceedingly grateful to A. John Pearson, Bethany College, for his professional service in the final phase of preparing the manuscript for publication, along with the computer support assistance of Jay Richardson.

The English translations in this volume are the work of the author.

Finally, I acknowledge with deep appreciation the patient and dedicated support of my wife, Irma, and my brother, Ermal, who made possible the completion of this project after I lost my central vision.

Part I

Years of Preparation

1

Early Years at Home and in School

In the gently rolling countryside of southern Västergötland, "the land of the West Goths," lies the village of Blidsberg. As one approaches this placid and beautiful area of southern Sweden, the spire of Blidsberg church dominates the landscape. In close proximity to the centuries-old stone church is the prästgård, the residence of the pastor and his family, an impressive two-story red frame structure located on a slight incline overlooking the broad valley below. It was in this house that Sven Birger Sandzén was born on February 5, 1871.

Birger, as he was called, was the third son of Rektor Johan Peter and Clara Caroline Elizabeth (Sylvén) Sandzén. Birger's older brother, Carl, became a physician in America, and the middle son, Gustaf, was a well-known pastor in the Lutheran church of Sweden. The Sandzén home offered great personal and cultural resources for the three sons. The father was a well-read theologian and a kindly pastor, but he was also a talented violinist and a capable poet with great literary interests. Clara Sandzén was a devoted, generous, and intelligent wife and mother. The daughter of a pastor and his wife, Clara's parental home had also provided fine cultural advantages, including a French-speaking governess and lessons in drawing and painting in her youth.

Birger Sandzén's family tree on his father's side is traced to Jöns Esping, who was born at Espered in Habo parish, Skaraborgs län, in

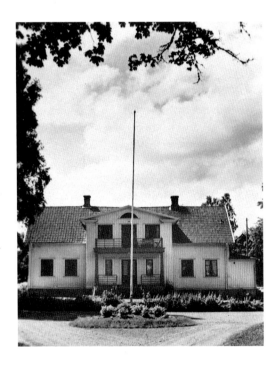

Birger Sandzén's birthplace, Blidsberg parsonage

1680. Birger's father, Johan Peter (1830–1904), and his brother, Carl Gustaf, sons of Peter Svensson, took the name Sandzén in the 1840s, which was derived from Sandem in southern Västergötland, the home parish of the family. Birger's ancestry on his mother's side had its origin with Magnus Sylvén (1692–1715), who was born in Handene, Skaraborgs län. The Sylvén name traces its origin to the Latin *Sylva longa,* for Långeskogen, between Skara and Lidköping. Birger's mother,

Rev. Johan Peter Sandzén,
father of Birger Sandzén

Clara Sandzén, mother of
Birger Sandzén

Clara (1836–1914), born in Bitterna, Skara-borgs län, was the daughter of Anders Magnus Sylvén and Catharina Margareta Carlson. Birger Sandzén is among the descendants of Lovisa Maria Hjelm (1754–1850), who had 3,305 descendants 200 years after her marriage, including a large number of well-known persons in Swedish life. There were many Lutheran pastors in the Sandzén and Sylvén families.[1]

The Sandzéns' family life was happy and enriching; the members shared meaningful devotional experiences in the home and participated actively in the worship services where the father preached and conducted the liturgical service. There was a steady stream of visitors for pastoral business and for personal calls, and friends of the Sandzén brothers came frequently as well. Carl, Gustaf, and Birger enjoyed exploring the old and beautiful Läckö Castle on the banks of nearby Lake Vänern, and Birger was later to make this castle known across the Atlantic by a magnificent lithograph (Figure 1). Young Birger was especially interested in picking wildflowers and collecting pebbles and beautiful small stones; some of these stones were later polished and became the sets in rings, a part of a large collection.

The mill-creek stream in the area was a source of great joy to the Sandzén brothers during the Blidsberg years. On summer days they sailed small homemade toy boats on it. In season, Birger watched Carl and Gustaf as they caught by hand large numbers of crayfish, a special delicacy for the family table. Carl and Gustaf were old enough to skate during winter months on the frozen mill pond. Birger went with them, bringing his little sled, which glided easily on the slick ice surface. One day tragedy almost occurred. The mill pond was frozen solid except near the waterfall where the water normally rushed over the mill wheel. Suddenly Birger's sled slipped rapidly into this dangerous area, but fortunately the sled caught on the root of a large tree that was partially submerged in the water. Carl rushed to the spot, threw himself on his stomach, and with Birger hanging tightly to the sled pulled his brother to a safe place on the ice.[2]

Christmas was a joyous time. On Christmas Eve, when the family was alone, the candles on the Christmas tree were lit, a familiar Christmas hymn was sung, and the Christmas story from the Gospel of Luke was read. The meal followed, which included lutfisk, sill, potatiskorv, and other traditional food. Gifts were then exchanged. Birger received his first water-color box at the age of eight.

He later described various aspects of family life in his parental home. When discussing the music of Mozart one day, he recalled, "Mozart takes me back to my childhood home, to the picture of Mozart on the piano and my father and his friends in the string quartette playing the compositions of Mozart. . . . That was one time when my

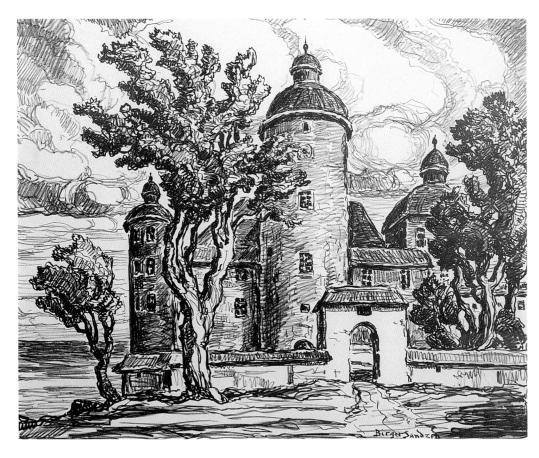

Figure 1

Läckö Castle
(1930) lithograph,
15⅞ × 20 inches

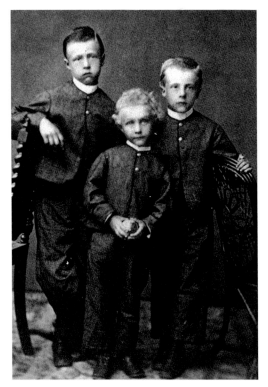

Carl, Birger, and
Gustaf Sandzén

father expected us to be absolutely quiet. We were expected to sit and listen to them play. . . . I learned to know quite a bit about music that way." Birger began to take piano lessons at an early age.[3]

The parents cherished the abiding values of good education for their children. Moster (aunt) Edla was Birger's first teacher, providing instruction in writing, reading, and spelling. Farbror (uncle) Strömbom served as a tutor. At the age of nine, Birger began drawing lessons with Komminister Gustaf Lundblad, Pastor Sandzén's assistant in the parish, who had been a student at Skara. Birger's interest and talent soon attracted Lundblad's attention, and the teacher generously shared his time with the eager boy. Although children of Birger's age were interested primarily in copying figures and horses, Birger showed considerable enthusiasm for freehand drawing. His lessons in drawing occurred at Järpås, another parish in Västergötland, where the Sandzéns moved in 1877.[4]

In September 1881 Birger left home for

Skara Läroverk
(Skara School)

studies at Skara Läroverk (Skara School) in the
old and famous cathedral city by that name;
the years at Skara until he passed the student-
examen (entrance to a university) in June 1890
were crucial in the life of the future artist
and teacher. His classes ranged from basic sub-
jects of a preparatory nature to the more exact-
ing disciplines that led to the studentexamen.
Birger responded well to the various subjects
and found them interesting. Skara, a fine
institution with 400 boys in attendance, had
an excellent corps of teachers; later the young
student remembered two of them especially,
in addition to Olof Erlandsson, his drawing
teacher. Anders Nilsson taught history. He has
been described as perhaps "the best known
and most original personality on the faculty"
in addition to being an avid collector of
antiques; Birger remembered his immense
collection housed in a large garret over the
bookstore. He also recalled vividly Karl Torin,
a famous and unique teacher of science, who
appeared to the boy to have the stature and
bearing of a general. Torin taught botany,
zoology, and related subjects and was also a
good researcher and writer. Torin required
that his students learn thoroughly the Latin
names of flowers in the tradition of Linnaeus,
and Birger passed one examination with the

mark, med beröm godkänd ("with praise")—
this from a teacher who rarely gave more than
a passing grade.[5]

Birger had clear memories of the visits of
the censors who represented the state educa-
tional agencies. He recalled that one censor,
by the name of Ahlin, gave a remarkable sum-
mary of Swedish history in forty-five minutes.
The final academic challenge consisted of four
days of written examinations to be followed
by an oral examination. He reported that the
experience "was challenging but I was scared."
He presented as a part of the requirements for
graduation an essay, "A Comparison of Reli-
gious Freedom at Augsburg and the Treaty of
Westphalia," a copy of which in his handwrit-
ing is still extant.

Birger enjoyed fully the many festive
activities following the examinations and the
completion of his studies at Skara. He was
thrilled to receive his vita mössa ("white
cap"), the well-known symbol of success in
these important examinations, and marched
with the other students out of the school
building in a double line until they were
hoisted on the shoulders of their friends. Then
they strode along to the singing of the words
of the well-known student song, "Sjung om
studentens lyckliga dag" (Sing to the Stu-

dent's Happy Day). The celebration, banqueting, and joy continued during the day and into the evening.

The academic studies and fine progress of Birger at Skara School were recorded in the results of the final examinations in June 1890. In the written section, his essay in Swedish and his translation of material from Swedish into French received a high mark, and his translation from Swedish into Latin was marked as passing. In the more extensive oral section, he furthered his position in a variety of subjects. In natural history, which included topics in the natural sciences, he received the highest possible mark, and other good marks were awarded in Latin, German, French, and English. He also received passing marks in Christianity, mathematics, physics, history, geography, and Introduction to Philosophy. When Rektor Jonas Fridolf Ödberg signed the document verifying his marks on June 12, 1890, he wrote, "Sven Birger Sandzén has displayed excellent diligence and fine achievement."[6]

Singularly important for the future of Birger Sandzén was the presence on the faculty at Skara of Olof Erlandsson (1845–1916), a gifted and dedicated drawing teacher at the school for more than forty years. Gustaf Lundblad, Birger's first drawing teacher, wrote about Erlandsson: "He was a conscientious and skilled draftsman and painter—modest, unpretentious, good-natured, benevolent. . . . He had a fine technical education and used modern methods of instruction. We drew models and many other things 'according to nature' in addition to making copies of good studies. Our energetic teacher continually walked around and around, supervising our work, correcting, encouraging, demonstrating the right concepts. We also had line drawing, perspective drawing and even painting."[7]

Sunday, February 27, 1887, was a red-letter day for Birger Sandzén; this was the date of a conference with Olof Erlandsson that initiated his career in painting. Sandzén's teacher believed that his pupil was adequately prepared for lessons in painting. In a letter to his father, Birger explained that he had been in-

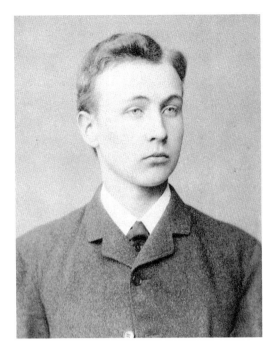

Birger Sandzén while a student at Skara

vited to begin painting and wrote that Erlandsson had made a list of the needed supplies. Birger's father provided the required twenty kronor, and Birger began the lessons. He was zealous in both drawing and painting, and in December 1889 he shared his enthusiasm with his father, reporting that the walls of his room were covered with thirty of his oil paintings, water colors, and drawings.[8]

Birger's interest in academic studies and art kept him occupied, but he also took part in other aspects of school life. He was a member and president for two years of the student organization, Musikens Vänner (Friends of Music), founded in 1886 and still a part of the school. This vocal ensemble serenaded the Rektor of Skara School and the Bishop each May 1 and performed annually on the closing day of the school term in May and December. Moreover, on Tuesday and Thursday evenings during May, they presented greatly appreciated public concerts in the Botanical Garden in Skara.

There were occasions during Birger's years at Skara when he was especially proud of his father. When Kyrkoherde (Pastor) Sandzén was visiting his sons during a pastor's meeting, old Skara students who had been members of the male chorus at Uppsala and Lund sought new words for an old Latin song, "Janne, you

are the one to do it." Birger's father wrote the new lyrics then and there. The son was also pleased when his father was invited to preach in Skara cathedral.[9]

In the early years of his residence in Skara, Birger lived with his brothers and Karl Kilander, Sven Errander, and Axel Sylvén in a house that Kyrkoherde Sandzén had rented for them near the cathedral; Johanna, the long-time family housekeeper, provided a home for the boys there. Later on, during four of his years at school, Birger lived in the home of his mother's cousin, Fru Ahlberg, also known as Moster Mahlin, where Birger had a small but comfortable gable room. Moster Mahlin had many fine paintings and sculptures, including some Chinese paintings and other items from the Orient. This exposure to Chinese art plus his experiences as a boy in visiting the home of Fröken (Miss) Winberg, which was filled with treasures from the Orient, further stimulated his imagination and interest in beauty.[10]

When Birger's studies at Skara were completed in June 1890 he took lessons in watercolor painting from Regina Kyllberg-Bobeck (1843–1913), a painter who has been de-scribed as an artist who emphasized color and "possessed almost an impressionistic attitude." Georg von Rosen (1843–1923), director of the Royal Academy of Art, described her painting, *Parkinteriör* (Park Interior) as "undoubtedly the most excellent water color ever produced by Swedish hands." Birger was enthusiastic about this new art medium, and his teacher, who sensed his great potential as a painter, urged him to study art intensively with the objective of making painting his career. Relatives and friends, however, prevailed upon him to continue with his academic studies at a university, for which the studentexamen had qualified him.[11]

In autumn 1890 Birger Sandzén went to Lund to study at the famous university there and to live in that beautiful city with its great twin-towered Romanesque cathedral dating from the twelfth century. He studied French principally, the language that had been of great interest to him in Skara, and he also attended lectures in art history. Yet he was not wholeheartedly attracted to a traditional university career, and his dominant interest in painting caused him to leave the university at the end of the year.

2

Study in Stockholm and Paris

A new and vital period in the life of Birger Sandzén began early in 1891 when he went to Stockholm to develop his interest and talent in painting. It was an exciting prospect for the young man to anticipate life and study in the beautiful Swedish capital with its rich historical legacy and abundant cultural resources. He enrolled at the outset in Tekniska Skolan and also took painting lessons with Axel Kulle (1846–1908), the "genre painter," the preliminary to his plans for becoming a student at the Royal Academy. The list of applicants was long and there was no vacancy, but in keeping with the regulations he attended several sessions of testing his drawing as a part of the entrance requirement. The only hope for admission to the Royal Academy was for an opening sometime in the future.

Instead, kindly fate dramatically changed young Sandzén's life. He met by chance a student who told him that Anders Zorn (1862–1920), one of the greatest painters and etchers in Sweden's history, had established an art studio in Stockholm and that the famous artist planned to take a few pupils.[1] Sandzén hurried to meet Zorn, and the great artist accepted the young man from Västergötland as a pupil. Birger was one of six men and two women who studied with Zorn (Figure 2) in the little studio on Nörra Smedjegatan in the autumn of 1891; when the number of students increased, a larger studio on Mäster

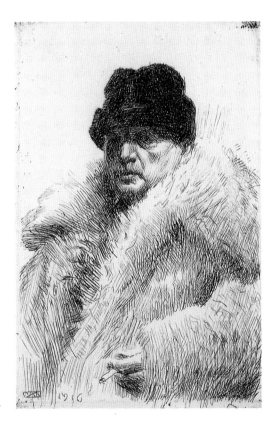

Figure 2

Self-Portrait (1916) drypoint etching by Anders Zorn, $11\frac{1}{2} \times 6\frac{7}{8}$ inches

Samuelsgatan was used. This was the origin of the school founded by members of Konstnärsförbundet (the Artists' League), who rejected the traditionalism of the Royal Academy and began an important national movement in painting.[2]

Young Sandzén's response to the opportunity of being a pupil of Anders Zorn is

9

recounted in a letter to his father in October 1891 describing his first lesson with the famous artist. The first model had been a street boy; the students then painted the second model, an American girl (see Plate 2). Sandzén wrote:

Zorn stood leaning over my shoulder for about twenty minutes when I started painting. It went about as follows as he said: "Now we will see how most easily we can get a simple, natural, and beautiful result in this painting. Perhaps we should begin with this part—pointing to the forehead. What colors will Mr. Sandzén select? Proceed so that I may see. Sienna, ochre, white. Fine, go ahead now, broadly and vigorously without being afraid. If one is afraid and doesn't press on, one will never see what the mistakes are."

I proceeded to paint and then Zorn said pleasantly: "That is fine. Look here, Mr. Sandzén, put some more paint on the chin. Yes, put it on. That is the way to do it. What do you consider to be the connection between this color (pointing) and that on the cheek? Or how shall we move in the best manner from this color to the former? Through the addition of light ochre and sienna? . . . Go ahead with the painting. What part shall we turn to now? Perhaps a little more color in the hair, a little more light."

Soon the first version of the head was finished. I was numb with amazement. Soon a light appeared indicating to me how one shall use color—simply, strongly, truthfully. How does one get such results from a little white, sienna, and ochre? . . . Perhaps tomorrow he will come, sit down and paint for us. That would be extraordinarily interesting.[3]

Birger reported to his father that he regularly painted five hours each day in Zorn's atelier (see Plate 1). Drawing lessons were held between 5:00 and 7:00 P.M., and when the teacher learned upon inquiry that the students did not attend church services on Sundays, he arranged to have the studio open so that they could paint then. Zorn proposed to the students that they acquire a large pendant lamp to enable them to draw in the evenings, and a gas line was installed to improve the lighting. Interesting visitors came to the studio, including Zorn's friend, Albert Edelfelt (1854–1905), the Finnish painter. Moreover, Birger was pleased with the dedication and talent of his fellow students: "What vigor and glowing enthusiasm among the students in that modest studio."[4]

Anders Zorn was the dominant influence on the young artist at that time and quite likely later. His greatest impact was in developing Sandzén's feeling for color and his direct brush work although Zorn's pigment was not as heavy as Sandzén used later. Zorn assisted Sandzén greatly in developing better use of the palette. Another influence on the young artist was Zorn's emphasis on light. Malcolm C. Salaman, who has written about Zorn, points out: "The pursuit of light was the guiding principle in the art of Anders Zorn. With oil-paint, water colors, with etching needle, untiringly he pursued light in its frank and subtle manifestations."[5] Sandzén's paintings and prints reflect this influence from his student days in Stockholm.

Zorn emphasized fundamentals in his teaching and stressed using a palette with five basic colors. Birger described his experience: "Zorn does not want us to mix up many colors. One can get what one needs with the basic colors was his strong belief. While discussing a student's painting (von Henning), who had used about fifteen colors, Zorn declared that this number was far too large. Zorn asked the student why he thought that it was necessary to use so many colors on such a small painting of the model. We soon observed the truth of what he had said when we began to paint."[6]

Young Sandzén was greatly impressed also by Zorn's personal qualities: "We see that we have in Zorn not an ordinary person. How brilliant and original he is in every inch. He is directly opposite to the customary and ordinary. . . . Zorn is a phenomenon. We are of course delighted. And how friendly and good Zorn is, he who is praised by all Europe."[7] When Zorn left Stockholm in October 1891 for a brief visit in Paris, Sandzén was selected by his companions at the school to draft and read an address of farewell to their highly esteemed teacher. The students assembled at the railroad station at Stockholm to wish Zorn bon voyage, and Birger reported that the students received words of hearty appreciation and gratitude from Zorn.[8]

Associated with Zorn as teachers in the school of Konstnärsförbundet were Richard Bergh (1858–1919), a portrait and landscape painter of distinction, and Per Hasselberg (1850–1941), the well-known sculptor. Sandzén greatly appreciated the enrichment that came from these fine artists as he worked with them in the school's studio. In reflecting on his relationship with Bergh he wrote, "He was a fine painter and a deep thinker, uncompromisingly honest as a critic and artist, whose qualities made a deep impression on me." He remembered for the future Bergh's observation during a lesson in painting: "You must know nature before you juggle her." Bergh was especially helpful in assisting young Sandzén with portrait painting, and Birger's achievement in this medium caused Bergh to suggest that the young pupil concentrate on portraiture.[9] Sandzén considered Bergh to be "very critical and severe" at times, but he was pleased on one occasion to tell his father that "Bergh was more gracious toward my studies than I had expected." Birger was selected by his fellow students to join Bergh in drawing up rules and regulations for Konstnärsförbundet's school.[10]

In later years Sandzén described and compared Zorn and Bergh as teachers. They shared one common characteristic: "Anders Zorn and Richard Bergh did not talk much but they certainly had a convincing way of showing the student out of difficulties in painting." When asked if Bergh was more of a scholar than Zorn, Sandzén replied: "Yes, of course. Few knew more than Richard Bergh. He was one of the greatest philosophers and scholars in art and a wonderful painter. Zorn was more matter-of-fact, a terrific technician. His etchings and paintings show perfect knowledge. He could just pick up the palette and go ahead and get it right and beautiful." Then Sandzén observed, "How different in creative temperament they were, these two famous artists, and how great they were, each in his own way."[11]

Per Hasselberg taught drawing and was, according to Sandzén, "a gentle and kind person but an exacting teacher who maintained high standards." Again and again he told his pupils, "Get the accents," suggesting the im-portance of details and precise lines in drawing (Figure 3).[12]

The Stockholm years were also vital in developing Sandzén's appreciation of art. He was a frequent visitor at the National Museum and at various galleries, and he later recorded his intense desire to know and to understand:

I was told by a young academician who called me "the artist," that Rosen's *Erik XIV* and *Karin Månsdotter* which I admired as a boy were "old junk" and that no one any longer painted such pictures. I came with that impression to Stockholm, but my teacher convinced me that these paintings were "noble works of art." I then determined to understand what made these paintings so esteemed. I looked at them for hours at the National Museum. In time I received an insight into what I was seeking in the feeling for style, grandeur and noble symbolism. . . . That happened also with many German, Dutch, Italian, and French paintings. . . . I learned to admire and be gripped by them. The good and the beautiful are two fair twins who love to abide in each other's fellowship.[13]

Sandzén also devoted much time to sketching and painting in Stockholm and the archipelago (see Plate 3). He was often accompanied by a fellow student, Carl Lotave (1872–1924), who later studied in Paris and was Sandzén's colleague for a few years at Bethany College; another close friend was the promising young painter Olof Sager-Nelson (1868–1896), who died at an early age.[14]

Although Sandzén was happy in his art studies and in his circle of friends, there were also serious problems. He lived austerely within his limited financial resources, and at times he was uncertain about the future. His family always cooperated to the best of their ability, and he sold an occasional painting to augment his funds, but in October 1892 he wrote to his father, "I have some difficulties again with my affairs this term and I have done what I could to raise some money. I hope that the situation will soon take a change for the better. Although it already seems as if the life of an artist is difficult and trying, I cannot but believe that it is God's will that I go this path. I think that I have been almost led by Him step by step for several years in that direction and it cannot be His intention to permit an

Figure 3
Early sketch (1892),
6 × 9 inches

honest, hard-working and struggling person to suffer want because he has chosen in many respects a difficult career in life."[15]

Sandzén's problems did not prevent him from working with great zeal and dedication, and especially rewarding was his substantial progress in painting. Among the better known landscapes that he completed during this period were *Mellan skurarna* (Between Showers), *Vintersol* (Winter Sunshine), *Skördescenen från Västergötland* (Harvest Scene from Västergötland), and *Från Vänerns strand* (From Vänern's Shore), which was purchased by the Göteborg Art Association. He also painted and sold several portraits during this period.[16]

Birger Sandzén left Stockholm in late spring 1893 for his parental home in Järpås. Since Zorn did not plan to teach in Stockholm in the near future, Birger decided to study in Paris beginning early in 1894, but in the interim he was occupied with a variety of activities. In June 1893 Birger spent a few weeks at Axval in Västergötland where he was conscript No. 166 in his company of the Västergötland Kungliga Regiment (Västergötland

Royal Regiment) in order to fulfill additional requirements pertaining to compulsory military training. At first he found the quarters uncomfortable and the military training strenuous, but in time he adjusted to the new conditions. He participated in a grand parade of 3,000 conscripts and regular army personnel, witnessed the great display in the presentation of the flags, and shared in the singing of "Du Gamla, Du Fria," the Swedish national anthem.[17]

When his period of military training was over, he returned to Järpås, where he sketched and painted and gave lessons in painting. Pupils came from Lidköping and other places in the area, and it is quite likely that he had some pupils from farther away because in correspondence he referred to a fine pupil from Kristianstad in Skåne. Moreover, his paintings were being well received. In November he wrote to his brother Carl, "I have had great success in selling my paintings and portraits during the last six months." The income had been more than 1,000 kronor.[18]

In October 1893 Birger went to Varberg

on the west coast of Sweden to show some of his paintings to Richard Bergh, who had joined Karl Nordström (1855–1923) and Nils Kreuger (1858–1930) in establishing the Varbergskolsmåleri (the Varberg School of Painting). Birger wrote to his brother Carl following the visit, "I received more recognition from Bergh than I had dared to hope. He said that my paintings were sensitive and original and he advised me to exhibit them. That I have done. Six of my paintings are exhibited in *Göteborgs Konstförening*." [19]

Early in 1894 Sandzén left Järpås for Paris, where he lived in the Hotel de Brest on La Rue de Rennes for 40 francs per month. In February, at the suggestion of Richard Bergh, he began painting in the studio of Edmond-François Aman-Jean (1860–1935), who had his atelier on Avenue de Saxe. Aman-Jean was a painter who had exhibited his works and had won distinguished prizes in leading European galleries, and at L'Ecole des Beaux-Arts, Aman-Jean was closely associated with Ernest Laurent (1859–1929) and Georges Seurat (1859–1891) in promoting impressionism. Students from twelve nations, including some Americans and one Swedish-American, Carl Lindin, were pupils of Aman-Jean at that time. [20]

Aman-Jean has been described as a painter "whose subtle color and decorative compositions are known wherever modern art is known," and Sandzén described him as "a wonderful teacher and a good artist." [21] The Swedish student was now introduced to new approaches in painting. He enjoyed immensely the cosmopolitan atmosphere of the studio on Avenue de Saxe and profited greatly from various teachers and their uniqueness and talent.

One Saturday in March 1894, Birger, accompanied by Prytz, an old friend from Stockholm days, went on a special trip to Montparnasse. They were en route to visit Anders Zorn, and Sandzén described the meeting: "Zorn was pleasant as always and took us to his studio. The studio, as could be expected, was attractive. There were precious old tapestries from ceiling to floor, beautiful paintings, including many old ones, fine statues, Japanese porcelains, etc. Zorn asked how we, his former pupils, were getting along. We had a long conversation about our studies, then about his trips to America, his latest paintings, etchings, etc." Sandzén and Prytz made moves to leave in order not to take too much of Zorn's time, but he told them that they surely were not so busy that they could not stay longer, which they did until Zorn was ready to leave. The three of them then walked for a long time until Zorn invited his former students to be his guests at one of the finest cafes in Montmartre. There they talked, listened to music, and sipped Vermouth. At 7:00 P.M. they left the cafe and parted from Zorn. "This was a pleasant and informative time. Prytz and I were more than satisfied," Sandzén concluded. [22]

Birger Sandzén's lifelong interest in music was enhanced in Paris as he became a pupil of M. Boussagol, the well-known singer. He went for a weekly lesson in the teacher's studio on Rue de Richelieu and was given thorough instruction in scales, voice production, and repertoire, including some of Boussagol's own compositions. Sandzén was pleased with this association, which served him well in his later musical career in America. Sandzén also often attended the opera, concerts, and plays in the French capital and witnessed an unforgettable performance by Sarah Bernhardt. He was deeply impressed by "her beautiful, dramatic and gripping voice. There is none like her." [23]

During the Paris period Sandzén's frequent and lengthy visits to the Louvre and to other art museums and galleries made a great and lasting impact on him. In a letter to his parents he recounted his regular experiences: "The study which most occupies the young painter is to go to the various salons to study the different trends in modern European art. One must naturally go several times to the salons and take in one or two rooms only on each occasion. There are really giant exhibitions both at the 'old' Salon des Champs Elysées and at the 'new' Salon des Champs Mars." [24]

The great cultural traditions of Paris enabled Sandzén to immerse himself in the beauty and meaning of art historically, and the lively activity stimulated him to enrich his own

talents. As a young painter surrounded by the inspiring work of famous painters, print-makers, sculptors, and architects, he felt a new sense of belonging to a great tradition. He was free to paint, to view masterpieces, to discuss art and culture generally with kindred spirits, to dream, and to share in the life of a Parisian. The Cafe Versailles and the Restaurant Le Maitre were favorite meeting places of the art students where they shared good food, pleasant fellowship, and fine music. This environment inspired Sandzén to full dedication to what now seemed truly to be his life's calling. Birger was only twenty-three years old, and life on the whole was good. Moreover, the knowledge he gained in Paris about America and Americans was destined to be an important factor in the years ahead.

Sandzén painted several landscapes while in Paris. Among those exhibited there and in Sweden, immediately after his return to his homeland, were *I Parken* (In the Park) and *Vid Seinen* (At the Seine). Sadly, his portfolio was stolen shortly before he left Paris; it contained seven drawings of nudes and twenty landscape studies that could have been converted into paintings.[25]

3

Emigration and Early Years in America

Birger Sandzén returned to his parental home at Järpås in June 1894, and although he looked back with pleasure on the months he had spent in Paris, his mind was fully occupied with another part of the world—America. On February 10 of that year, he had written a carefully worded, detailed, twelve-page letter to Dr. Carl Aaron Swensson (1857–1904), president of Bethany College, Lindsborg, Kansas, which began, "The one who writes this letter is a young Swedish artist and student who respectfully seeks a position in the service of your college."[1] Little did Sandzén suspect that he would spend the rest of his life—sixty years—at the college in Lindsborg. Similarly, the future veiled the great secret of the magnificent and lasting contribution that Birger Sandzén was to make to Bethany, to Lindsborg, and to a wider area.

Young Sandzén's letter cited methodically the "branches" in which he felt he could serve the college: French, Swedish, drawing, and painting. He supported his claim by detailing his educational experiences at Skara, Lund, Stockholm, and Paris and by listing the names of persons with whom he had studied and his achievements in art and languages. He also wrote about his interest in music, with special reference to studies and performance in singing. He concluded his letter: "I have heretofore worked hard and honorably and I have studied thoroughly. You will discover, if I may

Carl A. Swensson

sometime have you as a supervisor, that I will never shun any work or any effort to achieve the best possible results in your service. . . . Dr. Swensson, extend your firm hand to your countryman. I will strive with God's help to do you honor."[2]

The letter was not written on the spur of the moment. As a boy, Birger had avidly read

accounts and stories about life in America and especially about the American West. He had witnessed the spread of "America fever" in his native Västergötland and in Sweden generally when, during the previous decade, 324,000 Swedish immigrants, the greatest number in any decade, had crossed the Atlantic to find new homes in "the great land in the West." Moreover, in 1891 Carl Swensson had published in Sweden the volume, *I Sverige. Minnen och Bilder från Mina Fäders Land* (In Sweden. Memories and Pictures from the Land of My Fathers). Although the book was based primarily on Swensson's travels in Sweden, there were long sections on the Swedes in America with much material about Bethany College and Lindsborg, and it had been eagerly read and discussed within the Sandzén family circle at Järpås.[3]

Birger Sandzén pondered the prospects of life in America, and in two letters to his father from Paris in April 1894, prior to a response from Swensson, he discussed the situation: "Let us consider the American question principally from two points of view: the artistic and the economic." He began by reviewing the advantages of staying in Paris: "Why one is in Paris is, of course, principally that here is the most to see from all aspects of art and from all eras. . . . One does make progress here. One sees the old matchless things at the Louvre, one sees the good new things at the Luxembourg and at the hundreds of exhibits. One therefore receives impressions, insight and impulses by comparison with your own work. One learns without a pencil in hand. . . . The advantage of studying in Paris is, as I have said, that one can see so much art in all forms."[4] When it came to the alternative of going to America, Sandzén cited several compelling reasons. He pointed out that an artist must always be ready to travel and that wherever there are models, sky, water, earth, paints, and materials, he can paint. Moreover, he argued, "If one does not become a painter because of his own impelling desire, he never will become one. . . . Interest in art will not cease by living in America. It should be a time for progress just as much as in Paris."[5]

Birger also emphasized the advantages of living in a small community in America: "Out in the country, far from the principal art centers, one can usually do his best work. I am convinced of that. It is likely that I made greater progress at Järpås prästgård last year than at any other time. I observed it as I painted. I lived with nature and I found more feeling in color than I possibly would have done with studies in a studio. . . . If one has the artist in him he will develop inevitably; if one does not have that feeling, it is completely a matter of indifference if one is in Paris, Göteborg, or Skarstad [a small community in Västergötland]."[6]

Sandzén's decision to go to America was based upon the prospects there for an artist and not upon economic factors. He wrote, "It is not possible to predict in advance how well one may be able to succeed economically as an artist in America. This will depend upon a variety of factors. But there is good reason for making the attempt, and in my opinion, it is of little importance whether the attempt is made after six or eighteen months in Paris. In any event, I will learn the language, have many experiences, and surely make some money. If I see that the prospects are not good in America, I can later study in Paris on money that I have saved." Young Sandzén then concluded, "Now in order to make an assessment of the situation, since I expect that my development as an artist will continue, and although it is naturally unclear whether or not I will be successful as an artist, and even if the economic situation should not be advantageous, I will seek nevertheless, with God's help, to make a vigorous attempt this autumn, if Dr. Swensson offers me a position."[7]

There were some anxious days at the Järpås prästgård until Dr. Swensson's letter arrived on July 16. Birger replied to the invitation to come to America the same day: "A respectful and hearty thanks for your letter and the call [to become a teacher at Bethany College] which was included in it. . . . There will be much at the outset that will seem strange to me. Many weaknesses will appear. But I will receive your criticism with appreciation and I will work earnestly to improve myself in the new position. May I be able to be use-

Old Main,
Bethany College

ful!"[8] The following weeks were devoted to preparations for the voyage, and it was with lively expectation that Birger packed his trunk and made plans for the trip. He was confident that he had made the right decision, but in the background of his thinking was the realization that the American experience need not be for life.

Late in August 1894 Birger boarded the *Camio* at Göteborg for the voyage across the North Sea to Grimsby near Hull. He viewed the English countryside for the first time as he traveled by train from Hull through London to Southhampton. On August 25, when the USMS *Paris* sailed from Southhampton to New York, Sandzén was a passenger. Thus began his pilgrimage to America, which resulted in lifelong residence except for three trips to Europe and two visits to Mexico. The *Paris* arrived in New York on Saturday morning, September 1. After a brief sightseeing tour, principally on Broadway, he left New York that evening and arrived in Chicago the following Monday morning. He was impressed with the fine accommodations on the train and the cordiality of his fellow travelers.[9]

Sandzén left Chicago on the Rock Island train Monday afternoon, September 3, with McPherson, fourteen miles south of Lindsborg, as his destination. Arriving there the next day, he was met by John Swensson, Dr.

Swensson's brother, and by Olof Grafström (1855–1933), the art teacher at Bethany and a native of Sweden from Norrland. It was a hot September day, but the traveler was cordially received, and a light wagon with a sun top, pulled by brown horses which were "thinner than those at Järpås," brought Sandzén and his associates to Lindsborg in a few hours. He was enthusiastically welcomed by Dr. Swensson at the impressive five-story main building on the Bethany campus. That evening, the newly arrived visitor attended a farewell reception for Professor Westerland and was persuaded to sing two solos in the Swedish language. Sandzén's identification with the college and the community was instantaneous and lifelong.[10]

Young Sandzén's temporary residence was in the home of Dr. and Mrs. Swensson, but he soon had permanent housing in room eighty-eight on the second floor of the main building, where the unmarried faculty members lived. His room adjoined Olof Grafström's. Meals were provided in the college dining hall. Birger expressed great pleasure with his situation. Dr. Swensson soon told the newcomer that he "was already an American" and that the president was more than satisfied with the new teacher. Birger shared one concern in a letter to his parents: "I am almost anxious about the expectations they have of me. I will meanwhile do the best I can." He was called

upon to sing at the opening exercises of the new school year, and he listened to several speeches then and at other events, commenting in a letter to his father, "Americans give speeches on all possible occasions."[11]

Birger Sandzén had no difficulty in adapting to life in Lindsborg. He met every evening for about an hour with Prof. P. H. Pearson, who taught him English, and in return, Pearson received instruction in French. Birger spent much time with Grafström, whom he described as "a true hedersman" (man of honor) and a fine artist; they painted together and talked about art. He was often called upon to sing solos at public functions, and his fine tenor voice gained for him a wide circle of appreciation for his efforts. He became a member of the Bethany Lutheran Church during his first year in Lindsborg. Sandzén's principal assignment during the first year was to teach classes in Swedish and French. He assisted Grafström with instruction in the Art Department, and he also taught some private pupils in art. His compensation for the year was $340 plus meals and room.[12]

Life in the new world presented a variety of decisive contrasts with life in Västergötland, Stockholm, and Paris, with striking differences between his native Sweden and Kansas. The former was a land of miniatures, with abundant birch and pine trees, sparkling streams, and tree-lined lakes, all in subdued light. In contrast, Kansas was mostly arid with treeless plains except for an occasional river or creek lined with cottonwoods and a scattering of other trees, wind-whipped and struggling valiantly for survival in dry years, all bathed in bright and penetrating light, even on cold and wintry days.

The contrast was not only geographic and environmental; it was also cultural. Birger Sandzén had shared from childhood days in the fine culture of his home and of Skara, Lund, and Stockholm. He had been inspired by life in Paris with its rich historical and artistic resources. Now he found himself in a small, rather isolated immigrant community on the western frontier, founded only twenty-five years earlier. Yet Lindsborg was no ordinary plains-frontier community. Uppsala graduate

Pastor Olof Olsson had founded a Lutheran congregation there in 1869, and within a year a choir was singing the chorales of the Lutheran church, and a Swedish lending library of 300 volumes had been established. Slightly more than a decade before Sandzén arrived, Dr. Carl Swensson had founded Bethany Academy, which by this time was a baccalaureate-degree-granting college of liberal arts and sciences with a conservatory of music, a teacher-education division, a business college, and an art department. Sandzén soon found fellowship with kindred spirits: Olof Grafström and Carl Lotave, both artists; a group of European-educated musicians, Sigfrid Laurin, N. A. Krantz, Hugo Bedinger, Franz Zedler, and later Hagbard Brase and Oscar Thorsen; and a group of American and Swedish-American scholars and musicians. An oratorio society, twin-born with the founding of the college in 1881, sang Handel's *Messiah* and other oratorios, and a modest-sized symphony orchestra, chamber-music and vocal ensembles, and celebrity and faculty recitals contributed to the good life.

Birger Sandzén had been in Lindsborg only a few months when he was asked by Prof. N. A. Krantz, director of the oratorio society, to sing the tenor solos in the performance of Handel's *Messiah* during Holy Week. In March 1895 he sang the recitatives and arias for the tenor, accompanied by the orchestra, as the society performed the oratorio, and was thrilled by the entire performance. He had never heard such "a wonderfully created tone," as the large chorus and orchestra merged their talents.[13] The response to his singing was encouraging, and his success is evidenced in his continuing as soloist for ten years in the increasingly popular performances of the *Messiah*.

The young teacher's first year was a rewarding experience for the college and for him. In the new academic year, 1895–1896, his teaching responsibilities were substantially increased. His linguistic talents were recognized, and he was assigned to teach courses in Swedish, German, and French while he continued to assist Grafström in the Art Department. The two men went on frequent sketch-

Birger Sandzén
(wedding photograph)

Alfrida Sandzén
(wedding photograph)

ing trips, and Sandzén devoted much time to drawing and painting. In addition to his heavy teaching load, he was asked by Swensson to do extensive literary work in reporting on concerts and public events for Swedish-American newspapers. An amazing aspect of his career was his capacity for and will to work. He was young and energetic, and he gave himself wholeheartedly, then as throughout his life, in untiring service to the college and to the community.[14]

Birger also found time for reading and recreation, however. He had reviewed German literature during the summer months, and in October 1895 he reported with great pleasure that he was reading Shakespeare in a four-volume edition he had recently purchased. He considered the great English writer in "a class by himself" although felt that some of Goethe's works were comparable to Shakespeare's writings; he also read the works of Dickens and Molière. The young teacher played the guitar and gave lessons on that instrument. At Skara he had learned the fine art of fencing, and he instructed some students in this selective sport. He and Grafström often took long walks in various parts of the Smoky Valley; he was thrilled with what he saw on these walks—"brilliant yellow and red along the

creeks, gold buffalo grass on the prairie and large, bright sunflowers." Sandzén was also a keen observer of certain aspects of American life. In a letter to his father he commented, "No American goes a step more than he has to. The Swensson brothers ride everywhere. Dr. Swensson speaks with amazement about Swedish walking habits. He is certain that the Swedish people will walk themselves to death." He also identified another American trait: "How practical the Americans are in big and little things one cannot really grasp if one doesn't see it."[15]

In this early period of his life in America and in the midst of demanding professional obligations a personal aspect arose that was decisive for the young painter and teacher across the years. After slightly more than one month in Kansas, he wrote to his father that he had met the Eric Leksell and Enoch Engstrom families in McPherson (Mrs. Leksell's father and Enoch Engstrom were cousins of Birger Sandzén's father). Describing his delightful visit in McPherson on a Sunday in October 1894, he reported that the Leksells had a daughter, Alfrida, who was an outstanding piano student at Bethany College. Birger also celebrated a joyous Christmas with the Leksells and Engstroms in McPherson.[16] He became a frequent

visitor in the pleasant Leksell home, and in 1900 Frida (1877–1961), an attractive and talented young woman, became his wife. She had been a pupil of Godowsky in Chicago, and she presented much appreciated piano recitals and enjoyed great success as a piano teacher at Bethany.

Life at Bethany College continued to offer challenges to Birger Sandzén. He steadily established himself as a fine teacher and a valuable member of the college community although his role in the Art Department was as yet a minor one. When Olof Grafström left Bethany at the end of the academic year in 1897 to become head of the Art Department at Augustana College in Illinois, he was succeeded by Carl Lotave. Swensson, who viewed Sandzén's role mainly as a teacher of languages, accepted Sandzén's recommendation that Lotave be engaged as the principal art teacher. They had been good friends as pupils of Zorn in Stockholm, and Sandzén once said of Lotave: "It was early apparent that Lotave was a young man with great talent. Now we see the noble and firm achievement that he has accomplished. The recognition and admiration which is now lavished upon him is deserved because he is an honest artist who paints for the sake of art."[17]

When Lotave left Lindsborg in 1899 for a position in Colorado Springs, Sandzén was appointed as the principal art teacher at Bethany. He served in that position and as head of the Art Department until his retirement in 1946. The years of preparation were over, and Sandzén looked upon the dawn of a new century with confidence and joy. His marriage to Frida greatly enriched his life for more than half a century, and his position at Bethany College had been clarified with his appointment as head of the Art Department. He now had a specific mission, which he accepted with enthusiasm, and the future seemed to be bright with the promise of greater things.

Part II

Years of Productivity

4

Teaching at Bethany College and Elsewhere

Birger Sandzén taught hundreds of students at Bethany College and at other institutions where he was a visiting professor. This fine painter and printmaker made teaching a central aspect of his life; whether it was instruction in language or in art, nothing took priority over his responsibility to students.

An episode reported by Myron Vann, a student who served at times as Sandzén's chauffeur, uniquely illustrates this commitment. The two travelers were behind schedule en route to a Kansas town for a lecture, when in the north end of Wichita a highway patrolman stopped their vehicle for exceeding the speed limit. The student driver convincingly explained the situation to the patrolman, who, upon peering beyond the driver to Sandzén, said, "Oh, you're that painter fellow from Lindsborg." Without turning his head, Dr. Sandzén answered graciously, "Birger Sandzén, teacher at Bethany College."[1]

"Birger Sandzén, teacher at Bethany College"—and what a teacher! His dedication to his classes and to his students was unfailing; he missed classes only when the circumstances were beyond his control. In 1922, when his first one-man show was scheduled in New York, Christian Brinton (1870–1942) and Henry Goddard Leach (1880–1970) urged him by telegram to attend the opening at the Babcock Galleries, but he expressed his regrets and replied that he could not miss his classes for an entire week.

Although Sandzén did not often speak or write about his view of teaching, he described certain aspects of it in an article published in 1915 that represented the basic elements of his view across the years. A central principle was that "the art teacher as well as the critic and the general public should respect and encourage a sound and healthy individualism which is the one normal and logical motive power in art production, and should discourage imitation, repetition and standardization. A work of art is a personal message from soul to soul and cannot be made after formulas. The Cézanne formula will not lead to goals any more than the old academic recipe."[2] Giving further emphasis to individualism, Sandzén observed: "Fortunately, every artist has the opportunity of counselling with a teacher that is always ready to give the very best advice to the sincere and unsophisticated disciple. The name of the great master is Nature. Study various schools, traditions and masters as much as you like, but do not let them take away from you the most precious gift of the Creator, your own individuality. Individuality and Nature in honest partnership will always create new and fascinating works of art that will never grow old. . . . If we study long enough with the Great Teacher [nature] we shall gradually work our way through imitation to free interpretation."[3]

Sandzén emphasized for his students the

vital importance of color. He lamented that "the whole western world has lived through a long period of color-blindness. The Impressionist School was the first sign of recovery. Color will no longer be an unimportant element in painting, but an essential feature." He felt that there was a great weakness in teaching painting relative to color:

In most of our schools [1915] very unsatisfactory instruction is given in handling color. Instead of teaching the pupil from the very beginning how to strike a simple and clear chord of colors, he is put to work on still-life studies, such as dirty bottles, frying pans, vegetables, etc. shaded by screens or shadow boxes. He is requested to study vague colors in dim light, whereas he ought to begin by painting a few well grouped objects of color and attractive form in strong light. What would we think of vocal teachers who would be so chaotic in their methods as to coach pupils on interpretation before they could produce a decent tone or sing in tune?[4]

Sandzén also had practical advice for his students. They should use only the best canvas and pigment, and a sufficient number of studies should be made prior to work on the canvas. He offered these suggestions: "The safest way is to put on only one coat. Do all experimenting on separate canvases so that you do not need to do any guesswork on the picture. . . . There are four or five pigments that no painter can do without. As to the rest there is plenty of room for individual taste." Moreover, he pointed out, "It is no pleasure to work with a poverty stricken palette. There are several fine unflinching pigments. Get acquainted with them but do not put all of them on the palette at the same time. . . . Again I say: 'Let us experiment and learn the joy of orchestral color.'"[5] The Bethany teacher also had specific ideas about brushwork; he felt that it should be varied according to the subject and the texture of the canvas.

When Sandzén turned to the question of design and rhythm, he had the following suggestions for his students: "Even here nature is a trustworthy teacher. By studying humbly and diligently nature's form, we shall gradually learn to distinguish between essential and non-essential things, and develop our inborn sense of proportion and balance. When this reaches its maturity, we will be able to grasp rhythmic line. . . . There is no recipe for rhythmic line, but the great master [nature] can teach it to him who sees with the eye of a child and whose vision has not been dimmed by formulas. Let us remember Julius Lange's [Danish art historian, 1838–1896] words: 'Art must ever be rediscovered and made over again from the beginning.'"[6]

When requested to describe her father as a teacher, Margaret Greenough consented to do so only reluctantly. "My father, in the tradition of many great old teachers, taught by showing right on the student's work. I will never forget once when I was painting some wheat shocks. I wanted them to stand out, so I put more and more oranges and yellows, etc. on them. My father sat down and carefully, deliberately mixed some ochres and greens, and the shocks projected themselves immediately. There were other colors with the green, but the lesson was that in trying to project them with hotter and hotter colors, in relationship to the rest of the canvas, I lost them. A little cooling, and out they came."[7]

Her father's response to a painting in progress varied with the circumstances, according to Margaret. "If my father thought a painting was coming along all right, he didn't put a brush to it. He might make a comment that it was coming along satisfactorily and that I had caught the character of what I was doing. He had one form of criticism that he called 'pulling it together.' That was the last one when you thought you had finished. He didn't do this unless he thought it was really necessary. Raw edges were made to behave; what stuck out too far in relation to the rest of the canvas was put back; what needed to come out a little more was coaxed out, but always with regard to the whole. It was like magic because a rather mixed-up surface emerged unified, with the main theme and secondary themes all in place."[8]

An interesting experience with her father as teacher occurred shortly after Margaret returned from Paris in the early 1930s. She had brought with her many of her canvases, and "One canvas was of an old man that I thought was pretty good. Then Papa and I

each painted a portrait of August Lundgren [see Plate 40], a Lindsborg Swedish immigrant. Father did not touch mine but he made me work and work on it. Finally, when he was satisfied, he placed the Paris study and my recently completed study of August Lundgren side by side. His only comment about my new portrait was the following: 'Now you can tell there is a body under that coat.' "[9]

Margaret recalled vividly other emphases in her father's teaching: "He considered order the number one requirement for painting. . . . He used the word 'arrangement' rather than the word 'composition.' With regard to painting a landscape he said: 'We must simplify and sum up form in nature—in rather large masses.' He always said it was equally important to know what to leave out as what to put in. That was the main lesson in some of those large landscape classes in the mountains. He couldn't help chuckling at the memory of various students intent on putting every tree and rock their eyes saw on one piece of paper. He insisted that every sketch be thought out and not put down aimlessly."[10]

Valuable evidence about Birger Sandzén's talent as a teacher comes from the recollections of his students. Elizabeth Farrar Green Love affirms that "no one aside from my parents has had a greater influence on my life than Birger Sandzén. He opened up in his painting class a whole new life for me, a life of enrichment and fulfillment beyond anything I could have expected." He would come to the painting with encouraging words, and then "take the brushes and by a deft stroke here and an accent there, he brought life to an ordinary painting. He taught us how to see and use colors." After studies with Sandzén at Bethany College, Mrs. Love served as a painting instructor at Stephens College, Columbia, Missouri, when Sandzén was a part-time director of the Art Department and taught weekend art classes (see Plate 34). Whenever he came to Stephens College he would take a small group of students to dinner, and after dinner they would go somewhere for talk. She remembers him as a wonderful conversationalist who could speak in an interesting manner on many subjects. She felt that these

talks broadened their horizons and observed, "They did more than that—he gave us his philosophy of life which raised our moral and spiritual insights. He hated sham and insincerity. . . . When we were with him, we knew that we were in the presence of a great and good man."[11]

Dolores Gaston Runbeck, a Sandzén student and later his assistant and a well-known water colorist, recalls, "In every way he seemed to be stretching the student's mind and challenging his skills. Dr. Sandzén never lost the zest and satisfaction of opening up new pathways for future artists. He was never impolite or discourteous. His actions were very deliberate, thoughtful and unhurried. . . . He taught by example and demonstration which usually began with a marvelously soft mystifying deep chuckle. Eventually the discovery was made that such a chuckle indicated that the master had seen something which pleased him. If the chuckle was absent Dr. Sandzén would take the palette and brush, calmly sit down and with a stroke or two, he would show a better way which the student would never forget." Mrs. Runbeck also remembers the annual autumn sketching trip, which always included the small pond northwest of Lindsborg that boasted a charming willow tree by the water's edge. Teacher and pupils devoted themselves earnestly to sketching and painting that scene, which was given a kind of immortality in canvases and prints throughout this land.[12]

Many former students recall with gratitude Sandzén's great influence on them in their formative years. Myra Biggerstaff Holliday, another student who later became his assistant, records, "When I came as a student to work with Sandzén in the Swedish Pavilion, he opened up a whole new world for me. . . . As a teacher he was kind, dedicated and tireless. We tramped all over the neighborhood sketching creeks and willows, his favorite subjects. He was a master of line sketches— so few lines but very expressive. I really loved his drawings. We had a father-daughter relationship when I became his assistant. He called me 'little Myra' always and had I grown to be six feet tall, it would have been the same." Myra, who has a distinguished record of awards

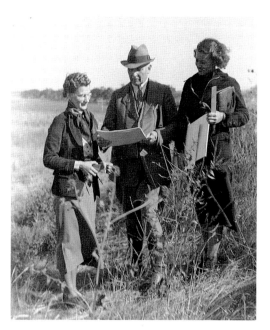

Sketching trip, Birger
Sandzén with two students

and prizes as a New York painter, cherishes her
memories of some of Sandzén's paintings,
which are "absolutely terrific, so much power
and life that they should hang in the Metro-
politan Museum and the National Museum,
Stockholm [some of Sandzén's paintings are in
the National Museum]. Moreover, as a person
Birger Sandzén had great dignity, integrity
and humility. If I were Irish I'd say 'He was a
dahlin man.'"[13]

Carl Wm. Peterson, painter, teacher, and
former co-director of the Birger Sandzén Me-
morial Gallery, has pleasant memories of the
teacher-pupil relationship. He recalls how
Sandzén would walk over to where the stu-
dents were painting and stop to see what pro-
gress was being made. Assessing the situation
he would tactfully say, "'I believe I will get
my palette and we'll work together on this.' It
was obvious that our own palette was a sorry
sight and the paint not very abundant. He
would come back with his palette glowing
with the very best paint available." The former
student also observed, "After pleasant conver-
sation while touching up an area and making
helpful comments concerning painting, he
would step up and pat you gently on the shoul-
der, then after generally making a complimen-
tary comment, he would move on to another
student." Looming large in Peterson's mem-
ory is Sandzén's "graciousness, his kindness,

his cautiousness, his generosity, all of these
qualities will be forever etched in the minds
and memories of his students."[14]

Charles B. Rogers, a well-known Kansas
painter who succeeded Sandzén in the Beth-
any Art Department, remembered his teacher:

I am not an overly sentimental type, but I would
admit that Sandzén, whom I knew for more than a
quarter of a century, was one of the few men for
whom I had affection. . . . He was a real gentle-
man. If anything, he was a bit too tolerant of in-
competence in his students. He would pat them on
the back and say, 'You're doing fine, doing fine,'
then sit down and try to rectify a poor piece of
work. That happened to me too with my first
painting in his presence. To demonstrate his think-
ing about a color in mid-distance he put a couple of
dabs on my canvas. I was in a dilemma, either paint
the whole like the dabs, or scrape them off. I scraped
them off—but though Sandzén never again touched
my work he did not hold it against me. . . . I re-
member how tolerant he was of ignorance. I made a
critical statement about one of the Dutch painters
to him. He smiled and said: "Oh, he was a pretty
good painter." Fourteen years later, after I had
learned something, I wrote a letter apologizing for
the statement.[15]

C. Louis Hafermehl, a Sandzén student
during the 1930s, has a firm conviction that
"Birger Sandzén was an ideal man to be asso-
ciated with a young student during those grim
depression days. He was not concerned with
transitory values. Through him we came to
believe that if art had no value then certainly
nothing else did. He passed on to his students
a sense of purpose." Moreover, Hafermehl
remembers clearly that "there were few stu-
dents, if any, who did not experience his gen-
erosity. Moral support was reinforced with
material assistance. There was that freshly
painted masonite panel when you did not have
the money to buy one. There was that costly
tube of paint when you needed it, for he seemed
to sense what your paint box lacked. Those
were acts of confidence in a time when a stu-
dent was filled with doubts. It gave a certain
dignity to the act of painting."[16]

Louis and Frances Hafermehl both shared
the privilege of being students of Sandzén and
jointly have many happy memories of their

esteemed teacher. In later years Frances was co-sponsor with Douglas Luther, a Bethany graduate, of a well-reviewed exhibition of Sandzén's works in Washington, D.C. Louis further described the fine relationship between teacher and pupil.

One of the most choice and cherished things in our collection is a 9 × 12 inch pencil drawing on white charcoal paper done by Birger Sandzén in 1936. Its subject is the Smoky Hill River east of Lindsborg. There is a remarkable structure to this composition and there is a great graphic strength to its line. This is an exceptional artistic statement by a sure hand and a penetrating eye. Two-thirds of this composition is filled with a high clay bank on the left while the river bends in a half elliptical movement behind the cottonwood trees in the upper right hand corner. I had the pleasure of observing this drawing since it was done on my sketch board as a demonstration on that April day forty-four years ago. I think I realized then the power of those pale blue eyes, for they had the ability to look beneath the surface of things.[17]

Dale Oliver, a longtime artist with Disney Productions, also remembers Birger Sandzén fondly: "We students always referred to him affectionately as 'Doc,' but rarely to him personally. He was always a most imposing man, without ever being intimidating—he held a modest reserve without being diffident. He would let a student struggle with a problem before he would intervene. Sometimes I felt that I was being ignored and then suddenly he would blossom forth with a bit of demonstration. No doubt this was his way of developing self-reliance." Oliver appreciated Sandzén's responsiveness to students: "He seemed to have a special sense that told him when some of us had run out of materials. I can still recall when my meager supply of funds was depleted only to have him suddenly come over to me with a new tube of cadmium white oil paint. His generosity was consistent. . . . We all loved him. The man was of such regal bearing and such simple common qualities of greatness of which greatness is made. Perhaps it is not his passing that is to be noted but rather that he had lived."[18]

Dr. Ray Stapp, a Bethany graduate, a former colleague of Sandzén as a teacher in the

Art Department, and later a member of the art faculty at Eastern Illinois State University, Charleston, Illinois, recalls other aspects of the mentor and friend whom he greatly admired: "It was a special treat to have our small history of painting classes in the Sandzén studio. We would sit in a semi-circle and Dr. Sandzén would show us reproductions of the paintings we were studying." Sometimes there would be an unusual interruption. One morning a large coach dog wandered into the studio. As the students were ready to start class this dog climbed up and sat in the rocking chair in the circle of students; it was hilarious, according to Stapp. Dr. Sandzén very gently scooped the dog up in his arms and put him out. Another dog, a Scottie type, a most unlikely-looking stray, was adopted into the Sandzén household and named Rags. The former student reports that it was an unforgettable sight to see dignified Dr. Sandzén holding Rags and feeding him an ice cream cone. In concluding, Stapp observed, "Being surrounded by Sandzén's paintings and prints was an education in art appreciation. The work of other artists and craftsmen in the studio gave further insight into Sandzén's philosophy of art. He had great love and appreciation for Oriental art and I felt that there was a kinship there."[19]

Statements that impressed Sue Jean Hill Boys, a former Sandzén pupil and assistant and a well-known painter and art teacher, included, "Have knowledge of the thing that you are going to paint. Draw it in various ways. Study it, think about its origin. If it is an apple, taste it. This is all a part of having knowledge of what you paint." "Imagination is the greatest asset a person can have." "Be balanced, give everything its place." "Master nature, know nature, but don't emulate it." There was interesting philosophy, too, as she remembers: "Art sees all our aspirations being made real in the paintings we struggle to create."[20]

Birger Sandzén was frequently invited to teach at art schools and other colleges. In 1921 he taught a large master class in association with the Kansas City Art Institute. In the summers of 1923 and 1924 he taught painting

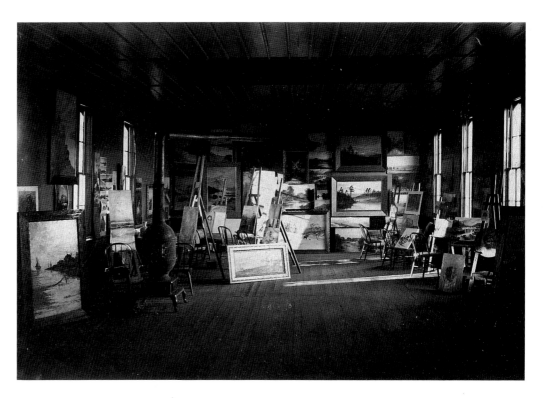

Early art studio,
Bethany College

at the Broadmoor Art Academy, Colorado Springs, and in the following summer he was on the staff of the Chapell School of Art connected with the Denver Art Museum. During the summers of 1928 through 1930 he taught classes in painting at Utah State Agricultural College (Utah State University), Logan. In summer 1931 he was in charge of the painting and outdoor sketching classes of the School of Architecture of the University of Michigan. Although he received attractive offers to join the faculty of well-known art schools and universities, he declined those opportunities because of his deep attachment to Bethany College and Lindsborg.

It is understandable that a teacher of Sandzén's charm and competency soon had some disciples who accepted without much question his technique, style, and emphasis. The art critic of the *Detroit News* wrote about Sandzén's teaching at the University of Michigan: "That something of his own outlook he successfully—perhaps too successfully—imparted to his students of the summer was evidenced at the closing exhibition. . . . But about the uniform excellence of the drawing and the feeling for arrangement and design there could be no doubt."[21] Most Bethany students had

no serious reservations, but some of them felt at times that they might have been excessively influenced, directly or indirectly, by their teacher's viewpoint and example.

Many students developed their own approaches, then or later as was appropriate; they continued, however, to profit from the instruction and contact provided by Sandzén. This legacy often went beyond demonstrations or lectures in the studio or classroom and consisted partly of impressions and remembrances that were not so much taught as absorbed from association with their esteemed teacher. Zona Wheeler, Wichita, who became professionally recognized both as a graphic designer and as a painter and who esteemed Sandzén highly as a teacher, typifies many students who have rich memories of the lasting influence of sharing in Sandzén's great cultural resources, whether it be in his recitation of gems from Chinese poetry, Greek mythology, Hans Christian Andersen's fairy tales, or Albert Engstrom stories or in accounts about the varied and interesting experiences of his own life.[22]

Art students at Bethany College took a variety of courses in art history, art appreciation, painting, drawing, design, and so on,

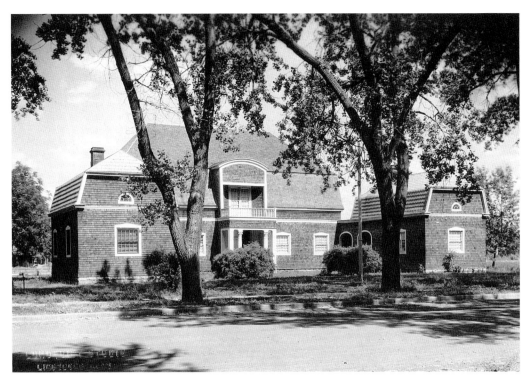

Swedish Pavilion,
Bethany College

but studies in the liberal arts, including an emphasis on modern languages, were also encouraged as an important aspect in the development of a professional artist. Sandzén was a happy combination of professional competency and genuine culture. Under his leadership the number of courses was increased and the staff expanded so that the certificate program was enriched in 1916 by a four-year program leading to the bachelor of painting degree. A two-year normal course, leading to certification by the Kansas State Board of Education, was also provided. In 1928 the curriculum was revised to provide for the bachelor of fine arts degree in painting, the bachelor of fine arts degree in art education, and a two-year certificate in commercial art. The enrollment increased as greater numbers of talented students came to share in the rich experience of studying with Birger Sandzén.[23]

Over the years, the art classes were held at three locations on the campus. At the outset the teaching of art was carried on in the college's first building, the former Lindsborg public school house, which was made available for art instruction after completion in 1886 of the five-story building later known as Old Main. In 1898 the art building was reno-

vated to provide better facilities, and after the Carnegie Library was built in 1908, art classes were held on the second floor of that building for a number of years. The final location was the spacious, well-lighted large room and two smaller rooms in the Swedish Pavilion, an old-style Swedish manor house that had served as the center for Swedish exhibits at the Louisiana Purchase Exposition in St. Louis in 1904. Shortly after the exposition, the building was moved to Lindsborg and reconstructed on the Bethany campus; it is presently an important part of the McPherson County Old Mill Museum and Park in Lindsborg.

The centennial anniversary of the founding of the Bethany College Art Department was observed in a festive celebration in October 1990. Highlights included special memorabilia, lectures, and seminars, but the central emphasis was a comprehensive exhibition of works by former faculty members and students across the century that was displayed in the Birger Sandzén Memorial Gallery, the Mingenback Art Center, and three other galleries of the Lindsborg community. The Sandzén period covered more than fifty years of the Art Department's first century.

Although Birger Sandzén's influence on

art students is apparent, his life and work were also important factors in the lives of young people in other fields of learning. One of those students was Allison Chandler, who first came into contact with Sandzén while studying at Lindsborg High School and later at Bethany College and who developed a lifelong interest and esteem for the artist during his own career as a journalist and an author. When the wire services flashed the news of the death of Sandzén in June 1954, Allison Chandler shared immediately his memories of the great artist in a letter to Frida and Margaret:

I like to remember the large Sandzén landscape in oil which hung from the center of the stage in the Lindsborg High School assembly room when I first came as a freshman in 1920 and Principal Ralph Peterson shortly thereafter showing a beautiful Sandzén water color with the announcement that it had won an important prize in an eastern exhibition.

I like to remember the many singular aspects of the man Sandzén as I knew him—his musical voice, his politeness, his western hat, his brightly trimmed robes at commencement time.

I like to remember how Sandzén slowly and carefully built the Lindsborg art colony, nurtured the Prairie Print Makers, founded The Prairie Water Color Painters, and encouraged so many others to attempt the expression of beauty on canvas, paper, wood and metal.

I like to think that he left a rich heritage that will benefit Kansas and Kansans and others indefinitely and an array of paintings and prints which will be enjoyed for generations as bold and beautiful interpretations of Kansas landscapes and western mountains.[24]

5

Art Appreciation and Personal Opinions

Throughout his long career Birger Sandzén made noteworthy contributions to the appreciation of beauty by stimulating interest in art. This achievement was based upon his view of art as he described it early in his career: "We no longer wish that art should be locked up in museums and palaces. We wish that art should step down among us, make us joyous, and be a wholesome force in this one-sided, nervous, mechanical era. . . . Why is there so much that is good and beautiful in the world if it means that we should not pay attention to it? Poor human beings! You have lived in a world of beauty and yet you have never had time to look at the beauty which surrounds you, and through which you could enrich your life in your own environment, if you learned how to love art and beauty."[1]

Sandzén began his work in promoting art appreciation at Bethany College. In formal classes and in lectures, exhibitions, and articles he devoted himself to developing interest in painting, graphic arts, and other art forms. He was also a key figure in organizing the function that became the well-known Midwest Art Exhibition, which is held annually in Lindsborg during the Holy Week *Messiah* Festival.

In a delightful article in *Präirieblomman för 1903*, Sandzén described the first art exhibition at the college in 1899, which was the forerunner of the Midwest Art Exhibition. A

Birger Sandzén, Carl Lotave, and G. N. Malm in Sandzén's living quarters in Old Main at Bethany College (1899)

few friends were visiting in Sandzén's room at the college when someone suggested that an art exhibition should be held in connection with the annual music festival, scheduled to begin the next day. The words led to immediate action as Carl Lotave, head of the Art Department, G. N. Malm, Lindsborg artist, author, and professional designer, and Sandzén launched the project. A frantic search was made for rugs, drapes, potted plants, and

Charter members of Prairie
Print Makers (1930)

other items to make the room as attractive
as possible. Included in the exhibition were
Lotave's *1861, Dödsdans* (Death Dance), *Nor-
diska sommarnatt* (Scandinavian Summer Night),
and a portrait; *Paris Street Scene* by Sandzén;
and other works by these two artists and Malm.
Over the years the exhibitions have included
Lindsborg and Bethany artists and the works
of regional painters and printmakers as well as
works of selected American and foreign art-
ists. The annual exhibitions of the Prairie Print
Makers and the Prairie Water Color Painters
were always included during the duration of
those organizations.[2]

In 1913 Birger Sandzén organized the
Smoky Hill Art Club "to help create by talks
and exhibitions a more active interest in art in
all its forms and also to establish a permanent
fund for the Art School, the income of which
is to be given to needy students." The Smoky
Hill Art Club greatly enriched the cultural life
of the college and the community, with its
membership reaching 400 in the 1930s. The
organization was active in promoting exhibi-
tions, in purchasing paintings and prints, in
acquiring art books, and in encouraging young
art students through scholarships. Sandzén

generously made prints available as an impor-
tant aspect of fostering membership.[3]

Birger Sandzén's interest in promoting art
is evidenced in the invitation that Sandzén
extended, at the suggestion of C. A. Seward of
Wichita, to several printmakers to meet in the
Sandzén studio on December 28, 1930, in
order to organize the Prairie Print Makers.
Seward, a former Sandzén pupil, was the lead-
ing person in this important development.
The purpose of the organization was to stimu-
late printmaking and the collection of prints.
The charter members were Charles M. Capps,
Leo Courtney, Lloyd C. Foltz, C. A. Hot-
vedt, and Seward, Wichita; Arthur W. Hall
and Norma Bassett Hall, Howard; Herschel
C. Logan, Salina; Birger Sandzén, Lindsborg;
and Edmund Kopietz, a former resident of
Wichita then living in Minneapolis, Min-
nesota. Carl J. Smalley, McPherson, who was
closely identified with Sandzén and Seward,
was also present at the meeting.[4]

Active membership was determined by
achievement in making prints; association
members included those individuals who had
an interest in art, and for an annual member-
ship fee of $5 they received each year a print

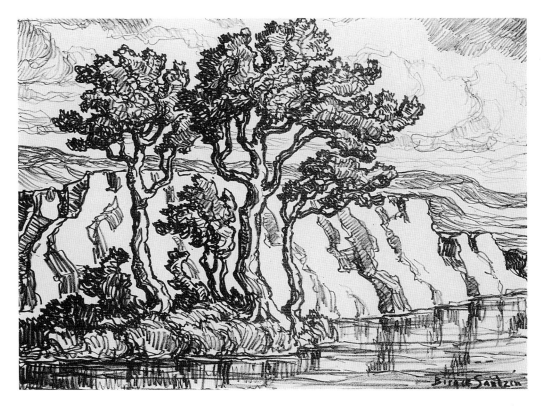

Figure 4

A Kansas Creek (1931)
lithograph, 7 × 10 inches
First "gift print" of the
Prairie Print Makers

by one of the active members. The Prairie Print Makers was soon widely respected and recognized. In the annual report for 1936–1937, Seward, secretary-treasurer, noted that there were forty-four active members from several states and Canada, a substantial increase over the original limitation of twenty-five active members. William Dickerson, Wichita, was the first artist invited to join the charter members, and Carl J. Smalley, McPherson, was the first honorary member. Meanwhile, the number of associate members had reached a maximum of 150. Four exhibitions of ninety prints each had been circulated in thirty-four galleries and museums in thirteen states.[5]

The splendid achievement of the early years was sustained until 1965. Records indicate that 100 printmakers from states throughout America and Canada had become members. Early invitations to membership had been accepted by John Taylor Arms, John Steuart Curry, and Peter Hurd, among others. The organization continued the splendid pattern of exhibitions. As the associate membership grew in numbers, gift prints were made available through the organization in an edition of 200 in various print media. Birger

Sandzén's print, *A Kansas Creek,* was the first in the series of thirty-four gift prints by active members (Figure 4), and all but three subjects were related to the American scene. The last gift print was presented and the final exhibition held in 1965; a variety of factors contributed to the demise of this noble and creative organization founded in Sandzén's studio.[6]

Fortunately, the achievement of the talented and dedicated Kansas artists who founded the organization and the course of its development over the years have been preserved for posterity by the publication of the well-written and beautifully illustrated volume, *The Prairie Print Makers,* by Barbara Thompson O'Neill and George C. Foreman, in cooperation with Howard W. Ellington. It contains descriptions of the careers of the ten charter members with illustrations of their prints as well as important historical information about the organization. Nine of Sandzén's prints are included. Moreover, the book's publication provided the stimulus for a touring exhibition of prints (1982–1986) in Kansas and in five adjacent states.[7]

Birger Sandzén founded the Prairie Water Color Painters in 1933; in the beginning the

Delta Chapter of Delta Phi Delta members with Birger Sandzén in his studio (1942)

headquarters of the organization was in Lindsborg. He was the first president, continuing in that office for several years, and Zona Wheeler the first secretary. The first exhibition was at Kansas State University (then known as Kansas State Agricultural College), Manhattan. M. K. Powell, art editor of the *Kansas City Star,* reported that fifty works were entered in the exhibition. Forty-two were by Lindsborg artists or by other artists who were represented in the permanent collection of Bethany College.[8]

Sandzén organized the Prairie Water Color Painters because he felt that "the professional water colorists of this region should have an opportunity to exhibit together and that the younger members of ability and training should be encouraged." Thirty artists generally formed the membership of the society. Annual exhibitions were arranged by Sandzén during the first seven years; later, a committee of three, including Sandzén, had this responsibility. In the 1940s there were two sections of the traveling exhibition, which were often seen in the museums and galleries of ten states. In 1948 works of the members were viewed in an exhibition in Derby, England, and the thirtieth

annual exhibition of the society was held in 1963–1964.[9]

Birger Sandzén was also an active member and leader of the Kansas Federation of Art, organized in 1932. Its purpose as stated in the by-laws was "to make lectures, exhibitions and other services available to its members through cooperation at the minimum expense and to develop greater appreciation of art in the State of Kansas."[10] Art organizations and individuals constituted the membership, and Sandzén was elected honorary president in 1952.

College and university art students were encouraged by Sandzén through his enthusiastic support of Delta Phi Delta, a national honorary art fraternity. He organized the Delta chapter at Bethany College on March 4, 1920, with fifteen charter members. The organization was active during Sandzén's time and later in promoting art on the campus and in the community. The activities of Sandzén, Bethany art alumni, and art students were regularly reported in the "Chapter News" section of the *Palette,* the fraternity's official publication.[11]

At the meeting of the National Council of

Delta Phi Delta in 1937 Sandzén was appointed honorary national president, succeeding Lorado Taft, a well-known sculptor. Shortly thereafter in a message to members of the organization he wrote in the *Palette,* "The Delta Phi Delta honorary art fraternity is one of the most important of American art societies because its field of activity is the American college and art school. It emphasizes the need of art and broad culture in an age that constantly demands specialized knowledge. Art in its manifold expressions is the greatest interpreter of life and one of the greatest sources of joy."[12] Sandzén was designated a laureate member on two occasions, the highest award of the society.

Sandzén's mission in promoting art involved personal commitment and activity from the outset. He lectured to women's clubs, religious organizations, teachers' associations, and school groups, often bringing paintings and prints for impromptu exhibitions. Many weekends found him loaded with portfolios, boarding a Missouri Pacific or a Union Pacific train at Lindsborg, en route to a lecture engagement.

In the first decade of the 1900s Sandzén found a kindred spirit in Carl J. Smalley of McPherson, who had become interested in art and had devoted his life to it. In 1911 George C. Pinney, superintendent of public schools in McPherson, with the aid of a newly employed art supervisor, planned an art exhibition in McPherson High School. Sandzén and Smalley joined in as enthusiastic supporters, and art exhibitions of high quality were held annually for many years under the sponsorship of the McPherson schools. The interest in art that these two men stimulated grew in a gratifying manner. Art exhibitions were held in many Kansas communities, and increasing numbers of paintings and prints were purchased as the public's appreciation of art increased.[13] Sandzén's interest in making original art available is illustrated by an anecdote related to the sale of his paintings and prints. When he was questioned one day as to why he sold his paintings for such low prices, he replied, "Oh, it is just as well to let them go and meet the people rather than sit here with too high prices and out of touch with the world."[14]

The direct influence of Sandzén on the Lindsborg community's appreciation and respect for art has been far-reaching. In 1925, when the town included about 2,000 people, a survey identified the number of original works of art in the homes: 597 oil paintings, 154 water colors, and 1,519 lithographs, wood cuts, and etchings; only a few homes in Lindsborg are without an original work of art. Moreover, the Lindsborg public schools sponsored art exhibitions annually for a long period of time.[15] A substantial and talented art colony in Lindsborg is further evidence of Sandzén's influence. The Lindsborg Arts Council in 1990 listed seventy persons in the community who are active in the visual arts, and a fine array of studios and galleries testifies to the interest in and devotion to this aspect of the humanities. Sandzén's desire to develop interest in art locally is recorded in the annals of the Lindsborg Round Table Club, the first women's study club in the community. When the president, Mrs. L. W. Soderstrom, introduced Birger Sandzén to the regular art meeting of the united women's clubs in the Sandzén studio in 1946, she reminded the audience that since his first lecture in 1912, Sandzén had been on the program of the Round Table Club annually for thirty-four years except for one occasion when his daughter Margaret substituted for him.[16]

The Lindsborg artist also emphasized beauty in design and structure in everyday life. He heartily endorsed the Swedish slogan, Vackra vardags varor (More beautiful everyday objects), adopted by the Swedish Society of Industrial Design at the beginning of the twentieth century. Staunton Holbrook, who also stressed this view, made a great impression on Sandzén, and he invited Holbrook to lecture at Bethany College.[17] The efforts of Birger Sandzén individually and through art organizations enriched the lives of many people. His achievement has been appropriately described by Leila Mechlin, a former editor of the *American Magazine of Art:* "Birger Sandzén lit little candles of art appreciation throughout the Midwest."[18]

In addition to his work in developing an appreciation of art among nonartists, Birger Sandzén was deeply interested in the great is-

sues and problems of the human race. He read widely on social, economic, and international developments and attended lectures on those subjects whenever it was possible to do so. He was also an active citizen in the Lindsborg community.

The Lindsborg artist closely followed developments at home and abroad, and at times he expressed intense concern. During World War I he wrote to his former pupil and fellow artist, Oscar Jacobson, "Three cheers for old Russia. I hope they will make a republic out of her while they are at it. It would be too bad if the old reactionary party would get any measure of control. I look for very radical changes in Austria and Germany in the near future."[19] A month later he wrote again to his friend, "The military forces of the Allies are evidently able to take care of the situation. Nevertheless, it would be a blessing if the inevitable change, revolution, or collapse of the old Prussian regime or whatever you might call it, would come soon. This would be a great advantage to Germany and her adversaries. What has happened in Russia will happen in Germany, I am quite sure."[20]

There were times when he reflected on the consequences of people's folly and the tragic failure of the forces of good to bring about a better life. In April 1923 he wrote to his brother Gustaf, "Our life is a fragile thing which is easily shattered. Nevertheless, life is a beautiful gift if we use it right. This is a serious thought—our short life on earth and our responsibility. That which occupies my thoughts is the boundless sorrow and the terrible suffering that now visits the world." He was overwhelmed by the thoughts that millions of the world's finest young men had been killed and others handicapped for life in World War I and that poverty and distress reigned for additional millions of people. Great values were struggling for survival in a world that was disillusioned. Disturbing him most was the idea that this could have happened among nations that were supposedly Christian and that had great cultural legacies. He observed, "What a terrible scandal in the sight of people whom we call 'heathen.' We must remember that we will be known by our truth."[21]

Birger Sandzén saw firsthand the negative results of the Great Depression of the early 1930s, and his knowledge of the national and international consequences alarmed the sensitive artist and professor. In June 1932, for example, he expressed his pessimistic view in a letter to Carl Milles: "Some day Communism may dominate here as in Russia."[22] Yet his tone was generally more hopeful, although he realized the inevitability of change. In a long letter to Prof. F. M. Fryxell of Augustana College he wrote, "The best thing we can do in these serious times is to work away as usual and do the best we can. It is strange to live in an age when we are facing a complete reorganization of the social structure. . . . There need not be a bloody revolution if we can keep cool. There are a few encouraging signs. Our politicians for the first time in history are trying to do some serious thinking. . . . If we can only understand what constitutes life's real essentials, there will be a solution to the great social problems. We can have culture and intelligent enjoyment of life without wealth."[23]

In a letter to his brother Gustaf, Birger commented on the American situation as he viewed it in spring 1934: "Conditions in the United States are alarming in many respects, in spite of some bright spots. One feels as if one is in a quagmire. All the old values are threatened with destruction, and it is impossible to foresee what the future, even the immediate future, has in store. In spite of rich natural resources, the economic condition of the country in many respects is in a desperate condition. The only possibility which now remains is to begin calmly from the beginning and build up from the ground. We must hope that if we rush toward revolution that it will not be a Russian revolution, but that the spiritual values will be saved."[24]

The portent of things to come appeared clearly to Sandzén as he viewed the world situation in late autumn 1938:

When one gets old, one thinks often about the beginning of life—the child and youthful years—and about the end. The world in general was undoubtedly more joyful and happier in our youth than in the present sad and restless atmosphere. Refugees from Germany and Austria arrive daily, destitute of

everything, but happy to have escaped with their lives. They beg and pray that they will be able to stay in the United States and that our immigration laws will be adjusted. . . . The Nazi press and its continuous attacks upon the United States are cited daily in our newspapers and the American press rings with anger and detestation. The world armaments are now rising to shocking figures. What will it end in? . . . The current situation reminds one of the statement by Axel Oxenstierna, famous seventeenth century Swedish foreign minister, to his son: "My son, you don't know with how little sense the world is ruled."[25]

In the same month, Sandzén wrote to Carl Milles lamenting the terrible treatment that Jews were receiving from the Nazis.[26]

The developments in the world during the 1940s cast dark clouds upon the future of humankind and upon the personal life of Sandzén. In January 1940 he wrote to Carl Milles, "One shudders when one stops to think that we stand before the entire Christian civilization's *dämmerung*."[27] The Christmas season had been observed by the Sandzéns in the traditional manner, but the joy and hope of the season were disturbed because of the terrible uncertainty about the situation in Europe, Russia's barbaric attack on Finland, and the possibility that Sweden would be drawn into the conflict. In 1940 Sandzén made available a special edition of the block print, *Blue Valley Farm,* to be presented as a gift for donors to the Finnish Relief Fund in the United States for the support of Sweden's neighbor in the struggle with the Soviet Union.

In March 1943 he described to a friend his desperate feeling when eight art students said good-bye as they joined the armed forces of the United States.[28] Not a single male art student was left at the college. The World War II years were sad ones for Sandzén as he pondered the question of humankind's strange fate in the midst of so many better alternatives for the good life.

Sandzén was also deeply concerned about freedom in the United States and the attacks upon it. When Sen. Joseph McCarthy's unfounded charges of alleged communism against reputable Americans were made in the 1950s and civil liberties were threatened, Sandzén was alarmed and clearly expressed his opposition to the McCarthy tactics: "That belongs to the dark side of democracy. A man like that is undermining faith, destroying reputations and hurting the country. He is a disgrace to the United States Senate." Sandzén was greatly troubled by all types of prejudice: "I cannot understand where we get that stupid race prejudice from in this country. There is nothing in the world worse than prejudice." Concerning Israel and its future, he thought it was terrible that the new nation was threatened, saying, "It is a shame that they cannot have their little corner of the earth and live in peace."[29] Sandzén's view of humankind knew no barriers of national origin, race, sex, religion, class, or condition. He was an enlightened citizen of his nation and of the world, a true believer in the tradition of civility.

6

Travel at Home and Abroad

Birger Sandzén had great enthusiasm for seeing new places and meeting new people. In the United States, his greatest interest outside of Kansas was in Colorado, New Mexico, Utah, and Arizona. He made two summer trips to Mexico, and on three occasions he traveled to Europe, where the major emphasis was on visiting Sweden although he was briefly in England and spent considerable time on the Continent.

Sandzén first saw the West and Southwest in 1899 when he traveled through that area on his first trip to Mexico. In Colorado and New Mexico he was almost overwhelmed by the massive mountains and magnificent views, and he later made many trips to the Rocky Mountains, which had a profound influence on his career as an artist.

As early as 1908 he went to Colorado for intensive travel and sketching, and in 1913 he began a series of regular visits to Boulder, Manitou Springs, Colorado Springs, and Estes Park that continued for more than three decades, with Manitou as the principal area for several years (see Plate 17). There he lived in Red Crags, an attractive hotel in Manitou with ready access to the Garden of the Gods and other scenic places. In 1922 he wrote to Raymond Jonson (1891–1982), a Swedish-American artist friend, "I discovered some wonderful new sketching grounds—Pike's Peak above the timberline, and a valley about

sixty-five miles from Manitou, a region absolutely unknown to tourists and artists. This valley is marvelously beautiful. It is wedged in between tremendously fantastic rock walls [see Plate 27]. I have made some wonderful studies."[1] In the early 1920s he taught summer classes at the Broadmoor Art Academy, Colorado Springs, also in this area.

Beginning in 1926, Birger Sandzén went almost every summer over a period of fifteen years to Estes Park because Rocky Mountain National Park provided unusual challenges for him. In the 1930s the Sandzéns lived in "Mountain Studio," (Figure 5), a fine summer home with a large studio, rented from Prof. John Roseborough, a musician from the University of Nebraska. Not only did the Lindsborg painter work steadily there, but the Sandzéns also entertained many guests. Highlights were the occasions when Mr. and Mrs. Josef Lhevinne were present, and the guests were thrilled by fine performances on the piano by the distinguished New York musician.

Sandzén spent many happy days with visitors at Estes Park. He joined Prof. Fritiof Fryxell of Augustana College, a well-known geologist and authority on the Tetons, on hiking trips into the mountains and learned much about the geological formations of the area. In the summer of 1929 happy times were shared with Dr. Edward Steiner, the author and sociologist who later visited the Sandzéns in Linds-

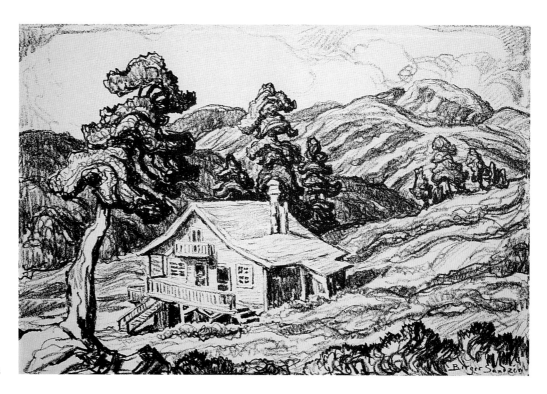

Figure 5

A Mountain Studio
(1934) lithograph,
11½ × 17½ inches

borg and lectured at Bethany College. Artists were also included in Sandzén's circle. In 1917 he spent several days sketching with Henry Varnum Poor, beginning a friendship with him, and Poor etched a portrait of Sandzén. In 1930 Prof. John F. Helm, Jr., of Kansas State University sketched with Sandzén on many occasions.

On July 12, 1915, Sandzén began an extended trip to the West that included California, Arizona, and Nevada. While staying at the Grand Canyon he described some of his experiences in a letter to Frida:

Yesterday Oscar [Thorsen] and I walked about twelve miles to interesting places. I have made forty sketches here and at least that many on the way here. The Painted Desert is indescribably beautiful and from an artist's point of view, even more attractive, on the basis of the great clearness, than the incomprehensible and inconceivably magnificent Grand Canyon. If one is going to paint the Grand Canyon, one has to be satisfied with only a few beautiful details if one is not to fail. It is absurd to try to grasp the great magnificence of it. We have been here two full days. Today we have been on the Bright Angel Trail.[2]

Although Sandzén was almost overcome by the magnitude and splendor of the Grand

Canyon, he was still able to grasp its beauty and majesty in some striking paintings.

Sandzén spent more than two weeks in San Francisco and the Bay Area and devoted considerable time to various attractions at the Panama Pacific Exposition, especially the art sections. He was greatly interested in the Swedish Art Exhibition, in which Carl Larsson and Bruno Liljefors received the Grand Prix, and Sandzén himself was represented by his works in one of the exhibitions. He enjoyed a one-day excursion to the University of California, Berkeley, and spent a few days in Santa Barbara, where the old missions were of special interest. He was often in the company of Oscar Thorsen, a Bethany College colleague, and Oscar Jacobson, a former pupil and a well-known Oklahoma artist.[3]

Although Sandzén enjoyed the trip, especially the time spent in the Grand Canyon and San Francisco, he wrote to Frida, "I am longing for my old, friendly and indescribably dear surroundings where I can work in quiet and peace." He also reported a fact of lasting importance: "I have brought home lots of studies."[4] These formed the source for his outstanding paintings and lithographs of the Grand Canyon (Figure 6) and of other areas

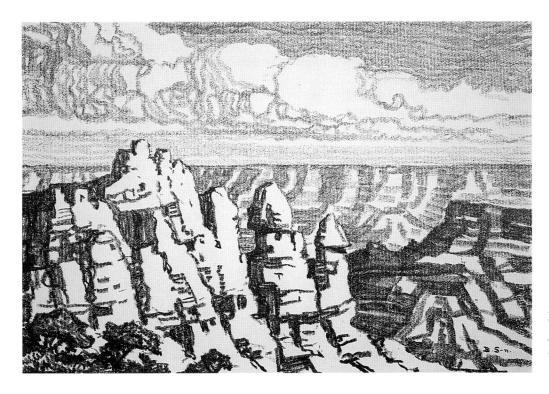

Figure 6
In the Grand Canyon
(1916) lithograph,
12 × 18 inches

that had been a part of this important journey to the West.

In 1927 Birger Sandzén visited Bryce Canyon and Zion Canyon in Utah and made another trip to the Grand Canyon. He also traveled to Mesa Verde National Park, where the old cliff dwellings fascinated him. He made an extensive tour of Yellowstone Park and the Tetons in 1930 (see Plate 37), and while teaching classes at Utah State Agricultural College during the summers of 1928 to 1930, he painted and sketched extensively in that area (see Plate 36). In 1950 the Sandzéns, with their daughter and son-in-law Margaret and Pelham Greenough, spent two months in Colorado and California.[5]

New Mexico was especially attractive to Sandzén, and he visited in 1919 with painters B. J. O. Nordfeldt and Marsden Hartley and printmaker Gustav Bauman, who were then residents of Santa Fe. Of one memorable excursion Sandzén wrote, "One of the many sights that we enjoyed was Frijoles Canyon about thirty-eight miles from Santa Fe with its wonderful cliff dwellings. We also made a 400-mile trip in the wilderness which took us four days, and saw some of the most picturesque Indian villages and ruined cities that

died of fear—Aba, Cuari and Gran Quivira—abandoned by the Pueblo Indians about 250 years ago after repeated attacks by the Plains Indians. The trip was delightful beyond words."[6]

Many of Sandzén's works provide eloquent testimony to his love of the West and the Southwest. As early as 1915 he expressed his feelings about the potential of these areas for his painting: "As a sketching ground the Southwest possesses unlimited possibilities and can offer the painter abundant material of every conceivable character. He will find idyllic, dreamy meadows, soft-lined groves, dancing brooks, red, yellow or white farm houses, beautifully nestled on the hillside—all those friendly, quiet little motifs that everybody loves and admires and understands, the Barbizon-Woodstock theme and its many variations. . . . There are also some highly characteristic features in the Western landscape that very few artists have studied as yet."[7] It was these "highly characteristic features of the Western landscape" that were to be so important in his paintings and prints.

Traveling in another direction, the Sandzéns and the Greenoughs shared a happy and busy summer in Rockport, Massachusetts, in

1948. Birger responded well to the scenery and thoroughly enjoyed the New England milieu, painting fourteen oils and ten water colors and making many sketches of the coastline and ocean (see Plate 48). Returning to Kansas, he described the summer in Rockport in a letter to Raymond and Vera Jonson, though expressing a certain preference: "I have told you about our delightful visit in Rockport, Massachusetts, about forty miles from Boston. The coastline is very picturesque, old houses, islands, peninsulas, rocks, pines, etc., and the ever-changing sea. . . . However, I believe our great Southwest is a still more fascinating country."[8]

Sandzén also made occasional trips to attend the openings of his exhibitions in various parts of the country and to lecture. One such trip occurred in March 1938 when the Sandzén family went to Kansas City, Missouri, on the occasion of the presentation of Sandzén's painting *Long's Peak* (see Plate 45) to the Nelson Gallery of Art and Atkins Museum (later known as the Nelson-Atkins Museum of Art) by Mrs. Massey Holmes, Kansas City artist and art patron. Great names in American art—John Steuart Curry, Thomas Hart Benton, and Grant Wood—were present for the unveiling of the fine oil painting.[9]

Birger Sandzén made three trips to Europe, traveling alone in 1897, accompanied by Frida in 1905–1906, and with Frida and Margaret in 1924. On the first European trip, Sandzén boarded the SS *Mongolia* at New York on May 28. Bad weather, especially heavy fog and strong winds, slowed the Glasgow-bound ship so that twelve days instead of the usual eight or nine were required for the voyage. In the traveling party were friends and colleagues from Bethany College: Dr. and Mrs. Carl Swensson, professors Samuel Thorstenberg and Sigfrid Laurin, and Pastor John Floreen. Various types of entertainment were provided on board, and Birger was especially interested in the tug-of-war between eight men from England and a similar number from the United States, including Dr. Swensson; the Americans easily won the contest. Concerts and lectures, reading, and conversation also helped pass the time during the prolonged journey.[10]

After disembarking in Glasgow and staying briefly in Edinburgh, the party spent several days in London, where they were part of a throng of visitors from all over the world who had come to celebrate Queen Victoria's Diamond Jubilee. The Lindsborg travelers attended a one-day Handel Festival at the Crystal Palace, and on June 11 they heard a performance of the *Messiah* by a great chorus and orchestra in the new hall. They were thrilled, recalling that in 1880, Lindsborg's founder, Pastor Olof Olsson, had heard a performance of Handel's work in Exeter Hall, the starting point of a tradition that still means so much to Lindsborg. The days in London were fully occupied by visits to the British Museum, the Houses of Parliament, and Westminster Abbey, where Birger was impressed with the white marble medallion created to honor Jenny Lind that bears the inscription "I know that My Redeemer Liveth" from the *Messiah*, which the Swedish nightingale had sung with such great feeling in several performances. Sandzén also devoted as much time as possible to the exhibitions in the National Gallery.[11]

The Lindsborg tourists then crossed the English Channel for a five-day visit in Paris. Sandzén was thrilled to serve as a guide and interpreter for his friends in the French capital, where he had experienced a happy time during his student days in 1894. He managed to arrange the schedule so that he had extra time for viewing the exhibitions in the Louvre and the Luxembourg Museum. From Paris, Sandzén and his friends traveled to Cologne, where he parted from them. When he stepped off the train at the railway station close to the great Cologne cathedral, beautifully illuminated, he realized that something special was going on. Soon he was in a throng of people who had come to witness a grand military parade in which Kaiser William II was the center of attention. Birger managed later to board a train at the overcrowded station, and without incident he continued the journey to Hamburg, Copenhagen, Göteborg, and finally to Järpås prästgård.[12]

The homecoming was thrilling; his parents, Moster Edla, and Johanna (who had been with the Sandzén family since 1863), as

well as brother Gustaf were there to greet him. Birger wrote to Frida, "The joy of seeing one another need not be described." He especially enjoyed showing photos of Frida and describing "the dear little girl in Kansas." Later he wrote to her from Järpås, "In about a month I will be traveling back to America. How different that will be from last time. Then I had everything on this side of the Atlantic. But now, how much do I not have on the other side? What is it that draws me irresistibly in that direction? It is the dearest and most lovable girl that I have ever met in my life."[13]

The days in Sweden were busy for the American visitor; many old friends came to see him, and he in turn was entertained in their homes. He attended a family reunion of twenty-two people and was always at the center of attention, answering questions about America. Gustaf and Birger made trips to Lidköping and other communities in Västergötland, and there were long and pleasant hours of conversation at Järpås prästgård. A highlight of the stay was a visit to Stockholm, where he rejoined Dr. Swensson. The president requested Sandzén's help in selecting a successor to Olof Grafström, who had resigned his position in order to join the art faculty of Augustana College. Sandzén recommended Carl Gustafson, a friend from his student days at Stockholm. Gustafson changed his name to Lotave and served at Bethany College for a few years. While in Stockholm, Sandzén also spent much time at the National Museum.[14]

Time passed rapidly, and toward the end of August farewells were said at Järpås prästgård. Birger rejoined his Lindsborg friends at Copenhagen, where they boarded the SS *State of California* for the crossing to Montreal, continuing by rail to Chicago and finally to Lindsborg. Birger understood how Gustaf felt when the latter wrote to him shortly after the farewells, "It was much harder this time than on the previous occasion to part from you. The circumstances that our family is separated into two parts by the Atlantic Ocean is certain to bring sadness to all of us. . . . May it all go well for us and may we all be together beyond

the grave. This I mean literally without any reservations."[15]

The second journey to Europe and residence there lasted from early June 1905 to late autumn 1906. Birger had received a leave-of-absence for one year from Bethany College and a stipend of $400 for travel and study in Europe and had made arrangements with four Swedish-American newspapers to write articles describing his travels. Illness, however, prevented him from writing more than twenty-four "Pennteckningar från en resa i Sverige" (Sketches from a Trip in Sweden), the last one written in November 1905.

Birger and Frida sailed on the SS *King Oscar II* from New York on June 7 and enjoyed a pleasant crossing to Copenhagen, where they stayed a few days before traveling to Sweden. It was an exciting moment when brother Gustaf met them at Ljung station and took them by horse-drawn carriage to Asklanda prästgård, gaily decorated and with the Swedish flag flying in honor of the American visitors. They were joyfully embraced by Birger's mother, Moster Edla, and Johanna, but Birger's father had passed away during the previous year.[16]

These were happy days for Birger and Frida and for the residents of Asklanda prästgård. Midsummer Day, June 24, was a festive occasion; many people came to meet the American visitors and to share in the events of the day. Soon there were excursions into the attractive countryside, introducing Frida to old friends and visiting familiar places, and visits to Lidköping and other towns in the area. Birger began to sketch and paint, agreeing to do two small altar paintings for the new Ornunga church.

Shortly after the American visitors arrived in Asklanda, Birger and Gustaf went on a walk that brought them to old Ornunga church, built in the thirteenth century. Since a new church had been constructed in the parish, the intent was to raze the old one in the immediate future. Birger was thrilled by the uniqueness and attractiveness of the old structure, however, with its beautiful wall and ceiling paintings, unusual stone altar, distinctive carved pulpit, and large number of wood- and

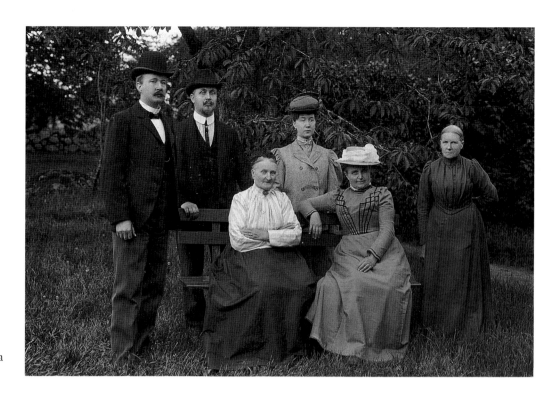

Family reunion in Asklanda (1905): Gustaf, Birger, Clara, Frida, Moster Edla, and Johanna Bengtsson

stone-sculptured figures. The benches, although quite roughly fashioned, were unique. There was also a klockstapel ("bell tower").[17]

Appalled to learn that the old church was to be razed, Birger turned to Gustaf and asked anxiously, "Isn't there any possibility of saving the old church? It is a crime against Swedish culture and Swedish history to raze such an old and remarkable building." Gustaf agreed enthusiastically that an attempt should be made to save the church.[18] A well-attended meeting at which Gustaf presided was soon held in old Ornunga church, and Birger gave an informative, emotion-filled speech that lasted more than an hour. The response was overwhelmingly positive; officers were elected to make plans for preserving the old church, and the Svältornas Fornminnesförening (Svältornas Archaeological Society) was organized. An appeal for funds was circulated, and Birger and Frida presented piano and voice concerts in the old church and in neighboring churches to raise money for the project. Sandzén also enlisted the support of Dr. John Enander, editor of the Swedish language newspaper *Den Nya och Gamia Hemlandet* (The New and Old Homeland) published in Chicago, and of Gunnar Anderson, secretary of the Swedish

Tourist Agency. The former raised money in the United States for restoring the church, and the latter provided financial assistance in Sweden.[19] Sandzén's leadership not only saved old Ornunga church, but the archaeological society flourished and established an interesting and well-equipped museum; Sandzén became the first honorary member of the society.

When the preservation of the old church had been resolved, time was available for travel, and it was with keen anticipation that Birger made a trip to Skara, which he described: "We continued our wandering from room to room and from floor to floor of *Skara Läroverk*. Here we studied history and on the opposite side were the rooms for botany and zoology. There was the largest room where the happiest and most memorable event occurred. Our *vita mösser* [white caps worn at graduation] were presented in this room. An old Skara student can hardly think about *Krabbelund* [a park area near the school] without his heart beating faster. I recall vividly those spring evenings, the songs of quartets, my happy friends, the first glowing of love." The climax of the trip to Skara was a visit with Olof Erlandsson, Birger's dearly-loved art teacher. Then followed visits to Läckö Castle, Lidköping, and

Järpås, and many memories came to mind as Birger saw those familiar places once again. Birger and Frida walked slowly along a stone wall to the place where his father was buried under an old ash tree. They greeted old friends in the community and then returned to Asklanda to make preparations for Birger's trip to the continent.[20]

Frida had suggested and Birger had agreed that in order to curtail expenses he should travel alone at the outset to be joined by Frida later in Paris. He left Asklanda on Monday, November 4, for Göteborg, where he visited with the artist Carl Wilhelmsen (1866–1928) and viewed art exhibitions at the Konstmuseum. He then traveled to Berlin, where he stayed for a week as the guest of Oscar Thorsen, who was studying piano there. Birger spent a few days at Dresden before going to Munich and then continued to Venice, Florence, and Rome. He was enthusiastic about his visits to the museums and galleries in Berlin, and at Dresden he found Raphael's *Madonna* "unearthly beautiful." He wrote to Mrs. Eric Leksell, "I have had overwhelming experiences one after another. Venice is indescribably beautiful. The whole city is like an architect's exposition. Florence is more cheerful and just as beautiful with its marvelous setting. The museums, for example, the Uffizi Gallery and the Pitti Gallery, are absolutely magnificent. In Rome I have been thrilled with Michaelangelo's ceiling paintings in the Sistine Chapel and with his great statue of Moses in San Pietro church and the various exhibitions in museums and galleries." He also reported that he had stood with awe and respect as he viewed the Forum, the Colosseum, the Capitoline Museum, and St. Peter's Cathedral.[21]

Sandzén was in Rome for approximately one month, and in the midst of the great pleasure of living in the famous city he became ill with what was described as "Roman malaria." He was terribly tired from the combined effects of a severe cold contracted in Germany, constant travel, sightseeing, and writing travel sketches, and although his illness caused him to consider returning to Asklanda immediately, he struggled through the situation

and stayed with the original travel plans.[22]

Sandzén left Rome about the middle of December on a journey that took him to Naples and Genoa, across the Mediterranean to Gibraltar, from Gibraltar to Algeciras, and then to Granada, Seville, and Madrid. The entire journey was interesting, but he was especially impressed with Spain, writing that "the scenery of Spain surpasses that of Italy." He found Madrid and Granada most attractive, commenting, "Madrid and The Prado. Imagine eighty of the works of Velázquez [Diego Rodríguez de Silva y de Velázquez, 1599–1660], one of the most complete and superb records of one painter's life in the world. And the gypsies of Granada. How they danced and sang and the beauty of the mandolin and guitar orchestras." When his students later gave him a recording of *Carmen,* he recalled with great joy the performances of it that he had heard at Seville.[23]

Sandzén was forced to leave Spain earlier than he had planned because of ill health, and he traveled directly to Paris. On January 1, 1906, he wrote to Frida from that city, urging her to come as soon as possible.[24] According to previous plans, Frida had just arrived in Berlin for a brief visit with Oscar Thorsen and a tour of the German capital, but after only half a day there, she left for Paris. The Sandzéns stayed for five days at the Hotel de L'Esperance in Paris. Dr. Roberts, an English physician, was consulted, and Frida reported in a letter, "There is no surprise that Birger was exhausted from traveling, studying, sightseeing, and writing articles. He said that with complete rest for some months he would become perfectly well and strong again." Despite his illness, Birger was eager for Frida to see something of Paris, and they were able to visit briefly the Louvre, the Luxembourg Museum and Gardens, the Pantheon, Notre Dame, Madeleine Church, and the Latin Quarter.[25]

The Sandzéns returned to Asklanda before the middle of January, and rest and restricted activity gradually restored Birger's health. The couple took long walks in the beautiful countryside as the weather moderated and spring came, and Birger sketched and painted. They were in Göteborg for a month

in April and May (where Birger had treatments every day but Sunday from Dr. Kruse, an old friend and a specialist in ear ailments) and spent much time at the Konstmuseum, attending concerts, and visiting with friends.[26]

When Birger returned to Asklanda, he received permission to use the old Ornunga church as a temporary studio, and it was a delightful experience to paint in those unusual surroundings; he completed an altar painting for Fröjered church. During the remainder of the time in Europe, the Sandzéns traveled extensively in Sweden. They visited relatives and friends at Halmstad, Varberg, and Vittsjö, and Gustaf and Birger made a trip to Skara, where they met Hagbard Brase, a Bethany College colleague who was visiting relatives in his native Västergötland. In July Birger and Frida went to Västerås, where Hugo Bedinger, a former colleague at Lindsborg, was now the resident cathedral organist. The Sandzéns went unannounced to the morning worship service, and while Bedinger was playing the postlude, Birger and Frida appeared unexpectedly in the organ loft. When the organist recognized his old Kansas friends, he pushed aside the postlude score, pulled out the stops, and played the opening section of the "Toreador," which had been a popular program number when Sandzén and Bedinger had presented concerts in the Lindsborg area. No report is available as to the response of the congregation to this change of pace in the music. The Sandzéns spent several enjoyable days with the Bedingers, including a delightful excursion to Lindholmen (an island in Mälaren Lake).[27] In the latter part of July the Sandzéns were in Stockholm for several days, where they enjoyed the great cultural resources of the city in a leisurely manner and Birger spent much time studying trends in contemporary painting at various museums and galleries.

Returning to Asklanda for the last time before their departure for home, Birger and Frida were entertained by friends in the area and gave a concert at the new Ornunga church as a kind of dedication of the two altar paintings that Birger had presented to the congregation. On August 28 the American vis-itors left Asklanda early in the morning for the return journey to America. After stopping over in Copenhagen to visit museums and galleries, they crossed the Atlantic on the SS *Oscar II* and arrived in Lindsborg during the second week of September.[28]

Birger Sandzén's final trip to Sweden occurred in 1924 when Frida and Margaret joined him for a visit that lasted from February to June. En route to New York they visited friends in Chicago, where Sandzén viewed an exhibition of French paintings featuring Picasso at the Art Institute. In Washington, D.C., they were guests of Prof. and Mrs. P. H. Pearson, who were on a leave-of-absence from Bethany College on an assignment with the Office of Education. They visited the Washington art galleries and were interested especially in the Chinese and Japanese paintings in the Freer Museum. In Philadelphia, Thornton Oakley, a well-known art enthusiast, was their host, and they visited museums and Independence Hall.[29]

The stay in New York was noteworthy because it gave the Lindsborg artist an opportunity to view his second large exhibition at the Babcock Galleries. He visited with Christian Brinton, who had written the introduction to the exhibition catalog; Dr. William Fox, director of the Brooklyn Museum; Foster Watson and Virgil Bache, publishers of the periodical *Arts;* Dr. F. Weitenkampf, the authority on prints at the New York Public Library; and Henry Varnum Poor and others in the world of art. The Sandzéns also saw other friends and devoted much time to the Metropolitan Museum of Art and the New York Public Library.[30]

The family sailed on the SS *Kungsholm* of the Swedish-American Line on February 7. After a wintry crossing, they arrived at Göteborg to the strains of the Swedish national anthem, "Du Gamla, Du Fria," and the "Star-Spangled Banner." Gustaf met them at the pier, and after a brief stay in Göteborg, they went by train to Lidköping. Irene and Birgitta, daughters of Gustaf and Hedda, met them, and they all traveled by automobile to the parsonage at Räckeby along Vänern Lake in beautiful northern Västergötland. In de-

scribing nature there in February, Birger wrote, "Outside the snowflakes fly around like large butterflies. Through the swarm of white butterflies I see the beautiful forests, fields and farmhouses." The snows of winter were followed with the coming of spring when as if by magic the flowers blossomed and the trees became resplendent with beauty. The Sandzén brothers and their families had a wonderful, relaxing, and happy time together. On Sundays they all went to church to participate in the impressive liturgical service of the Lutheran church, conducted by Gustaf, and to hear him preach. Margaret, meeting her Swedish cousins for the first time, stayed with Irene and Birgitta for a week in Lidköping and visited their school there.[31]

After a lengthy stay at Räckeby, with only short trips to other parts of Västergötland, the Sandzéns went to Stockholm early in April for two weeks. They lived in Nylins Pensionat on Kungsgatan 23, and Gamla Stan (the Old Town) and other sections of the historic Swedish capital provided interesting sightseeing as Birger reminisced about his student years there.[32] During the stay in Stockholm, Sandzén met Carl Milles (1875–1955), the world-famous sculptor, at a banquet at the Grand Hotel in honor of Eero Järnefelt (1863–1937), the Finnish painter. The Sandzéns were then invited to be guests of Carl and Olga Milles at their beautiful home in Lidingö, a thrilling experience for the American visitors and the beginning of a personal family friendship that lasted across the years. Fifteen-year-old Margaret never forgot that glorious day in the Milles' home, with its great art treasures, relaxed conversation, and Carl Milles playing the old Italian organ. Birger wrote later to Gustaf, "Carl Milles is not only a great artist but also a sympathetic and kind-hearted person."[33] Sandzén had long admired Milles's achievement as a sculptor, and later, when Milles saw a painting by Sandzén in the home of Francis Plym in Niles, Michigan, he hastened to congratulate the Lindsborg artist and urged the National Museum of Stockholm to acquire a Sandzén painting (see Plate 37). Similarly, Sandzén became an enthusiastic promoter of Carl Milles in influential art circles in America.[34]

Another highlight of this trip was a brief visit to Waldemarsudde, the home of Prince Eugen (1865–1947), who showed them his own paintings and the splendid collection that he owned. The Sandzéns also toured the beautiful grounds of the prince's residence and were deeply impressed by their host's friendliness and hospitality. The Lindsborg visitors spent one day in Uppsala as the guest of Sven Linder, enjoying many of the great cultural resources of that city and its university.[35]

In the latter part of April the Sandzéns traveled to Copenhagen, stopping en route for a visit with relatives and friends at Borås and Vittsjö and for a memorable trip to Molle, a beautiful tourist town near the well-known Kullen (see Plate 28). After leaving Copenhagen, they returned to Sweden and stayed a few days in Lund. They spent one day visiting Hedvig af Petersens, a well-known author who had been a guest of the Sandzéns in Lindsborg and had shown great interest in Sandzén's paintings.

After a brief, final stay at Räckeby, the Sandzéns began the return journey to America, boarding the SS *Bergensfjord* of the Norwegian-American Line at Göteborg on May 27, 1924. When the ship made stops at Oslo and Bergen, they were reminded of a previous visit to Norway when they had been thrilled with the fine paintings and prints at the National Museum in Oslo, especially those of Edvard Munch (1863–1944), and had enjoyed a trip to the fjords (see Plate 38). As the ship sailed slowly along the coast between Oslo and Bergen, Birger was often on the deck sketching the fascinating scenery. The Sandzéns arrived home again in Lindsborg during the second week of June; Birger's last trip to his homeland was over.[36]

In summer 1899 Birger Sandzén went to Mexico to study the Spanish language and to sketch and paint. Four nights and three days were required for the railway journey from Kansas via El Paso, Texas, to Mexico City. He stayed a few days in the Hotel Guardiola on beautiful San Francisco Street and then moved to a pension on Paseo de la Reform.[37] He was impressed with the city's cathedral, which he thought "must be the most beautiful on the

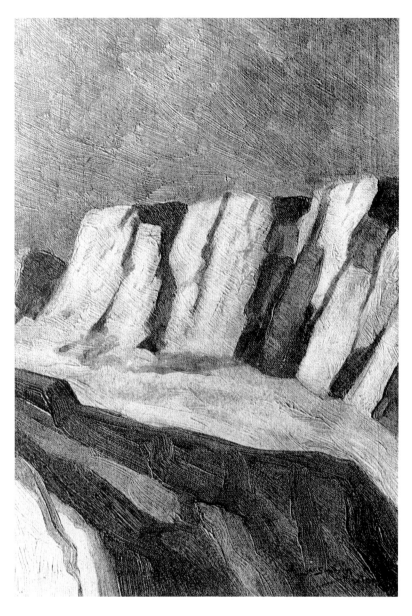

Figure 7

Moonlight (c. 1900)
Photograph of an oil
painting, 28 × 17 inches,
owned by Mrs. Carl Victor
Swensson, Mölnlycke,
Sweden

in the area and saw many Mexican and Indian crafts. In Mexico City he attended classes in Spanish and received private instruction from Oliveria.[38] Whenever time permitted, Sandzén sketched and painted (see Plate 5). In the volume *Med Pensel och Penna* (With Pencil and Pen), thirteen of his Mexican paintings and drawings are reproduced (Figure 7), and he also brought home a large number of studies that were completed at a later date.

Many years later, Birger and Margaret Sandzén enjoyed a visit of several weeks in Mexico during summer 1935, seeing the historic places in the capital and spending much time in the National Museum and at the University of Mexico. Birger was greatly interested in the mural decorations of the famous Diego Rivera (1886–1957), and father and daughter both studied the native crafts and work in silver, pottery, wood, stone, and textiles. A week in Taxco was a pleasant and rewarding experience for both father and daughter. Birger described the city as "one of the most picturesque cities I have ever seen, built in Indian-Spanish architecture," and he discussed in detail the wonderful cathedral, several small churches, and a lovely shrine on one of the hills close to the city. They lived in Hotel Victoria, a most charming place with a fine view of the town and the mountains, and had the good fortune to visit with a prominent native artist, Señor Valentin Vidaurreta, in his studio and garden, where gay parrots and tropical flowers created a riot of color.[39] As much time as possible was devoted to sketching and painting by the two artists, and the productiveness of the Mexican journey is amply demonstrated by the paintings and lithographs that resulted from studies during these pleasant weeks. Moreover, there was the good fellowship of father and daughter and the great satisfaction that came with sharing their mutual interest in painting and in studying the great cultural resources of their southern neighbor.

Writing in his hometown newspaper, the Lindsborg artist responded to his weeks in Mexico: "The great lesson for us to bring home to the United States is the overwhelming enthusiasm back of national art in Mex-

American continent"; and the National Museum and the National Palace occupied much of his time.

He had brought with him a letter of introduction from Prof. Hjalmar Edgren, the Swedish immigrant linguist and poet at the University of Nebraska, to Prof. Jose Oliveria, one of Mexico's prominent language scholars. Sandzén was received by Oliveria as an old friend and lived in his quarters during the rest of the stay in Mexico City. Birger often accompanied the Mexican scholar to his country place, Coyocan, outside Mexico City; and in the company of his generous new friend, Sandzén visited the historic and cultural places

ico." An expression of Sandzén's integrity as he learned more about developments in Mexico is revealed in a letter that he wrote to Raymond Jonson: "I was somewhat prejudiced against Mexico's leading artists, Orosco, Rivera, and others on account of our very unbalanced art criticism, but my criticism vanished when I saw what they have done and what they are doing. Rivera is splendid and so is Orosco. Several others are fine. There is more life, color, and animation in Mexican painting than in ours."[40]

7

Family and Friends

Birger Sandzén's family life provided resources that made possible a happy and productive career. Frida Leksell and Birger Sandzén fell in love when they were young—she was eighteen and he was twenty-three—at their first meeting at Bethany College in October 1894. There was mutual love and esteem from the outset, and it never ebbed during the next six decades. Their marriage occurred on November 28, 1900, in the Leksell home in McPherson. At exactly the same time, which was late at night in Sweden, the wedding in Kansas was celebrated in a festive manner at Järpås prästgård. Birger's father read an appropriate passage from the Bible, a wedding hymn was sung, and the newlywed couple in faraway Kansas was toasted.

Although words cannot express the love of one person for another, there are nevertheless some telling remarks that indicate the depth of feeling. Birger commented once about his love for his family: "I have studied several languages but I do not believe all of them are enough to express the depth of my gratitude to Frida and Margaret." In March 1943 he wrote to Carl Milles, "Frida is better now after her cold. She is an ideal companion with her clear head, warm heart and enthusiastic art sensitivity. When the day's work is over the two of us sit down almost every evening and take time to relax. Our little Rags [Figure 8] sits down faithfully between us and waits for his graham crackers." All through their lives together Birger said to Frida after every meal, "Tack Käre Frida [Thank you, dear Frida]."[1] In 1953, after more than five decades of happy married life, Frida Sandzén spoke about her husband to Margaret: "You cannot imagine how wonderful it has been all these years to live with such a rational human being as your father, who at the same time is such a great artist."[2]

Birger and Frida were inseparable. If they were apart, there was great longing for reunion and a steady flow of letters, but only infrequently did they not travel together. Frida often accompanied her husband on lecture tours and exhibitions unless conditions beyond their control made it impossible. They were together in Lindsborg, walking down Main Street to attend an evening show at the Wonderland Theater, or at the Bethany Lutheran Church for Sunday morning worship services, or at the many college concerts, lectures, and plays where they maintained a superb pattern of participation. They shared their great personal resources with each other and in these happy experiences.

In summer 1900 Birger arranged to have a house built in preparation for their marriage in November. A lot at 421 North Second Street, directly west of the southwest section of the Bethany College campus, was purchased for $100, and a modest-sized yet comfortable

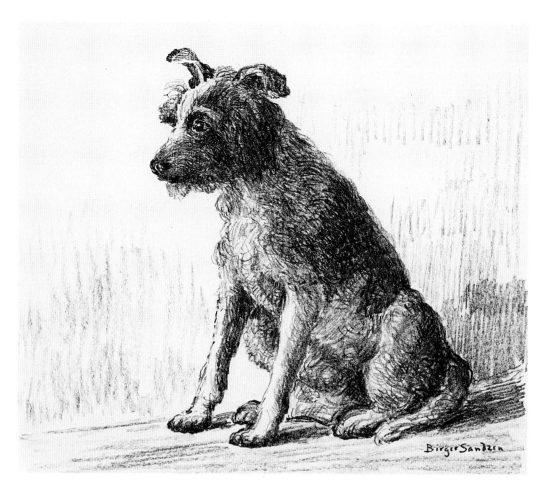

Figure 8

Rags (1942) lithograph,
10¼ × 11⅞ inches

house was built for $900. In spring 1907 a modern heating system was installed, a basement excavated, the foundation raised, and other improvements made. This was their only home in Lindsborg. Birger once shared the meaning of his home in a letter to Frida: "I think with warm gratitude about the peace and sympathy which prevails in our little home, about all the loving interest that supports and helps all my work."[3] In 1985, under the leadership of Dr. Peter Ristuben, then president of Bethany College, the Sandzén home was purchased by the college, thus assuring that this cherished place will be a permanent legacy of the Sandzén tradition.

Great joy came to the Sandzén home when a daughter was born. A proud and happy father wrote with enthusiasm to his brother Gustaf about the birth of Margareta Elisabeth, June 16, 1909. He was pleased to report that Frida was doing well and that "the little one is also in good health, active, and has the

Sylvénisk appetite. [Birger's mother's family was Sylvén.] Margareta Elisabeth in everyday language will be Greta."[4]

The pleased father described the seven-year-old Greta as "cheerful and lively." He liked to listen as she sang and played the piano for her mother. "Greta thrives best in the studio," her father reported with joy. "When I stretch out the canvas, she stands by me with tacks in an ink bottle, and gives me some one by one. . . . She stands a long time at the paint box and picks out tubes of paint that she wants me to use."[5] Earlier he had written that "Greta talks beautiful Swedish." On one occasion when the Sandzéns were entertaining guests at a coffee party Margaret declared to the group in Swedish, "Pappa, mamma och Greta är allt bra vanner [Papa, Mama and Greta are truly good friends]."[6] He was also pleased to report that Greta had made some small drawings "which the father has sent to Grandmother Leksell."[7]

Margaret's talent and interest in drawing and painting at the age of eleven were observed by her father. In a letter to Gustaf he wrote, "Greta has unusual talent in drawing and painting. I do not know if I should cry or rejoice. . . . Good and practical ordinary people are happiest. The path of the artist has more sorrow than joy for one who takes it seriously, and it must be taken seriously."[8] Margaret, to the great pleasure of her mother and father, prepared for a career in art, however. After studying with her father at Bethany College, where she was awarded the Bachelor of Arts degree in 1931 and a Bachelor of Fine Arts degree in 1932, she spent the academic year 1933–1934 in Paris. She was enrolled in the art school Les Trois Atelliers and studied with Edouard Leon, the famous French etcher, and also with Allan Osterlind (1855–1938).[9] Margaret traveled extensively in Europe, and upon her return to the United States, she joined the faculty of Bethany College. During her years of graduate study and teaching, she continued to paint and exhibit her works and was especially devoted to painting portraits of Swedish immigrants and local residents.

From 1939 to 1941 Margaret was a student in New York at the Art Students' League and Columbia University on a Rockefeller Fellowship. At the former she studied life drawing with George Bridgman (1864–1943) and figure painting with Robert Brackman (1898–1980). At Columbia, she primarily studied art history and presented a thesis for the Master of Arts degree on Edvard Munch, the famous Norwegian painter and printmaker. While in New York, she was made a member of the National Association of Women Artists.

Margaret married Charles Pelham Greenough 3d in the studio adjacent to the Sandzén home in November 1942. Pelham was wholeheartedly received into the family circle, and their happy marriage enriched not only their own lives but Frida's and Birger's as well. Pelham's splendid talents, his well-developed cultural interests, and his sensitivity to beauty and the good life were cherished qualities. Pelham and Margaret made their home in Lindsborg and together worked zealously to develop the Birger Sandzén Memorial Gallery there. In rec-

ognition of her fine achievements, Bethany College conferred upon Margaret the honorary degree of Doctor of Fine Arts in 1981.

The Sandzéns enjoyed watching the habits of nature's residents around their home. Margaret wrote, "How interested Father was in watching the birds and squirrels and Mother was equally interested. All had to get up and leave the table to see Mr. and Mrs. Cardinal in the trumpet vine. Father saw to it personally that No. 1 squirrel got fed. He felt that cardinals among all birds 'had the most beautiful and liquid sound. And what color—the most perfect red imaginable.' He found pleasure also in sparrows: 'They have such a pleasant chirp that it's just as good as singing.'"[10] There were family pets as well. Flicka was the college dog and a companion of Pal, Margaret's dog. Sandzén reported that he was met one day by Flicka and Pal, and "they overwhelmed me with kindness." Mugs and Rags were favorite pets. The former always enjoyed the little automobile trips in the country, leaning out of the window and watching the passing scene, because "he wants to get acquainted with the world." Rags, according to Sandzén, went over to the Swedish Pavilion every day to paint. "It was almost his profession."[11] Birger wrote to Gustaf that "our little dog Rags was completely overcome with joy when Greta came home for Christmas in 1940. He jumped high in the air again and again, licked her hand, and ran around on two legs. He did not take his eyes off her during the whole day. It was touching."[12]

The Bethany College painter and professor had a deep and abiding affection for Eric and Charlotte Leksell, Frida's parents. He always remembered their kindness when as a newly arrived immigrant in 1894 he had shared the hospitality of their home in McPherson, and when the Leksells moved to Hill City in Graham County, Kansas, in 1906, the Sandzéns were frequent visitors and occasionally stayed for some time. Wild Horse Creek (see Plate 23), located near their farm in northwestern Kansas, became a familiar subject for Sandzén's paintings and prints, and he seriously considered building a summer studio on the Leksell farm (see Plate 47).

The Eric Leksell and Birger
Sandzén families (c. 1930)

The artist has described that area in Graham County: "Wild Horse Creek is a wonderfully picturesque creek, with trees, limestone banks and background hills. I have spent several summers there and I have done about 300 studies in and near the creek. To learn landscape painting there is nothing like simple, primitive motifs where the artist can study nature in the nude." On one occasion while describing the beauty of the farm, he expressed the hope that it would never be sold. When Margaret pointed out that there were some problems associated with the property, Birger replied, "That doesn't matter. It is a fine piece of ground and we have plenty of good cottonwood trees, and the most beautiful limestone in Kansas."[13] Margaret still owns the Leksell farm.

During one visit to Graham County, the Leksells and the Sandzéns spent a summer afternoon and evening in a Dutch settlement near the Leksell farm. They listened to the songs of Holland, saw the folk dances, and ate Dutch food; later they entertained their hosts by singing Swedish songs, including the familiar "Du Gamla, Du Fria." When darkness settled upon the quiet prairies, they returned tired but happy to the farm home in a horse-drawn vehicle with burning lamps to guide their path. It had been a memorable day as representatives of two national cultures of Europe had shared their traditions on the plains of Western Kansas.[14]

After the Leksells left their farm home in the mid-1920s and moved into a cottage on North Second Street in Lindsborg, one block from the Sandzén residence, there were daily contacts between the two families. During the Christmas season, they would share the festive traditions of the old country, and in 1924 Birger wrote to Gustaf, "Only a few hours are left in this year. We three and Oscar [Thorsen] have been to call on my father-in-law and my mother-in-law in their pleasant little home and celebrated New Year's Eve in pleasant quietness in the old Swedish manner with *lutfisk* and rice pudding."[15] The years passed, and in November 1938, Birger expressed his feelings in a letter to Gustaf: "My mother-in-law was 84 a few days ago and my father-in-law is 90.

He is spry and active. Both are full of mental vigor. They are such wonderful people that I feel strengthened and thankful every time I meet them."[16]

Although Sandzén was generally happy with his life in America, he often expressed hemlängtan ("longing for home") and the desire to be near his family in Sweden. Extensive correspondence with his father until his death in 1904, with his mother until she died in 1914, and with Gustaf, who survived Birger, shows the depths of his feeling for family and the old country. For several years, beginning in 1907, Birger and Frida gave serious consideration to living in Sweden, and Birger thought about a new home for his family in Västergötland near the residence of Gustaf. In July 1908 Birger wrote that the Leksells were also interested in moving to Sweden, and he hoped that these plans could be realized "in the not too distant future." He sent money regularly to Gustaf for deposit in a savings bank in Sweden so that the financial basis for their plan could be soundly established, but a variety of factors, including World War I, caused them to abandon the idea.[17]

In the Lindsborg community the distinguished painter was well liked, and he responded thoughtfully to the townspeople's interests and concerns. The weekly meetings of the Lindsborg Rotary Club found Sandzén, a charter member, in regular attendance and enjoying the singing and fellowship with men from various vocations and professions. When it became clear that Lindsborg needed park space in the late 1920s, Birger wrote a full-length article in the *Lindsborg News-Record* to advocate such a public commitment, and he also supported the cause in public meetings. He was an active and enthusiastic member of the Lindsborg Historical Society, which had as one of its objectives the establishment of appropriate recognition of the high bluff northwest of Lindsborg known as Coronado Heights (commemorating the visit of Coronado and his conquistadors in 1541), and of course his interest in and support of the Bethany Lutheran Church continued throughout his life.

Sandzén's circle of friends was large and

Hagbard Brase, Oscar Thorsen, Carl Lotave, Birger Sandzén

varied because he was a good friend. He enriched other peoples' lives, and in turn he shared their resources for the good life. In Sweden he made efforts to contact several of his childhood friends whenever he visited there, and two of them, Oscar Thorsen and Hagbard Brase, emigrated from Sweden and followed Sandzén to Kansas to become members of the faculty of Bethany College because of his recommendations and encouragement.

Oscar Thorsen's home in Sweden was in Lidköping, but he had lived also in Järpås and was well known to the Sandzéns. After extensive music studies at Karlstad and elsewhere in Sweden, he came to Lindsborg at the turn of the century. He studied and taught piano at Bethany College, studied also in Chicago and Berlin, and became a professor of piano and a fine performer. Sandzén visited his friend in Berlin, and they often traveled together in America. Thorsen's love of art was almost equal to his love of music, and no one was closer to Sandzén and his family. He admired and encouraged the Lindsborg artist, and he undoubtedly had the finest private collection of Sandzén's works. Today, the large Thorsen Room in the Birger Sandzén Memorial Gallery, in which some of the artist's finest oil paintings are hung, is eloquent testimony to the longtime and close friendship of these two talented individuals.

Hagbard Brase, like Sandzén, had been a student at Skara Läroverk before graduating in organ from the Royal Conservatory of Music, Stockholm. Sandzén urged Brase to come to America, which he did in 1900. He eventually

Ernst F. Pihlblad

became professor of organ and music theory, the distinguished director of the Bethany College Oratorio Society, and founder of the college a cappella choir and was an outstanding organist and a fine composer. Brase and Sandzén were intimate friends, and their families had a close relationship. The Brase Room in the Sandzén Gallery is another testimony to the friendship of the two former Skara School students.

The association of Sandzén with both Thorsen and Brase was meaningful to each of the three men. Their common cultural legacy provided resources for understanding and intimate fellowship, and there were times of happy reminiscences about the old country and interesting comparisons of the old European culture with the American scene. They also united their talents and efforts to enrich life in the country where destiny and choice had placed them.

An early colleague of Sandzén at Bethany College was Rev. Ernst F. Pihlblad, professor of classical languages; their friendship was sustained and enriched during the thirty-seven years that Pihlblad was president of the college. The services of these two distinguished men were decisive factors, together with those of other colleagues, in developing the great tradition of the fine arts at Bethany.

Carl J. Smalley of McPherson was also one of Sandzén's close friends. An enthusiastic and well-informed promoter of art and a decisive influence in making the works of Sandzén known in the early years, Smalley published two volumes of Sandzén's prints—*The Smoky Valley* and *In the Mountains*—and his article in the *Print Connoisseur* provides interesting information about the Lindsborg artist as a printmaker.[18]

Richard Gordon Matzene and Birger Sandzén shared a mutually rewarding personal and professional friendship. Matzene was an excellent photographer and a well-known art collector whose years of travel and residence in China and India had immersed him in the culture of those areas. He had acquired a fine collection of oriental art objects and shared with Sandzén his great knowledge and enthusiasm for Chinese painting. He exchanged art from the Orient for Sandzén's paintings and prints and promoted interest in the artist's works in new areas. Matzene maintained his American residence in Ponca City, Oklahoma, and he left the Ponca City Library a fine collection of paintings and prints (see Plate 22).[19]

Close relationships developed between Sandzén and a number of the faculty members of Kansas State University, Manhattan. Charles Matthews, Hal Davis, Charles Straton, and John F. Helm, Jr., were all great Sandzén enthusiasts, and Helm, head of art studies at Kansas State University and a capable leader of the Kansas Federation of Art, was active in promoting the exhibition of Sandzén's works. These faculty members wrote several articles about the work of the Lindsborg artist, and the people associated with the *Kansas Magazine,* published in Manhattan, later issued the volume by Charles Pelham Greenough 3d, *The Graphic Work of Birger Sandzén.* Even today, Kansas State has a fine collection of Sandzén's paintings and prints.

Maude Schollenberger, a dynamic leader of the Wichita Art Association, was a staunch friend and supporter who arranged a series of one-man shows of Sandzén's works at the Wichita Art Association Gallery and invited him to lecture on a variety of art subjects. Edmund L. Davison, a Wichita banker, became Sandzén's close friend through a unique development. His Commercial Bank was located two doors from Ralph Martin's paint and art store, and after seeing a Sandzén oil painting there, Davison responded enthusiastically to it. The inspiration created by the painting was further stimulated by meeting Sandzén, and as a result Davison took a leave-of-absence from the bank in order to take painting lessons with the Lindsborg artist. He continued as a banker but also developed his newly found talent as a painter. Davison maintained his close friendship with Sandzén over the years while painting in Taos, New Mexico, and in Wichita. His oil paintings are of high quality, and the Edmund L. and Faye Davison Collection in the Wichita Center for the Arts provides further evidence of the banker-turned-painter's devotion to art.[20] Another resident of Wichita for a time, Anna M. Carlson—a former editor of the *Lindsborg News-Record*, a staff member of the *Wichita Eagle*, later a correspondent for the *Kansas City Star*—was tireless in writing important articles about Sandzén and his work.

Included among Sandzén's friends and admirers were former students and assistants. One of them, Sam Holmberg (1885–1911), studied with Sandzén for three years and became his assistant in 1905–1906. After Holmberg had studied in Paris, he and Sandzén worked together in Lindsborg. Holmberg became an art teacher at the University of Oklahoma in Norman, but he was stricken by illness and died suddenly while visiting in Lindsborg. Sandzén wrote about him at that time, "Sam Holmberg was an unusually gifted and sensitive young man and was already an outstanding artist. We had planned to work together and paint in Western Kansas. He was one of my very best friends, although he was much younger than I."[21] Oscar Brousse Jacobson (1882–1967), another former Sandzén

pupil and Bethany College graduate, was also a close friend and a fellow artist. He was a fine painter, director of the School of Art at the University of Oklahoma, and the author and illustrator of several books about the American Indian. Sandzén and Jacobson exhibited together on occasion, and they always encouraged one another and carried on a regular correspondence.

Sandzén quickly acquired the admiration and affection of new students, and he sustained their loyalty and enthusiasm during their student years and later. He painted with his students as Zorn had done in Stockholm, and students shared their talent with the master artist in an atmosphere that was conducive to learning. The unanimity of love and esteem for Sandzén among his former students is singular. Some of them served with him as teaching assistants, and others became members of the Bethany art faculty, including Anna Keeler Wilton, Jessie Bob Severtson, Dolores Gaston Runbeck, Myra Biggerstaff Holliday, Alice Whittaker, Ramona Weddle Raymer, Gladys Hendricks, Charles B. Rogers, Annie Lee Ross, Margaret Miller, and Ray V. Stapp. Several of Sandzén's students made significant contributions as teachers, painters, and printmakers.

Sandzén also had many other friends in the world of art; one with whom he kept in close contact was Carl Milles. From the time of their first meeting in Stockholm in 1924, almost 300 letters were written by the Lindsborg artist to his Swedish friend, who in turn wrote regularly to him. Sandzén shared his views on art more fully with Milles than with anyone else, and the scope and nature of their friendship is clear. The Sandzéns visited Carl and Olga Milles in Sweden and at Cranbrook, Michigan, when the Milles were staying there during a trip to the United States, and the Swedish sculptor visited the Sandzéns in Lindsborg on three occasions. In June 1931, on the recommendation of Sandzén, Bethany College awarded Milles the honorary degree, Doctor of Letters, the first of several honorary degrees conferred on him by American colleges and universities.

In 1935 Carl Milles presented the beau-

Birger Sandzén and
Carl Milles (1931)

tiful fountain, *The Little Triton,* to Sandzén,
Pres. Ernst F. Pihlblad, Prof. Oscar Thorsen,
and Dr. Hagbard Brase, with the understand-
ing that it should be placed in the artist's
garden. It now has a prominent place in the
courtyard of the Birger Sandzén Memorial
Gallery. When arrangements were made in
1936 to permit *The Little Triton* to be on loan
at the Dallas Exposition, Sandzén wrote to
Milles, "But it will be horribly empty after
the departure of *The Little Triton,* which we
love not only as a noble work of art but as a
dearly loved friend, a joyous and good little
tomte, who watches out for our home and
the people here and all over our little Linds-
borg. . . . I contemplate with fear and trem-
bling that he will never return. I hope that no
great tragedy occurs." In January 1937, how-
ever, the Lindsborg artist wrote joyfully to
Milles, "*The Little Triton* has come home and
is more enchanting than ever."[22]

Sandzén's feeling about Carl Milles is ex-
pressed at least in part in a letter that he wrote
to Gustaf: "Life's greatest cause for rejoicing
is to meet splendid and gifted people, espe-
cially someone like Carl Milles who is talented
in the highest possible degree. He has retained
throughout life his clear unswerving view on
both life and art. He sees everything with the

inquisitive eye of a child and his expressions
on art questions are therefore fresh, original
and fascinating. His noble art reflects his dis-
tinctive and simple soul."[23]

Sandzén also kept in quite close contact
with American artists. He met Raymond
Jonson for the first time in 1918 on a visit to
Santa Fe, and a close friendship developed
between Raymond and Vera Jonson and Birger
and Frida Sandzén. The New Mexico artist
gained prominence steadily as he moved toward
abstract painting, with special emphasis on
what he described as "Design," and Sandzén's
response to this development is found in his
letter to Jonson in January 1933: "I believe
that every artist should express himself accord-
ing to his own ideas on life and art. A painting
may be beautiful in a hundred different ways.
Artistic imagination is, according to my un-
derstanding, either creating things abstract,
or only suggested by nature or an intensified
vision of nature. An artist with creative imag-
ination may present his motifs in a fairly real-
istic way but they will be interpretations and
not imitations because the artist's vision goes
beyond the surface. I believe that it is good
for us to try different interpretations. I am
planning for the near future a few imaginary
paintings."[24]

Another close friendship developed be-
tween John Taylor Arms (1887–1953), a well-
known American printmaker, and Sandzén.
Arms expressed his appreciation for Sandzén's
achievement by writing in a letter that Sand-
zén was "one of the few men of our day who
has made a contribution of lasting significance
to graphic art" and that Arms had "for the
work itself great admiration."[25] Additional
evidence of Arms's esteem for Sandzén is
found in his inscription of deep personal re-
gards on two prints that he presented to the
Lindsborg artist.

Although Sandzén made only occasional
trips to the East, he had several friends there
with whom he kept in contact. Among them
were Christian Brinton, a well-known New
York art critic, and Thornton Oakley, a tal-
ented water colorist who was long associated
with the Philadelphia Water Color Society. Dr.
Henry Goddard Leach, author and editor of

Forum Magazine and a leader in the American Scandinavian Foundation, New York, was a close friend, and both Brinton and Leach were key personnel in presenting Sandzén's paintings at the 1922 Babcock Gallery Exhibition in New York.

The scope of Sandzén's friends and admirers was large. Thousands of people viewed his works at exhibitions across the decades in small towns and in large cities, but Bethany College, Lindsborg, and the Smoky Valley played central roles in Sandzén's life. There was great esteem for him there, not always fully articulated but ever present. Successive presidents and members of the faculty of Bethany College shared in the blessings of his presence since they and their families and other Lindsborg residents were the beneficiaries in a special way of the genuine friendship and hospitality of the Sandzéns. The greatly loved painter and professor chose to live out his mature years in "our little Lindsborg," where he felt at home and where he is still held in kindly and affectionate remembrance.

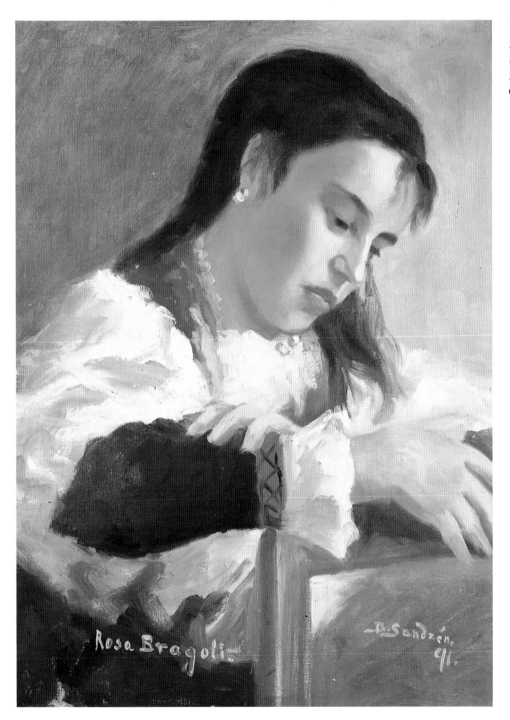

Plate 1

Portrait of Rosa Bragoli
(1891) oil on canvas
$21^{1}/_{2} \times 16^{1}/_{2}$ inches
Greenough Collection

Plate 2

Fröken Rosenqvist, also
known as *Portrait of a Girl*
(1891) oil on canvas
21½ × 16½ inches
Private Collection

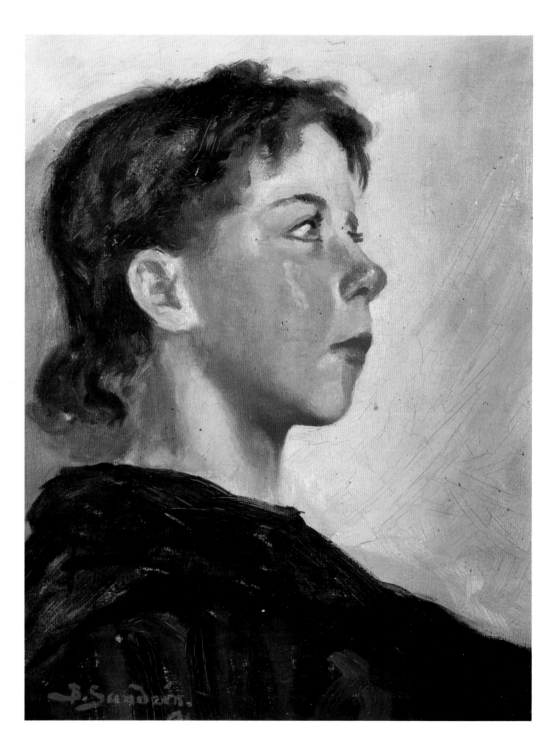

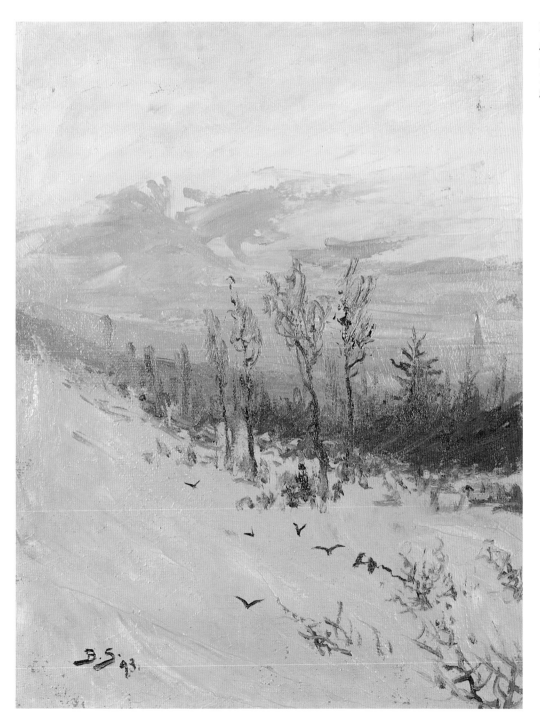

Plate 3
Sketch from Sweden
(1893) oil on canvas
16 × 12 inches
Sandzén Gallery Collection

Plate 4
St. Cloud, France
(1894) water color
7³/₄ × 5 inches
Greenough Collection

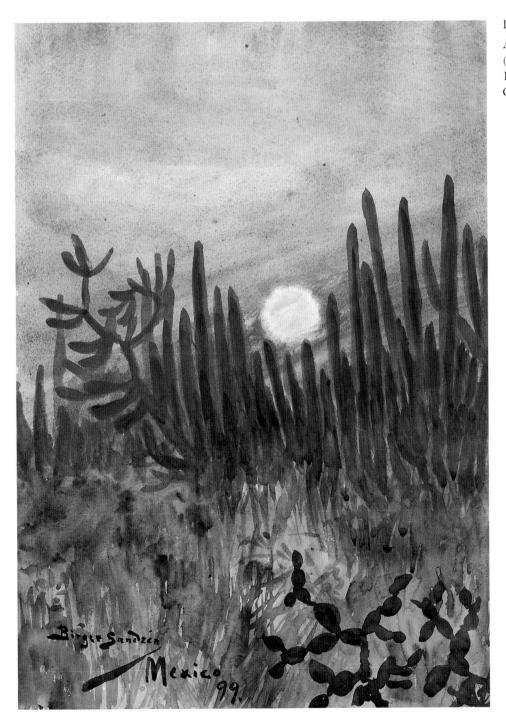

Plate 5
Mexican Motif
(1899) water color
19½ × 13½ inches
Greenough Collection

Plate 6
Sunset
(1910) oil on canvas
18 × 24 inches
Sandzén Gallery Collection

Plate 7

Mountain Sunset
(c. 1911) oil on canvas
24 × 36 inches
Sandzén Gallery Collection

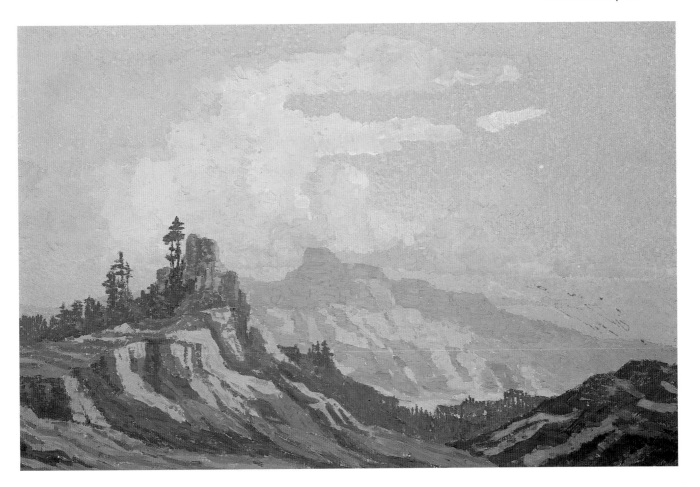

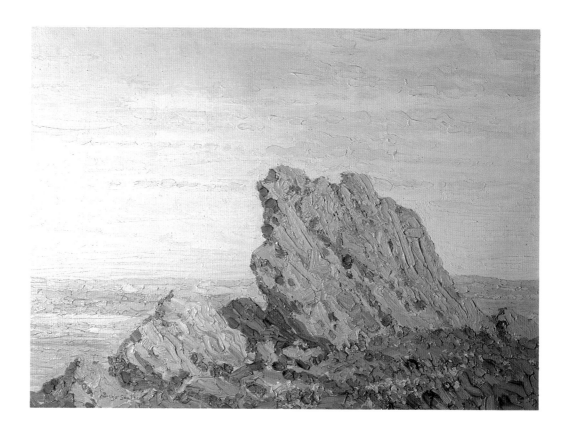

Plate 8

Rocks on Salemsborg Hill
(1912) oil on canvas
17½ × 23½ inches
Stinson Collection,
Grand Island,
Vermont

Plate 9

Wheat Stacks,
McPherson County
(c. 1914) oil on canvas
15¾ × 23½ inches
Greenough Collection

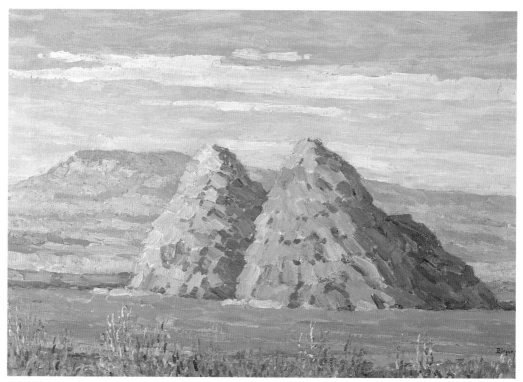

Plate 10
In the Painted Desert
(c. 1915) oil on canvas
32 × 48 inches
Unified School District
#418 Collection,
McPherson, Kansas

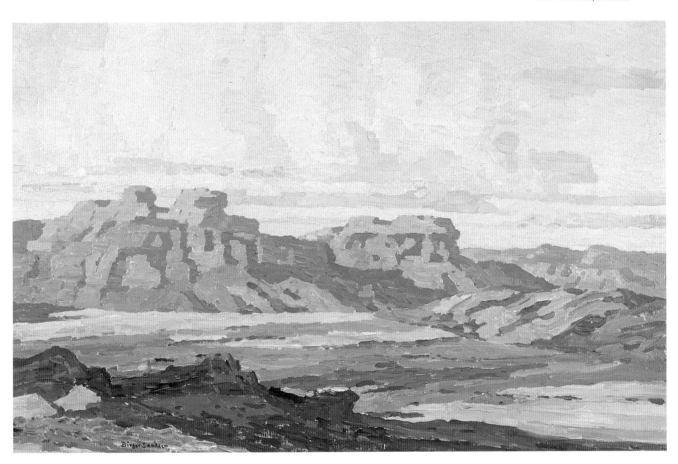

Plate 11
Grand Canyon
(c. 1915) oil on canvas
18 × 12 inches
Collection of Federated
Women's Club,
Mulvane, Kansas

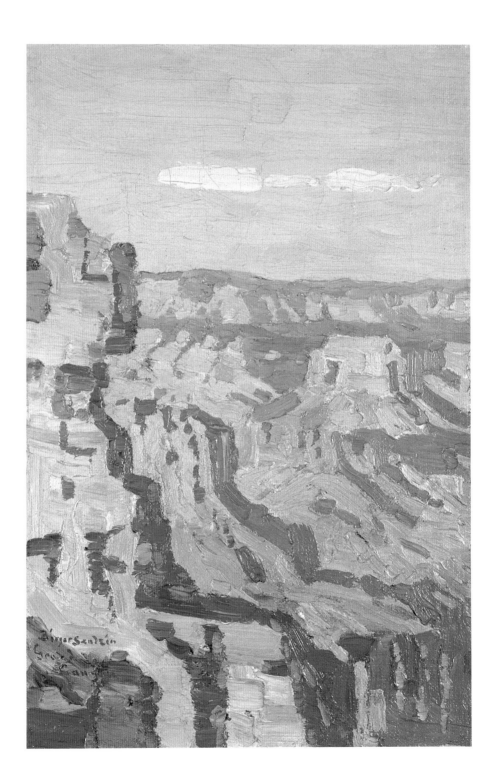

Plate 12

Above the Timberline
(1917) oil on canvas
36 × 48 inches
Museum of Fine Arts,
Museum of New Mexico,
Santa Fe, New Mexico.
Gift of the artist
and Carl J. Smalley

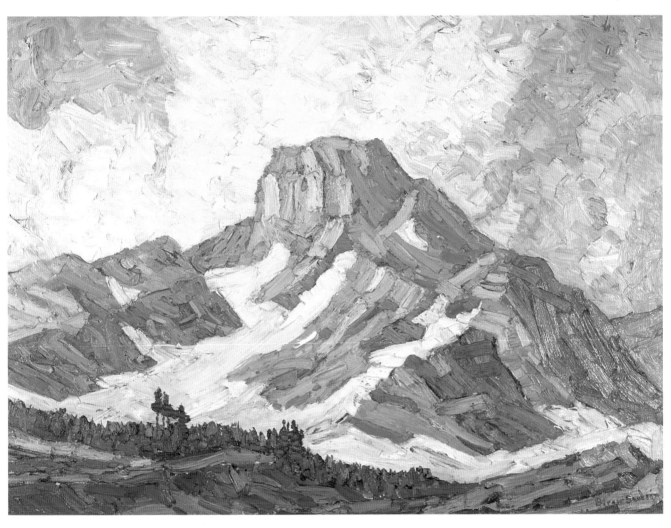

Plate 13
Smoky River
(1919) oil on board
22 × 26 inches
Sandzén Gallery Collection

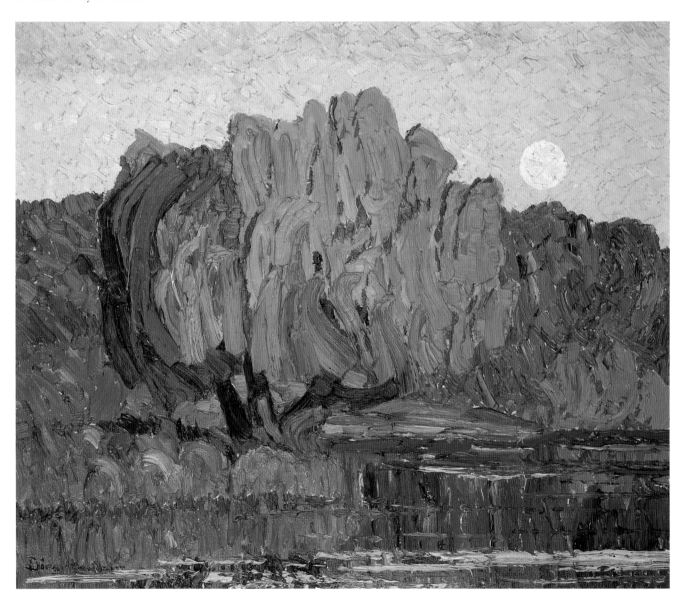

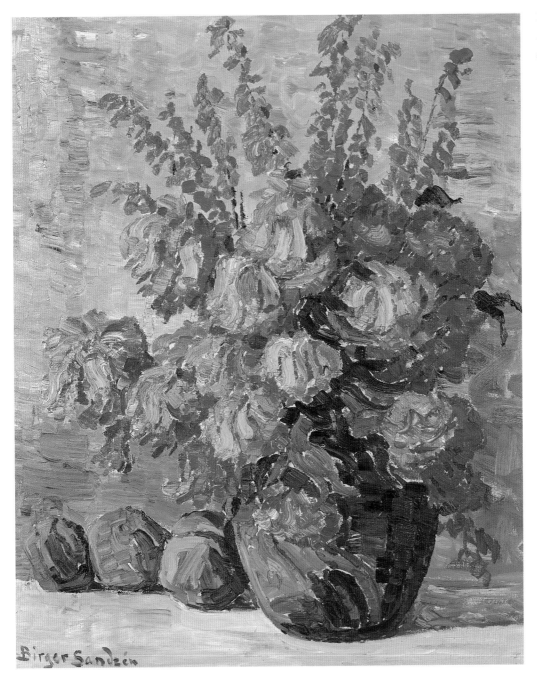

Plate 14
Chinese Woolflowers
and Salvia
(1919) oil on canvas
34 × 24 inches
Greenough Collection

Plate 15

Sunshine and Shadow
(1919) oil on board
36 × 54 inches
Greenough Collection

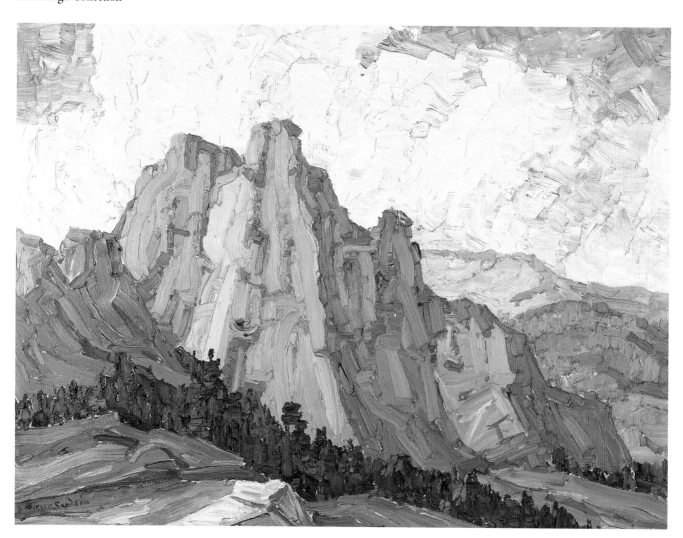

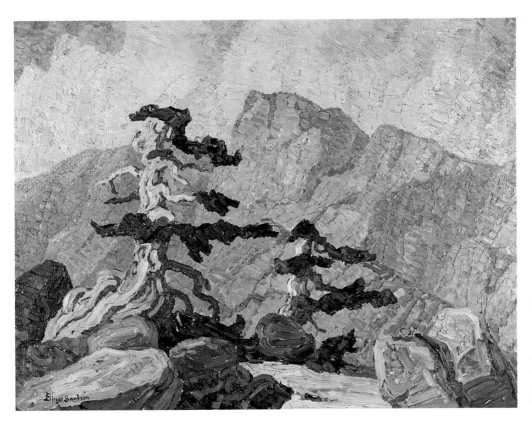

Plate 16

Timberline Trees
(c. 1919) oil on canvas
47½ × 35 inches
Collection of the Wichita
Center for the Arts,
Wichita, Kansas

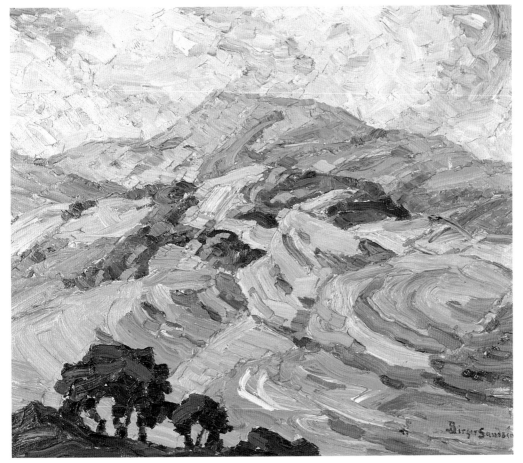

Plate 17

*Red Rock Region,
Manitou, Colorado*
(1920) oil on canvas
24 × 28 inches
In a private collection,
Wichita, Kansas

Plate 18
In the Black Canyon
(1920) oil on canvas
36 × 48 inches
Sandzén Gallery Collection

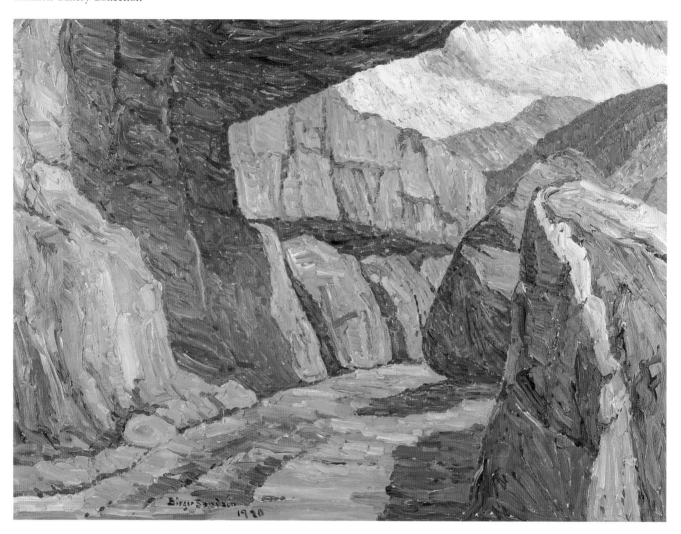

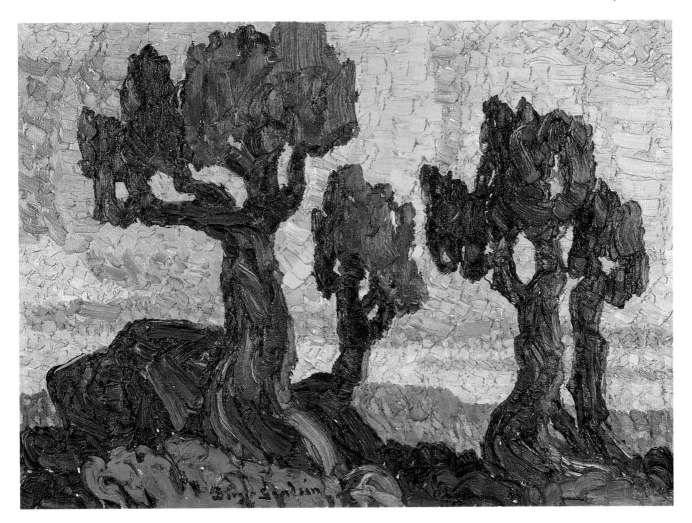

Plate 20

Landscape with Four Trees
(1920) oil on canvas
47³/₄ × 35⁵/₈ inches
Spencer Museum of Art,
University of Kansas,
Lawrence, Kansas

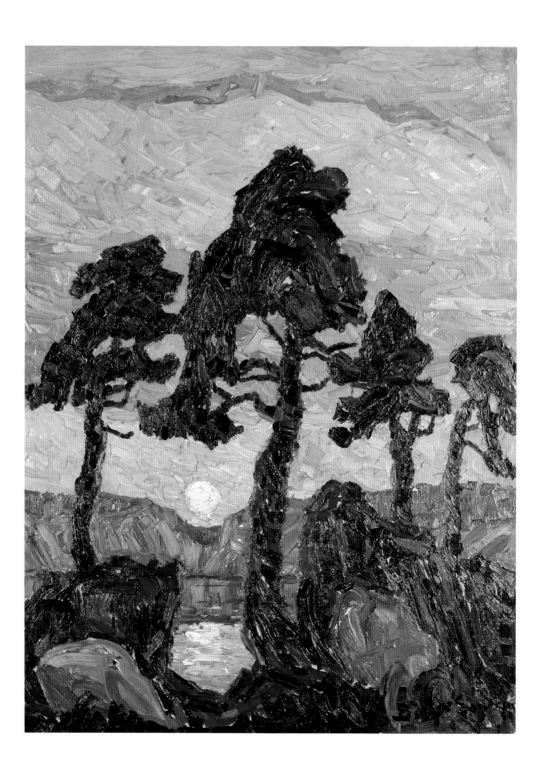

Plate 21

Creek at Moonrise, also known as *Wild Horse Creek* (1921) oil on canvas
36 × 48¹⁄₈ inches
The Brooklyn Museum
22.101
Gift of Dr. and Mrs. Henry Goddard Leach

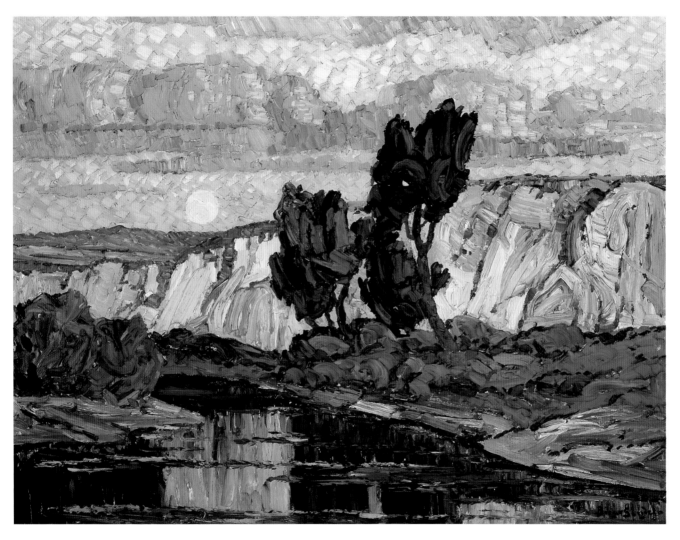

Plate 22

Sunset,
Smoky River, Kansas
(1921) oil on canvas
72 × 151 inches
Ponca City Library
Collection,
Ponca City, Oklahoma

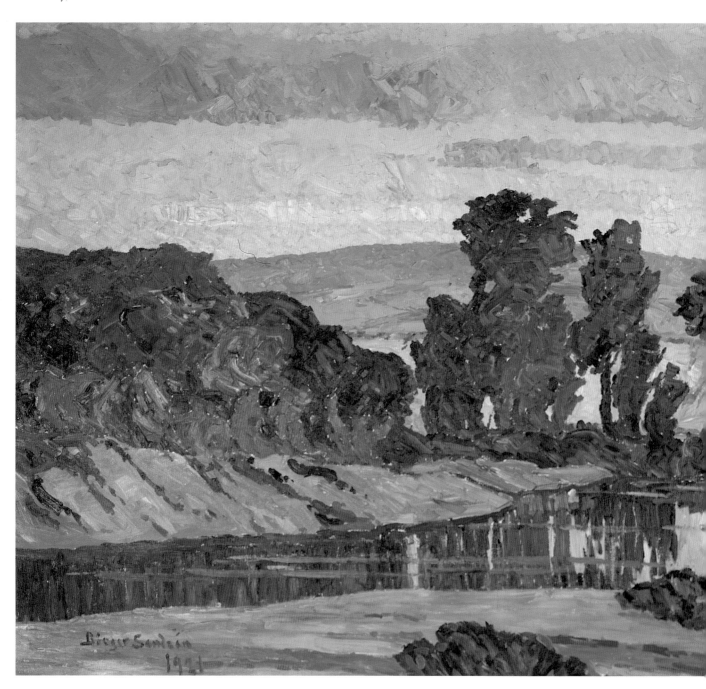

Plate 23

Creek at Moonrise
(1921) oil on canvas
60 × 80 inches
Unified School District
#400 Collection,
Lindsborg, Kansas

Plate 24

The Old Homestead
(1921) oil on canvas
36 × 48 inches
Sandzén Gallery Collection

Plate 25
Rocks and Snow
(1922) oil on board
9 × 11⁷⁄₈ inches
Greenough Collection

Plate 26
Peonies
(1922) oil on canvas
18 × 24 inches
Greenough Collection

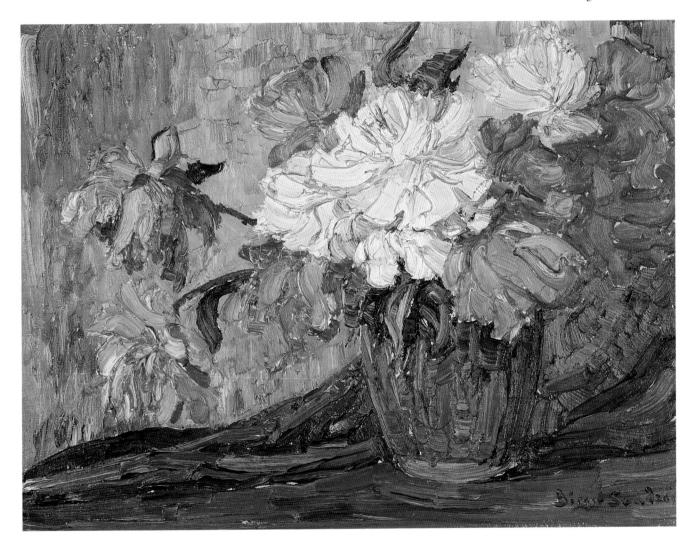

Plate 27

Cathedral Spires
(1923) oil on canvas
80 × 60 inches
Greenough Collection

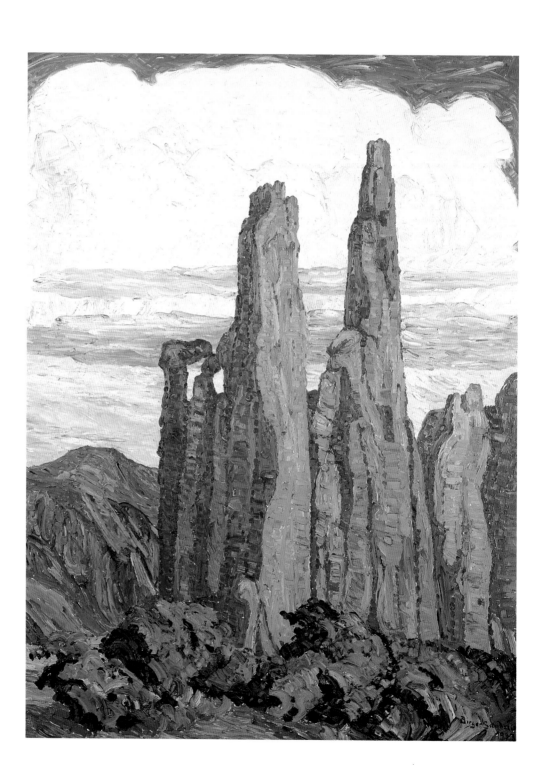

Plate 28
Breakers, Kullen, Sweden
(1924) water color
21 1/8 × 27 1/4 inches
Greenough Collection

Plate 29
Twilight
(1924) oil on canvas
19$\frac{1}{2}$ × 23$\frac{1}{2}$ inches
Collection of
Millesgården,
Lidingö, Sweden

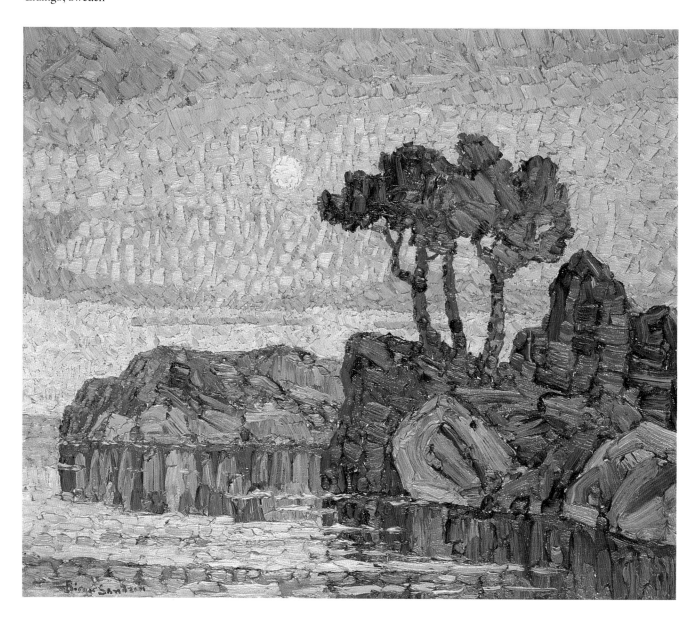

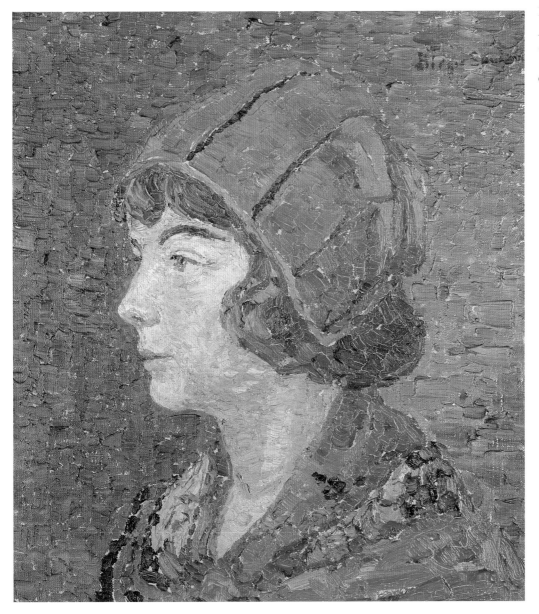

Plate 30
Portrait of Margaret
(1924) oil on canvas
16 × 14 inches
Greenough Collection

Plate 31

Castle in the Snow, Colorado
(1925) water color
21$\frac{1}{4}$ × 27$\frac{1}{4}$ inches
Greenough Collection

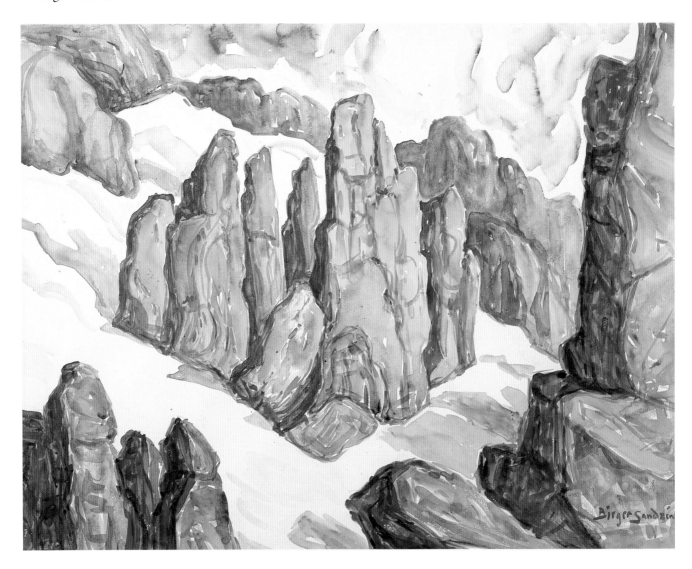

Plate 32

Lilacs
(1926) oil on canvas
24 × 30 inches
Sandzén Gallery Collection

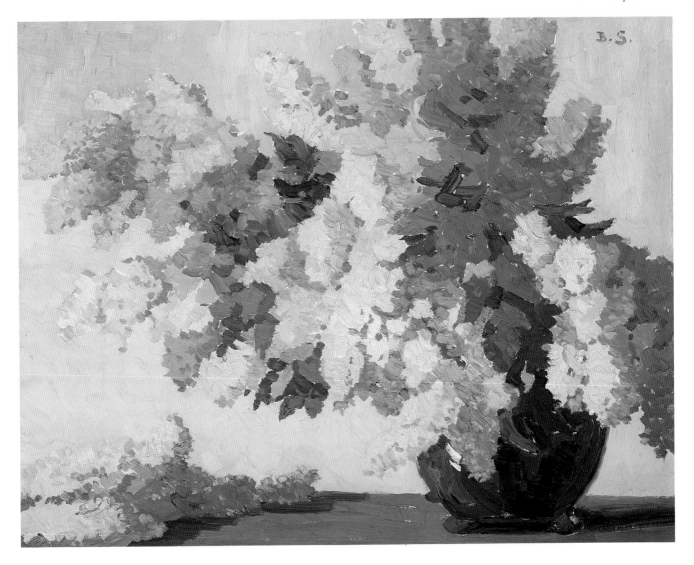

Plate 33A
Pond with
Cottonwood Trees
(1927) oil on board
27½ × 21½ inches
Sandzén Gallery Collection

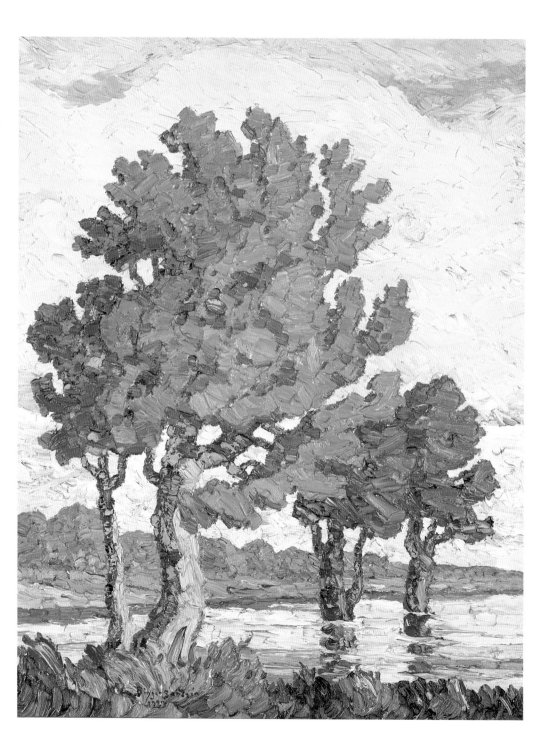

Plate 33B

Pond with
Cottonwood Trees
(1922) lithograph
17⅞ × 14 inches
Sandzén Gallery Collection

Plate 33C

Sketch for Pond with
Cottonwood Trees
(1922) 9½ × 7½ inches
Sketchbook #50, page 68
Greenough Collection

Plate 34

Old Missouri Farm,
Columbia, Missouri
(1928) oil on canvas
21$\frac{1}{2}$ × 27$\frac{1}{2}$ inches
Greenough Collection

Plate 35

Hour of Splendor,
Bryce Canyon, Utah
(1928) oil on canvas
59⅞ × 80 inches
Greenough Collection

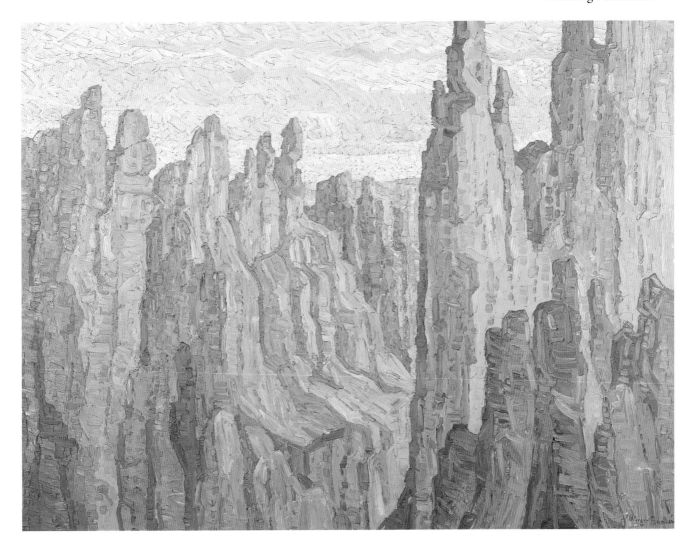

Plate 36

The Red Mill,
Logan, Utah
(1929) oil on canvas
26½ × 33½ inches
Unified School District
#259 Collection,
Wichita, Kansas

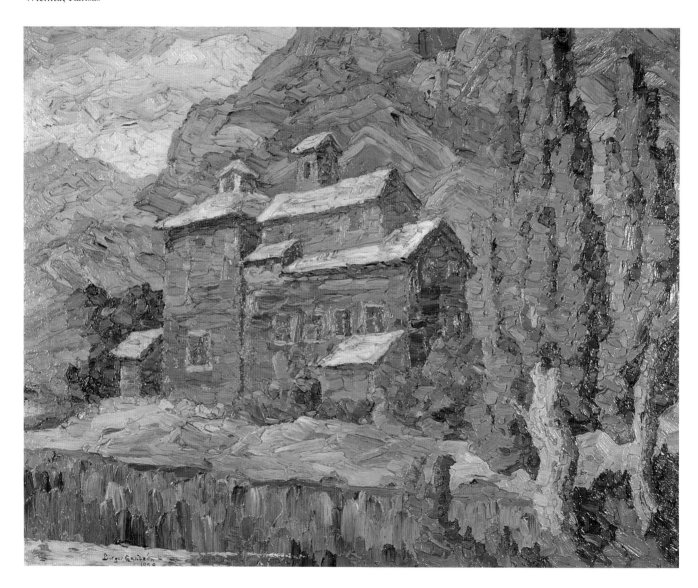

Plate 37

*Grand Teton Mountains
in Wyoming*
(1931) oil on canvas
25 × 30½ inches
National Art Museums
Moderna Museet,
Stockholm, Sweden

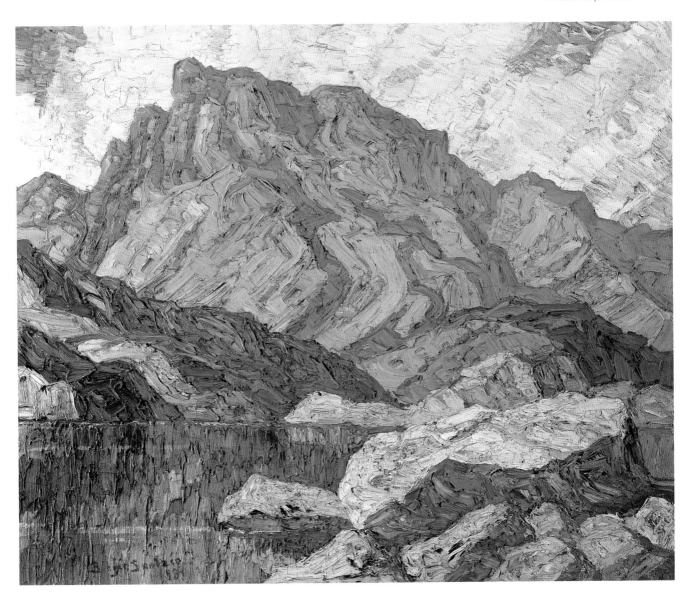

Plate 38

In Stavanger Fjord
(1932) oil on canvas
40 × 48 inches
Greenough Collection

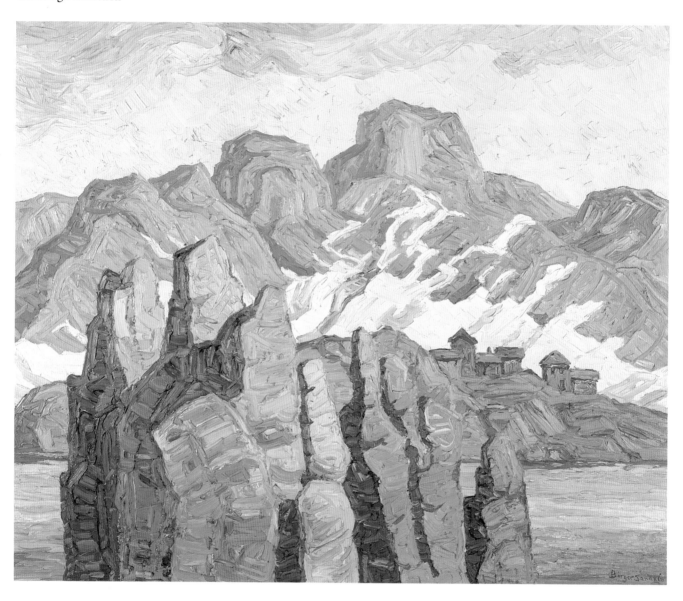

Plate 39

The War God
(1933) oil on canvas
40 × 30 inches
Collection of
Dr. and Mrs. H. H. Porter,
Tulsa, Oklahoma

Plate 40

Portrait of a Pioneer,
August Lundgren
(1933) oil on canvas
24 × 20 inches
Greenough Collection

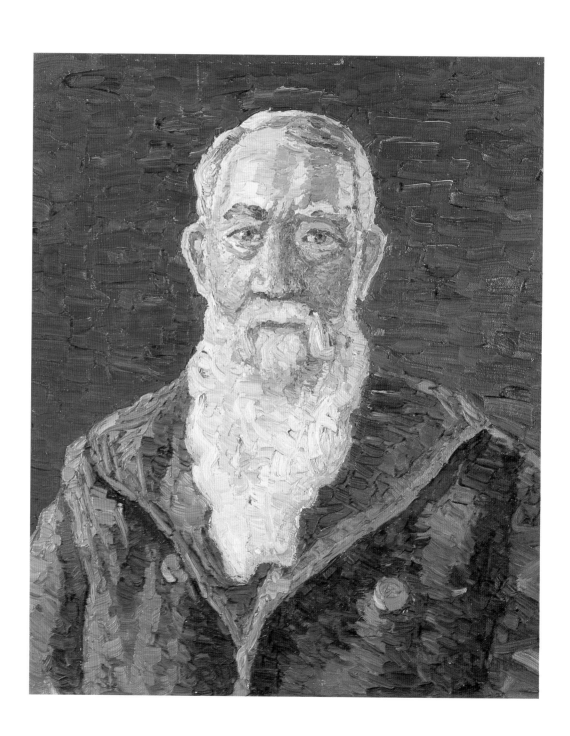

Plate 41
Portrait of Richard Steiner
(1933) oil on board
24 × 20 inches
Greenough Collection

Plate 42

Street in Nevadaville
(1934) oil on canvas
30 × 40 inches
Greenough Collection

Plate 43

Mexican Mountain Town
(1935) oil on canvas
40 × 48 inches
Greenough Collection

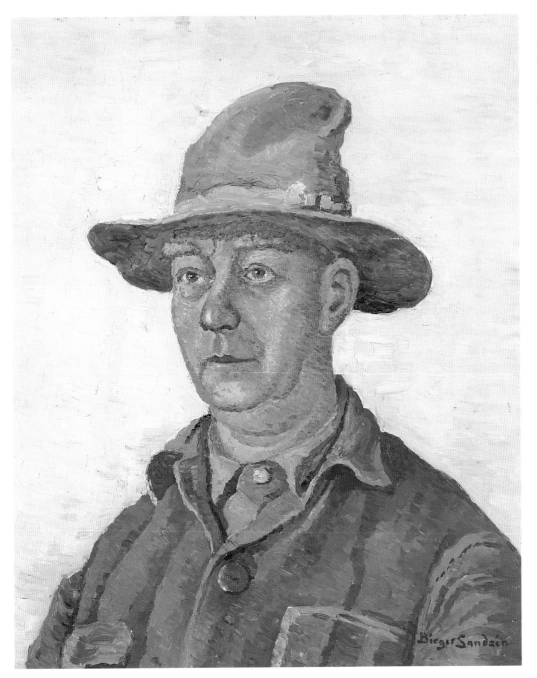

Plate 44

Kansas Farmer,
Pete Ellerson
(1938) oil on board
24 × 20 inches
Greenough Collection

Plate 45

Long's Peak, Colorado
(1938) oil on canvas
39¹⁵⁄₁₆ × 48¹⁄₈ inches
The Nelson-Atkins Museum
of Art, 38-10
Kansas City, Missouri
(Gift of Mrs. Massey Holmes,
in memory of her husband,
Massey Holmes)

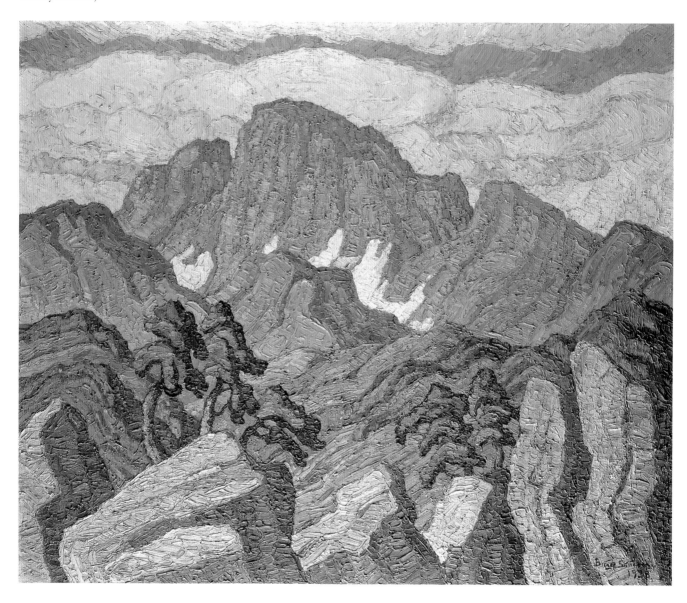

Plate 46

Autumn, Smoky Hill River
(1942) oil on board
22 × 28 inches
Sandzén Gallery Collection

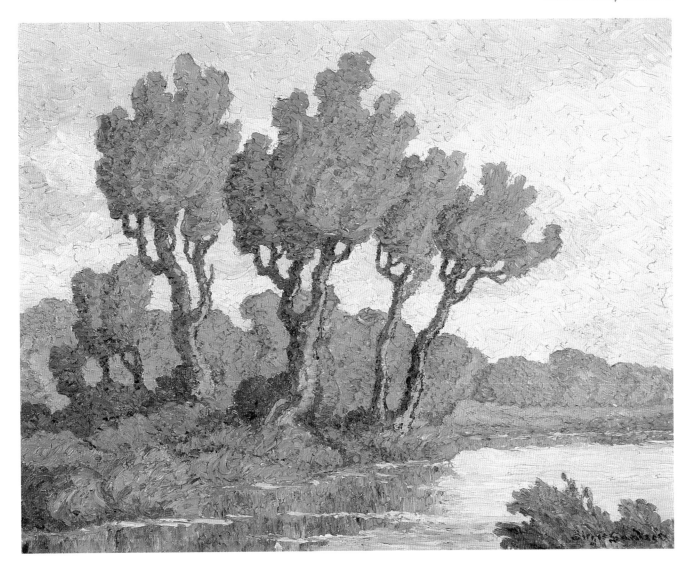

Plate 47

Stevenson's Lake
(1943) oil on canvas
34$^{1}/_{2}$ × 58 inches
Greenough Collection

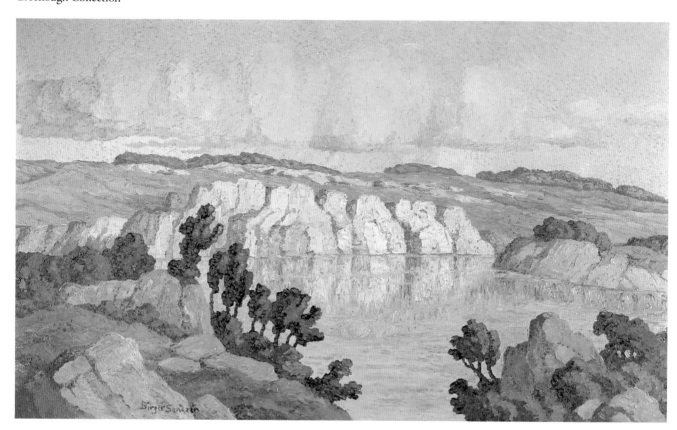

Plate 48

Rockport Motif,
Rockport, Massachusetts
(1948) oil on board
22 × 28 inches
Greenough Collection

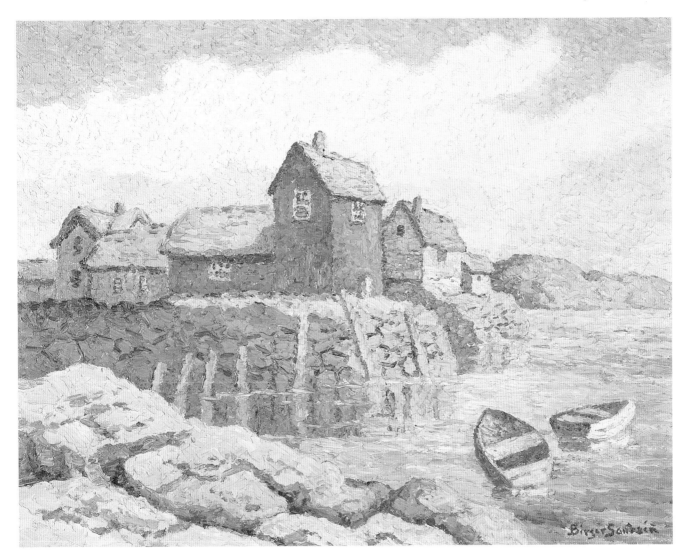

Plate 49

Kansas Landscape,
McPherson County
(1949) oil on board
15³/₈ × 19¹/₂ inches
Spencer Museum of Art,
University of Kansas,
Lawrence, Kansas

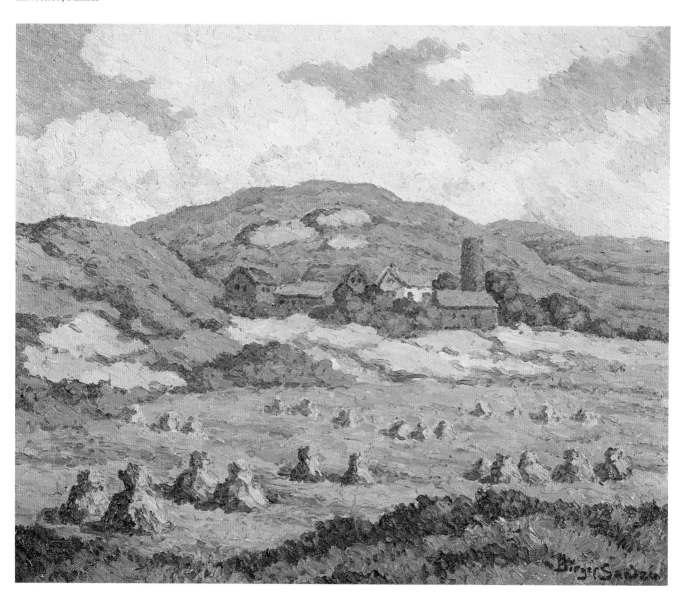

Part III

The Artist and His Work

8

Background Factors and Influences in the Paintings and Water Colors

Various influences on an artist are often difficult to evaluate, and such judgments are likely to be highly subjective at best. Nevertheless, some aspects are quite readily ascertainable in the life and work of Birger Sandzén. Sandzén went to Stockholm in 1891 to study drawing and painting seriously, and this period in Sweden was characterized by change. Swedish literature was entering a new era: "In place of the cultural cosmopolitanism of the 1880s, it returned to national themes and regional materials of all kinds." These years are referred to as the decade of Heidenstam, Selma Lagerlöf, Fröding, and Karlfeldt, who were fully identified with the new emphasis upon Swedish themes and structure.[1]

Sixten Strömbom has pointed out that the decade beginning in 1891 was also a turning point in Swedish art history. Konstnärsförbundet, critics of the old order or opponenterna (opposite group), had made a formal break a few years earlier from the established tradition represented by the Royal Academy of Art. The so-called "Paris boys," a term used by Strömbom because of their studies in Paris, had returned with few exceptions to Swedish soil, where they worked steadily to establish a new phase of artistic emphasis. Their interest in Swedish subjects had a parallel relationship with the new literary emphasis. Included both at the outset and later were Richard Bergh, Anders Zorn, Nils Kreuger, Karl Nordström,

Per Hasselberg, Carl Larsson, Bruno Liljefors, and others—names written large in Swedish art history.[2]

In the authoritative historical study of Konstnärsförbundet, Sixten Strömbom describes the new emphasis in the art school founded by these men:

The work methods were basically in harmony with the anti-academic studio schools around the world at that time. They did not seek to develop a maximum of routine but to awaken and promote each individual's potential. They sought therefore to avoid the conventional, academic, discipline-bound methods. According to this point of view the following forms of work were of irreparable damage to the student's joy of work and free personal development: precise exercise in line perspective, shading blocks, copying old art, drawing sculpture casts, tests in composition, etc. The absence of these exercises caused Georg von Rosen, head of the Royal Academy, to call the school "a dilettante institution." The members of Konstnärsförbundet sought instead to conduct instruction in realistic forms and color study, drawing and painting of live models, still life and open-air motifs. Nature study was also a principal emphasis.[3]

It was Birger Sandzén's good fortune to become a student in this school. The students were associated with young, enthusiastic, and dedicated artists and teachers who were on the line of discovery. Strömbom records that "the gap in years between teachers and pupils was

on the whole scarcely greater than between the older and younger pupils." The methods of instruction were informal. Pupils were encouraged to develop their talent, although guidance, consultation, and criticism were provided. Strömbom appropriately stated that "the feeling of freedom and artistic expectations released inherent talents in a far higher degree than was possible in the rival institution."[4]

The years at Stockholm undoubtedly had a great influence upon Sandzén. He became inspired by the challenge of a career in painting, was encouraged by his distinguished teachers to pursue such a career, and profited greatly from their instruction and from the association with kindred spirits among the pupils. Carl Milles, in the catalog introduction to Sandzén's exhibition in Gummeson's Gallery at Stockholm in 1937, wrote that "as a young artist Sandzén painted exclusively with *Förbundet's* eye [the Artists' League emphasis] and this influence continued later when in the American West he was overwhelmed by the color of the new milieu [see Plate 6]."[5]

Swedish art critics and historians often associate Birger Sandzén with Varbergskolsmåleri (the Varberg School of Painting), which traces its origin to the residence of Richard Bergh, Karl Nordström, and Nils Kreuger at Varberg on the west coast of Sweden. Bergh had been Sandzén's teacher, and all three artists were members of Konstnärsförbundet. Evert Wrangel, former professor of art history at Lund University, Folke Holmér, former Intendent (curator) of the National Museum, Stockholm, and Katarina Dunér and Bengt Olvång, writing in *Svensk konstnärslexikon* (Swedish Art Encyclopedia), are among those who identify Sandzén with the Varberg School. Nordstrom and Kreuger principally painted landscapes that are identified by effective use of color and light. The pointillism of Nordstrom's paintings has been cited as being reflected in part in some of Sandzén's work. Sandzén, however, used more pigment and brighter colors than are found in the paintings of the Varberg School.[6]

Another possible influence of the Artists' League is related to Sandzén's extended stay in Sweden in 1905–1906. The effect of this group was at a high point in the first decade of the new century. Although there is no evidence that he met artists of that school while in Sweden, Sandzén saw many of their paintings in various galleries, and a profound change occurred in the technique, brushwork, and use of color in his paintings within a few years after his visit in Sweden.

It is also to be remembered that Sandzén, as a pupil of Aman-Jean, had painted in his atelier on Avenue de Saxe in Paris in 1894. The postimpressionist Aman-Jean, primarily a portrait painter, had been closely associated with Georges Seurat, who used the brilliant colors and intense light of the impressionists along with his own brushwork technique, known as pointillism, or divisionism. As early as 1879, Aman-Jean and Seurat had shared a studio in Paris, and they had remained friends until Seurat's death. It is difficult to ascertain the influence of Seurat and Aman-Jean on Sandzén, but Prof. Evert Wrangel has written, "Sandzén at the time [the Paris period] turned in the direction of pointillism, whose great champions were Seurat and Signac. Sandzén represents what may be called Post-Impressionism, Impressionism after Manet."[7]

Moreover, while a student in Paris, Sandzén spent much time studying paintings in the museums and galleries and thus came into direct contact with impressionism. He was especially interested in Claude Monet (1840–1926) and Pierre August Renoir (1840–1919). Later in life he said, "If I could choose just one of the great masters of the nineteenth century, or if I could choose one of the painters of more recent times who I thinks ranks with the great masters of all time, it would be Renoir." He also stated that he liked the impressionists because their paintings were characterized by an abundance of joy and life.[8] Although Birger Sandzén received great resources from famous teachers like Anders Zorn, Richard Bergh, Aman-Jean, and others, it is appropriate to recall his statement: "They were splendid men, all three of them, but the question is if they had more to give than my old drawing master, Olof Erlandsson, stern but fatherly, unknown to the world."[9]

When Birger Sandzén emigrated to Linds-

borg in 1894, he left the world that he had known at Järpås, Skara, Lund, Stockholm, and Paris and was thrust into the new milieu of the Plains. In time, his new world also included the Rocky Mountains and the great Southwest. Novel and decisive influences were in the offing. Some of the new forces were almost traumatic in their impact; nevertheless, he responded to them joyfully and meaningfully. Studying in Paris, Sandzén had met several American students and was impressed by their openness, optimism, and friendliness. He sensed the promise of American life: "A free, new country. It should be heaven for a painter. Out there in the West a painter could develop a style of his own to fit the country."[10]

Sandzén was thrilled with the Smoky Hill River valley of central Kansas. "We have glorious scenery right here at the very door of Lindsborg. I discovered a little canyon about fifty miles northwest of here called Red Rock Canyon. It is red, red, red, almost vermillion." And later: "In this clear, transparent atmosphere you get the most marvelous effects—double effects—when the sunset is reflected in the sky East and a moon is rising at the horizon. It's all color. It's wonderful. It's different every day of the year [see Plate 13]."[11]

What may have seemed commonplace to some viewers was exciting for Sandzén (see Plate 8). In Kansas there were miles and miles of low hills, ravines with groups of trees here and there, drawing deep winding lines along the sides of the hills. He saw "huge boulders or fantastic fortresses and castles of yellow or light sandstone, fit dwellings for the giant stone men of Indian legend, standing out here and there in bold relief" and became deeply impressed with the rolling Kansas prairie. A creek would cut a deep gash in the undulating prairie, and he might "follow the creek for hours and perhaps find nothing especially interesting, but suddenly the creek would spring a great surprise. Perpendicular sandstone walls, high and gay colored palaces, minarets and temple ruins loomed up against the sparkling greenish blue sky."[12]

Sandzén also became enamored of the beauty of the Southwest and of the Rocky Mountains. In 1915 he wrote that it was not possible to describe "the great romantic wonderland of the Southwest with its rugged primitive grandeur, its scintillating light, its picturesque people. What a world of beauty waiting for interpretation in story, verse, color and line." Moreover, there was the "endless desert painted yellow, blue and red, the solemn, mystic Grand Canyon [see Plate 11]." Colorado provided the inspiration of glorious nature: "golden plains, towering peaks, granite cathedrals, deep blue lakes, pine forests, deserted mining towns all swimming in color and light." What Sandzén saw he summarized in one sentence: "What a paradise for the painter."[13] The artist's enthusiastic descriptions of his new world have been cited to show its influence upon his painting. There was something prophetic in the words of Richard Bergh: "Consciously or unconsciously, artists are constantly influenced in their choice of form and color by nature that surrounds them."[14]

Another influence on Sandzén was his interest in and love of Chinese art. His friend Gordon Matzene further stimulated Birger's interest in this magnificent tradition, and he read widely on the subject and collected Chinese paintings and other art objects. He was especially impressed by the great Song landscape papers and felt that Chinese artists showed unusual skill in showing depth and in reflecting the elemental forces of nature: "The Chinese have a way of combining respect for nature with creative imagination which produces marvelous results." The last book he purchased was a new publication on Chinese painting.[15]

In a reminiscent mood, Sandzén once recounted the following childhood memory: "I guess my interest in Chinese art goes back to a little old woman, *Tant* Klara Winberg, a friend of the family, who lived quite close to our home in Järpås. I often visited there as a boy. Her father, grandfather, and great grandfather had been either captains or chaplains on East India sailing ships. She had a beautiful collection of porcelains, silver, draperies, and Chinese paintings and art objects." Those closest to Sandzén will always remember the

great thrill he had when the first exhibition of Chinese paintings was held in the Swedish Pavilion on the campus of Bethany College.[16]

Art critics occasionally found possible Chinese influences in Sandzén's work. Laura Bride Powers, commenting on his water colors in a San Francisco exhibition in 1920, observed, "Indeed, in some of these water colors there is a feeling of orientalism in the design, and a rhythm that is a suggestion of the old Chinese forms."[17] Charles Pelham Greenough 3d, in his book *The Graphic Work of Birger Sandzén,* stated that "there is rhythmic vitality in many of these prints [linoleum cuts] that brings to mind the linear rhythms of some Chinese art."[18]

Apparently only one painting, *The War God,* (see Plate 39), is related directly to Chinese subject matter. When it was exhibited in the Midwestern Artists Exhibition in Kansas City, Missouri, the art critic of the *Kansas City Star* commented, "Sandzén's *War God* is something out of his cherished Chinese collection and with the god is an attendant porcelain dog, the pair painted with a wealth of color, clarion clear."[19] C. Louis Hafermehl has pointed out that "Sandzén, like the Impressionist painters, tended to put the horizon high in his compositions. This may also be due to his interest in Chinese art. The Chinese painter thinks of the picture plane as bottom, middle and top, rather than foreground, middle-ground, and back-ground as the Western painter tends to view the problem."[20]

Sandzén and the painter Sam Holmberg discussed at length the history of painting in modern times and especially the contributions of Renoir and Monet. The two men painted energetically, trying new techniques, experimenting with color and line, modifying old methods and exploring alternatives—Sandzén reported that a substantial number of canvases in this period went into the incinerator.[21]

Comments have been made quite frequently that Sandzén's paintings show the influence of van Gogh. Such observations came to the attention of the artist, and in January 1924 he wrote in a letter to his brother Gustaf, "That I am influenced by van Gogh is impossible. I saw my first van Gogh original

this year."[22] Sandzén's style and technique had been well established before this time, but a survey of reviews indicates recurring references to such a relationship. In the *American Art News,* a critic wrote about Sandzén's paintings at the Palace of Fine Arts, San Francisco, in 1919: "Mr. Sandzén uses what may be termed an elongated pointillist method not wholly dissimilar to van Gogh's."[23] In 1940 the *Philadelphia Inquirer* printed this assessment: "In the glowing color quality of his oils, in his rich impasto and method of composition, especially in respect to trees, Mr. Sandzén is reminiscent of van Gogh."[24] Even the Swedish reviews of an exhibition in 1985 cited the van Gogh influence, and Claes Sturm in *Stockholm Dagens Nyheter* wrote that "Sandzén in America developed a style like that of van Gogh."[25]

William H. Gerdts, in a comprehensive and praiseworthy three-volume study, *Art across America: Two Centuries of Regional Painting 1710–1920,* has summarized the background influences on Sandzén's painting:

At first a Tonal landscapist whose work reflected the manner of Scandinavian Romanticism, by the 1910's—shortly after his first trip to the Rockies in 1908—Sandzén had turned to Pointillism and then, about 1915, to an exciting, colorful style. He laid paint on his canvases in expressionist blocks of pigment with rich impasto, creating modernist work that combined Fauve color with the structural concerns of Paul Cézanne. While some of Sandzén's landscapes, such as *Creek at Moonrise* [see Plate 23], depict Kansas scenery, many were inspired by his western travels, particularly after he taught during the summers of 1923 and '24 at Broadmoor Art Academy in Colorado Springs and in the summers of 1928, '29, and '30 at the State Agricultural College in Logan, Utah.[26]

Evidence is lacking of any direct influence on Birger Sandzén by the famous Armory Show in New York, February 17–March 15, 1913, an event that has been described as creating "an artistic revolution by confronting conservative critics with modernist trends and shocking a complacent public," with the result that "American art was never the same again."[27] In the midst of the great controversy resulting from the Armory Show, contempo-

rary painting gained a new and vital status. Doors formerly closed to nontraditional painting were now opened, and the individualism of Sandzén benefited advantageously from this new situation. The impact on Sandzén was related to the growing interest in contemporary painting, however, rather than to any direct influence of painters who participated in the Armory Show. Sandzén became a member of the Society of Independent Artists organized in 1916, which took the place of the Association of American Painters and Sculptors whose members had been so closely related to the Armory Show, and he participated in the exhibitions of the Society of Independent Artists in 1917 and 1918.

Although the influences on Sandzén may not always be firmly established, the facts remain that by the beginning of the second decade of the twentieth century his paintings entered a new period and that by the end of the decade the main elements of Sandzén's work that later became so well known and readily distinguishable had been demonstrated. In retrospect, certain observations may be made: Sandzén's first decade in America was a time for adaptation to the new milieu and culture. He was intensively occupied with a heavy teaching load in modern languages, which involved long hours of study and grading of papers; with translating; with writing about concerts, programs, and activities at Bethany College for the Swedish-American press, and so forth. There is even evidence that at one time he was giving serious attention to a career in teaching languages. Although he taught a few pupils in art and painted as much as possible, there was neither time nor opportunity for developing fully his talent in painting.

It was later that painting became the central focus in his life, and two factors, one latent and the other immediate, merged to fashion the technique, style, use of color, and motifs by which Sandzén's work is distinguished. First, the emphasis upon freedom and individuality during his student days in Konstnärsförbundet's school enabled him to respond freely and personally to the newly discovered world of nature in America, which he saw with clear eyes, a keen mind, and deep feeling. Birger Sandzén surveyed this new world and liked what he saw. He not only responded but transferred his response to canvas.

The second significant factor was the western milieu in which Sandzén lived and worked; it not only influenced his choice of subjects but also had a strong effect on all aspects of his painting and graphic work. Although he cherished the great tradition of old European culture, he felt new freedom in his adopted land. Nature and life presented a more rugged quality; the light was brighter and more vital; not only did the landscape of the prairie have a broad horizon, but parts of it had great distinctiveness; and the Rocky Mountains produced unusual challenges to the painter. The artist was more than a spectator; he was an intimate part of this prairie and mountain world, which was waiting for someone to paint it, to interpret it, and to assist others in realizing the beauty around them. The influences of family, education, and cultural interests were latent and powerful in the personality and in the art of Birger Sandzén. Yet they were transcended by the man himself—by his talent, sensitivity, individuality, imagination, integrity, and belief in the good, the true, and the beautiful. When one speaks of a painting by him as "a Sandzén," the language is appropriate because his distinctive paintings and prints reflect his distinctive personality and view of life (see Plate 15).

9

The Painter and His Craft

The paintings of Birger Sandzén are an expression of his view of art and a response to what he felt and perceived, translated on canvas by his distinctive technique and use of color. In 1922 he made a comment that revealed his view of painting: "Good art is the fruit of adequate craftsmanship and aesthetic vision. Results may be attained in many ways. An artist must have his material well in hand, do innumerable studies before he can begin to simplify and interpret. We can as a rule only interpret convincingly that which has become a part of ourselves, of our life, in other words, that which warmly interests us. A good technique can, of course, make a clever picture of anything, but an interpretation is quite a different thing. To interpret we must go deep, give ourselves, all our love, all our energy."[1]

Certain basic emphases are found in his paintings, and the role of nature had a high priority. In 1902 he wrote that the artist "should not separate himself from nature as the model." Later, in a letter to his brother Gustaf, observing that a critic of his paintings in Chicago had described them as "sensational," Birger wrote that "although the color is a little 'individualistic,' the paintings are very simple studies of nature. I hold myself strictly to nature, but I strive after simple and practical methods of expression [see Plate 7]."[2]

Sandzén sought to understand nature as fully as possible, and his love of rocks, trees,

and mountains is evident. He understood the spirit, structure, and substance of landscape forms but seldom indulged in the moods of nature, stressing rather the more abstract elements of composition, color, and texture. His point of view was expressed in 1927: "All color in nature is stronger than anything one can possibly have on the palette. For instance, the white of the moon-beam or the vividness of the newly opened flower. There can be no danger of exaggerating nature's color."[3]

The impact of the sunshine of his adopted country made such an impression on him that his colors became brighter and lighter. Years before he ever painted the Colorado mountains and after having seen them for the first time, he wrote to Frida that he hoped he would be able some day to evolve the means by which he could put on canvas the intense excitement he felt in their presence. Indeed Sandzén invariably responded to nature with excitement and pleasure, whether it was the Painted Desert or a single rock or flower, and he created paintings that conveyed this response to the viewer. The cliché "copying nature" puzzled him; he said, "It is impossible to copy nature because one is compelled to select, rearrange and organize."[4]

Birger Sandzén's paintings provide unusually interesting color, and he has described its vital importance: "Painting is mainly color expression, although other elements are neces-

sary, such as form and expression. A painting done according to the laws of black and white with an additional touch of color is not a real painting. A painting is from the beginning felt and planned in color."[5] Stating his views on the special relationship of the landscape to the use of color, Sandzén wrote:

I feel that one should be guided in both composition and use of color by the character of the landscape. There are western motifs out here, especially in a certain light (for example, in gray weather), which are distinguished by their majestic lines as in protruding rocks, rolling prairie and winding ravines. One should, when painting such motifs, first of all emphasize the rhythm and then sum up the color impression in a few large strokes. In other words: a severe decorative treatment is best adapted for this purpose. However, it should not be understood that color is less significant. No, not at all. The color arrangement, however simple it may be, should support and enforce the lines. A false arrangement of color may completely destroy the rhythm. In the atmosphere in which the intensive light vibration and ring of color produce the great power of light, which is often the situation in the dry air of the Southwest—it is clear that a color technique should be used that emphasizes the most characteristic feature of the landscape. One must then use pure colors which refract each other, but which through distance assimilate for the eye—the so-called "optical" blending—since the usual blending on the palette, the "pigmented blending" is not intensive enough and does not "vibrate."[6]

In April 1915, when Sandzén was attending an exhibition of his works in Kansas City, Missouri, he discussed his response to the new milieu: "When I came to this part of the country twenty years ago, I had much to learn over again. The atmosphere here is so different from that in Sweden. There everything is enveloped in a soft clinging atmosphere with colors in greens and blues. But here the air is so thin that the colors become more vivid and the shadows lighter. The colors here are purples and greens and yellows with everything bright in this clear ringing atmosphere of the West. When I started to paint here I had to pitch everything in a higher key."[7]

Sandzén preferred that his palette be neither too simple nor too complicated: "There are four or five pigments that no painter can do without. As to the rest, there is plenty of room for individual taste. . . . Vary your palette a little for different subjects. . . . We can get every imaginable color by mixing a few pigments, it is true, but too much mixing kills the color. Again I say: 'Let us experiment and learn the joy of orchestral color.'" He exhorted his art students: "Simplify! Simplify! Put on generous coats of paint simply, the simpler the more lasting. Never brush one coat on top of another. . . . Don't be afraid of big things. The Chinese did big things. Too many painters are timid. We in the West are on the right track with our big plains, long lines of hills and the desert."[8]

Sandzén's palette was varied: titanium and permalbe white; cadmium yellow, medium; cadmium red, medium; yellow ocher; raw sienna; alizarin crimson; permanent green, light; emerald green; French ultramarine blue; cobalt violet. Extensive use was made of emerald green and French ultramarine for blues, and later, he fell in love with cobalt violet. When asked why he used so much purple he replied, "Because I like it."[9]

Sandzén felt strongly that "the brush work should be expressive." He described the problem:

The brush work should be varied both according to the subject and the texture of the canvas. The light and ethereal "touche" in most of Corot's [Jean-Baptiste-Camille Corot, 1796–1875] paintings is a source of enjoyment because it is in perfect harmony with his motifs. His soft and tender birches, poplars and willows want exactly that kind of garb. But how would Rousseau's [Pierre Etienne Theodore Rousseau, 1812–1867] sturdy oak appear in such apparel? . . . Those who claim that the character of the artist's brush work is of no importance have not studied the matter sufficiently or have no eye for the sensuous charm peculiar to the art medium.[10]

Abundant evidence is available on the high priority that Sandzén gave to drawing. At Skara School he had had the good fortune of receiving intensive instruction in various aspects of drawing from Olof Erlandsson, who recognized fully the role of drawing in painting and printmaking.[11] An interesting source

for young Birger's attraction to drawing is found in twenty-four original drawings he made between 1884 and 1889 when he was the artist for the Skara School student publication *Brage*, of the Idun Society, a literary organization. (These drawings today are in Skaraborgslänsbibliotek, Skara.) The setting is generally that of a body of water and a wilderness. A Viking ship is often seen in the distance; a harp, a symbol of music and poetry, is frequently present, and rather ornate herbaceous borders surround some of the landscape scenes.[12] Knut Peterson, a fellow Skara student, and Birger also created a series of "cartoons" for a Skara stationer; Birger reported that "we made a pile of them," for which they received 18 kronor. No examples are extant.[13] In Stockholm, as a pupil of Zorn, Bergh, and Hasselberg, Sandzén shared in the great emphasis on drawing in Konstnärsförbundet's school. During the daily lessons in drawing, Hasselberg stressed "getting the accents." Birger also enrolled in an anatomy class taught by a faculty member of Carolinska Institute, a famous medical establishment, in order to gain greater competency in life drawing.[14]

Nina Stawski has made a superb study of Sandzén's sketchbooks and autonomous drawings and produced a meticulously prepared catalog of Sandzén's eighty-three sketchbooks from 1884 to 1952, which lists 5,655 sketches, primarily of landscapes.[15] Although graphite pencil, blue pencil, pen and ink, water color, indelible pencil, and sepia pen and ink were used, only 223 sketches were done in other than graphite pencil, with 113 in blue pencil next in frequency. The Stawski study, based on American sources, shows that there are gaps in the sketchbooks only between 1884 and 1889 and 1895 and 1897, a remarkable fact. The sketches are predominantly of landscapes in Graham County, the Smoky Hill Valley in Kansas, and the Rocky Mountains, but there are also many drawings from Sandzén's visits in the Southwest, California, and Massachusetts and from his travels in Europe, especially in Sweden, France, Italy, Norway, and Spain. The sketches vary greatly in size, but they are most commonly 5-by-7, 8½-by-5½, or 9½-by-6 inches.

The sketches generally show remarkable detail and effort; only a relatively small number are hurried recordings of impressions. The majority are autonomous and are signed and dated. A large number contain notations in Swedish about color, time of day, or special features, and some sketches in the later period include a color chart. A few are in full color. The combined result is that many items in the sketchbooks can be readily identified as the source for paintings and prints. Sandzén occasionally used the same sketch for a lithograph and oil painting; *Pond with Cottonwood Trees* is an example (see Plates 33A, 33B, and 33C). Mary E. Marsh, an art critic familiar with Sandzén's activities, has written, "At night, when he could not paint he made numberless detailed drawings of the landscape that he was studying." She also wrote that in studying a landscape, Sandzén made as many as fifty sketches of it, followed by studies in color.[16]

Margaret Greenough has often described her father's enthusiasm for sketching. On automobile tours, he frequently asked the driver to stop when an attractive view came to his attention. He would scramble up a hill to the location that was most appropriate, and perhaps on the back of an envelope he would sketch what he saw and felt. She recalled his eagerness for action when he arrived at Nahant in Massachusetts, as he hurried to make sketches on pieces of white paper before unpacking, later to transcribe them to his usually present sketchbook.[17]

In a letter to Carl Milles in 1935 Sandzén discussed the importance of drawings (see Figure 9): "I work often over and over again to find clarity and strength in composition and color although I seldom redo the same canvas. . . . For some of my large canvases . . . I have sketched and painted hundreds of studies in pencil or color. That is not in the least an exaggeration. I burned one time 500 large drawings, studies that I did not wish to use any longer. . . . By studying humbly and diligently nature's forms, we shall gradually learn how to distinguish between essential and nonessential things and develop an inborn sense of proportion and balance. When that reaches its maturity we are able to grasp rhythmic line."[18]

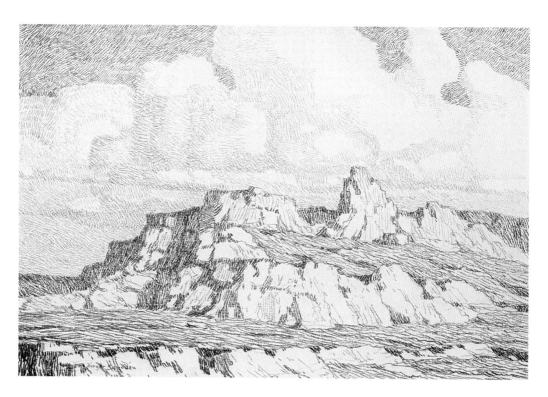

Figure 9

Rocks on Salemsborg Hill
(c. 1920) charcoal drawing,
14⅝ × 20½ inches

Nina Stawski also presents important information about Sandzén's autonomous drawings, which were specially created or taken from sketchbooks, the first being *Portrait of Frida* (see Figure 10). Landscapes provide the largest number of subjects, but portraits, herbaceous drawings, animals, and flowers are also included. Sandzén often used the transfer method in printing drawings for lithographs, and the original drawing often survived that process.[19]

Margaret Greenough has provided an interesting description of the development of her father's painting:

Sandzén's earlier water colors and oils from Sweden reflect the rather somber atmosphere of the North, with the exception of a vividly remembered early oil, still in Sweden, featuring bare trees in snow against a flaming sunset sky. A portrait of that time [approximately 1892–1893] is remembered for deft brush strokes and fresh but restricted colors. The influence of his teacher, Anders Zorn, is faintly present. A large landscape painted [during Sandzén's first year in America, 1894] from a small on-the-spot water color sketch in St. Cloud [near Paris] is completely low key and atmospheric, bearing little resemblance to later Sandzén except for the vital, sturdy, rhythmic construction of a large tree

and the presence of some foreground rocks, which have doubled for his signature [see Plate 4].

Another small oil, dated 1903, anticipates the love of moon, rocks, and water in subject matter, but the colors still are blues, grays, blacks, and earthen tones going into brown. A 1904 date on an oil of simple, lateral construction consisting of ground, rocks, and sky shows the elimination of all blacks and browns, but the basic key is still subdued with grayed blues and ochres predominant. Oscar Thorsen, Sandzén's oldest and closest friend, who collected his work from earliest times, once owned an unusual small painting dated 1899, which he said had broad, flat brush strokes, rather brilliant color, and heavy pigment. Almost seventeen years were to pass before Sandzén employed this combination again. Since there are no sales records of early paintings, and since the only substantial group which could have shown the development of Sandzén's art, between roughly 1900 to 1918, was lost in a fire which destroyed much of Oscar Thorsen's collection, it is difficult to be accurate.

An interesting group of paintings which were pointillist in technique are dated 1902–1905, 1910, and 1911. This approach did not last long in its purest form but was retained, nevertheless, throughout the years in a broader, freer application, the color becoming ever purer and more brilliant. By 1916 the brush strokes were quite free and direct. At times he must have used a palette knife to

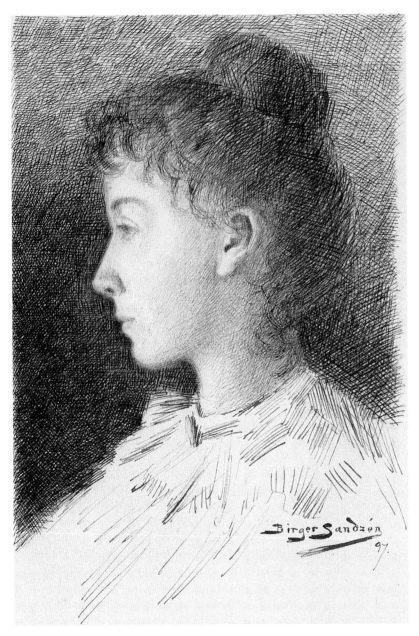

enjoyed the physical act of applying brush filled with paint onto the canvas or board. His actions were deliberate and contained, the timing between paint and palette to paint on canvas was almost rhythmical.[20]

C. Louis Hafermehl, a former Sandzén student and a former member of the art faculty at the University of Washington, Seattle, provides an intimate description of Birger Sandzén at work in the Swedish Pavilion studio:

Sandzén always shared the pavilion studio used also by the students. Along one wall was a table and shelves where he kept his palette, brushes and paints. When he came to work he would remove his coat and put on a tan smock. He would then prepare his wood palette. This was always very much in order with warm and cool colors separated with a large portion of white. He never used black. The mixing area on his palette was always clean since it had been carefully cleaned the previous day. Unless the painting being worked on was large, he sat in a chair with a back rest. He did not seem distracted if a student stood some distance behind to watch the remarkable forming taking place. He never scraped a color off to replace it with another. He did, however, adjust the function of color with the addition of another which would be placed on top, sometimes wet paint on wet paint. . . . Sandzén sized his own masonite panels with an oil and lead based paint. He stretched his own canvas but I do not recall his making his own stretching bars. If the above sounds simple it is meant to be so because that is the way Sandzén preferred it. He did not use linseed oils, driers, painting knives and the like.[21]

Sandzén had great concern for the proper emphasis upon light in his paintings. When painting in Kansas and in the Rockies where the light is especially bright and penetrating, he was able after extensive experimentation to make the appropriate application of this new-found quality in nature. When he planned a painting, he held up an opaque pencil to show the contrast between darkness and light. Although the structure is strong in his work, the darkness is not really as dark as it may seem to be.[22]

His daughter reported that "as a boy, Birger was asked by a teacher at Skara College

Figure 10
Portrait of Frida (1897)
pen and ink sketch,
10 × 7 inches

modify the surface, but only one painting remains to verify this supposition. The year 1919 saw Sandzén's work at its most vigorous with the large, flat, short-bristled brushes laden with paint, but always controlled. These strokes delineated the structure or objects painted in a logical manner and were never arbitrary. However, to those who like their colors "natural," his colors might have seemed arbitrary. In this period, the use of deep siennas, blues, ochres, and reds predominated. As time went on, he kept lightening and heightening the colors of his palette to "let the sun shine in," this sunshine of the New World which he was worshipping on canvas.

And speaking about painting, Sandzén visibly

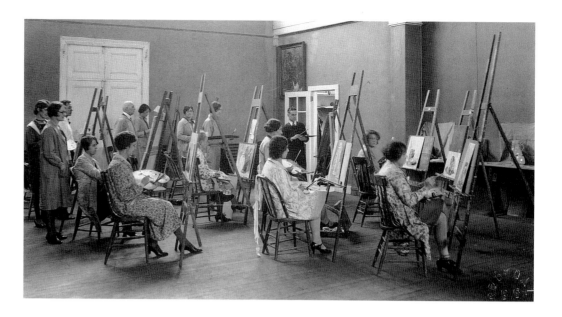

Painting class in the
Swedish Pavilion

to do large ink and brush drawings of rock formations for geology classes. Perhaps this started his love of rocks, because love them he did. One could say that he was quite mad about them. He had an equal passion for trees, especially the twisted old timbers struggling for survival. His regard for the good earth was balanced by a longing for water, for the still water of reflections, for running streams and ocean perimeters. Sandzén was sometimes criticized for not putting people in his landscapes, but nature to him was a world apart from man."[23]

Margaret further indicated that her father's paintings of Kansas show a predilection for the intimate aspect of the countryside (see Plate 9), centering around the areas he knew best—the Smoky Valley, bounded by the Spanish Buttes on the north, the Smoky Hill River running through the valley (see Plate 46), and the stony pastures of Graham County accented by Wild Horse Creek. Sandzén was as fond of the Kansas cottonwoods as he was of the Colorado pines. He knew every pioneer house in the Smoky Valley, and he must have drawn and painted most of them (see Plate 24). Occasionally, he would paint a sturdy Swedish pioneer with vigor and understanding, and he also drew animals well, using them infrequently but successfully in his compositions.[24]

Margaret also described Sandzén's love of

flowers. They were a favorite subject matter, and this enthusiasm probably came from his mother, who, in a country enamored of nature, was extraordinarily fond of flowers. Sandzén had an uncle who was a botanist, and together they took many field trips. Birger learned how to assemble a herbarium at an early age, and at Skara School he earned top grades in botany. His earliest extant studies of flowers were done in pen and ink, the flowers usually framing a small landscape. Later still lifes in oil are visual testimony of the pleasure he had in painting them—joy in the actual application of paint and color and joy in the subject matter itself. Among the flowers he painted were zinnias, Chinese woolflowers (Plate 14 and Figure 11), coxcombs, sunflowers, tulips, iris, peonies (see Plate 26), chrysanthemums, and lilacs (see Plate 32). Sometimes he combined fruit or vegetables or both with flowers in one glorious array of texture and color.[25]

There were times when Sandzén took minor liberties with the shape and color of his flowers. As in his landscapes, Sandzén suggested detail without going into detail, believing that one must seize the essentials. He did not indulge in complicated compositions or angles, usually placing the flowers in a solid bunch in a trusted bowl or vase, often tossing a flower or two in the foreground for good measure. Occasionally he painted sunflowers,

and in one instance, peonies, against the open sky.[26]

Sandzén did not believe in destroying the two-dimensional aspect of a painting, and he did not especially admire murals whose figures "tumble down" from the wall. He did appreciate historical Western art, but he preferred the art of China and the means by which a Chinese painter could suggest depth without insisting upon it. He thought that color should be used to develop the form of an object directly rather than applied to areas already built up in monochrome; however, this emphasis on color did not exclude a respect for form. Sculptors and architects recognize his innate feeling for solid structure and often express admiration for his work.[27]

The Lindsborg artist was an avid seeker of ideas and impressions that would contribute to his understanding and description of nature. Living far from the famous centers of culture, he appropriated the resources that he discovered in the universe of nature where he found himself. An artist friend once looked around little Lindsborg and asked Sandzén how he could achieve the mood to paint so far away from the artistic centers. "I take my brush and palette," Sandzén answered, "and then I am in the mood."[28]

Sandzén enjoyed the experience of working alone, alert to impressions that came to him. The family's Graham County farm often provided the locale for numerous excursions. Equipped with pencils, sketch pads, and a large umbrella, he would set out to view and respond to the landscape, and he saw much more than the ordinary observer. He would perhaps set up the umbrella in the dry bed of a stream and study the eroded and weather-beaten limestone ledges, which had survived the ravages of time to disclose a hidden beauty, or he might choose to be on the top of a wind-swept bluff and have a panoramic view of almost unending space.

Sandzén also liked to walk and dream amid the great majesty and quietness of the Rocky Mountains, where he felt an impelling urge to translate by pencil or brush what he sensed in the vastness of God's magnificent and mysterious universe. The response would vary, from the mass effect of a snowcapped range of rugged mountains to a scraggy, struggling tree on the side of a bare mountain, a symbol of the eternal battle of man and nature for survival. He enjoyed walking in the twilight to observe the splendor of a glorious Kansas sunset and, later, the mystic effects of a bright moon in a starry sky. Painting for Sandzén was much more than technique and color, sketching and planning. The dominant and pervasive elements were dedication, love, and excitement; on canvases and prints, the viewer

Figure 11

Chinese Woolflowers (1916)
woodcut, 14 × 9 inches

Little Triton fountain
by Carl Milles, near
Sandzén studio

could see that Sandzén was a man who created as he lived—from a great depth of being.

The Lindsborg artist painted without hesitation, carrying up to ten stiff-bristled brushes in his hand and using the rich palette with confidence. Sandzén on one occasion expressed his feeling about a subject he wished to paint: "I see it alive, standing before me." When the last brush strokes had been taken, he would step away without returning to make changes. This decisive and certain concentration, based upon extensive prior thought and thorough preparation, was undoubtedly an important factor in the productivity of this busy artist-teacher.[29]

As a student, Sandzén had been encouraged by Richard Bergh to become primarily a portrait painter. Although most of his works were landscapes, he painted possibly fifty portraits, often of Swedish immigrants. He painted sensitive portraits of Frida and Margaret, describing the latter portrait as "joyful and colorful" in a letter to Carl Milles (see Plate 30). Another fine portrait was that of Richard Steiner, the son of Edward Steiner—scholar, author, and friend of the painter (see Plate 41). Sandzén's portraits generally reflect

the technique and the use of color characteristic of his work.

Post office murals painted by Sandzén at Lindsborg, Belleville, and Halstead, Kansas, were created as the result of the Federal program for art in public buildings during the 1930s. The Lindsborg mural has a Smoky Valley motif, and the others represent area scenes. They are colorful interpretations of nature in the Sandzén style and interesting examples of his ability to use large space effectively.

Altar paintings by the Lindsborg artist are found in Lutheran churches with Swedish antecedents in Kansas, Nebraska, Iowa, Minnesota, Illinois, and South Dakota as well as in Sweden. The best known perhaps are the two large paintings in the Bethany Lutheran Church, Lindsborg, and the three large panels in the Immanuel Lutheran Church, Salina. The technique and style of these paintings reflect the changes in and development of his work during the period 1904–1925, the dates of the altar paintings in these two churches.

Birger Sandzén was an enthusiastic painter to the end of his career. Shortly before his death, and after his retirement from formal teaching at Bethany College, a lady asked him if he still painted. "You ask if I'm still painting," he replied. "You might have asked me if I'm still breathing." At about the same time he said, "I hope that I can live a little longer so that I can paint a little longer. I'm getting terribly excited about painting."[30]

Sandzén painted with his students in the Swedish Pavilion and in his studio on Second Street, adjoining the western edge of the campus. The studio had a pleasant location and was surrounded by well-trimmed shrubs and trees and flowers. After the 1930s, Carl Milles's *Little Triton* added its unique charm to the setting until 1957, when it was placed in the courtyard of the Birger Sandzén Memorial Gallery. The studio, only a short distance from the Sandzén home, was an L-shaped structure with 1,000 square feet of space and fine light from the north. The french doors on the south were painted a light green, the walls an off-white. The ceiling was high, and the large wall space provided extensive area for paintings, prints, and other works of art. Cab-

inets along one wall were used to store paints, brushes, and other materials.[31]

One section of the floor was covered by a tan and brown carpet woven by Maja Verde, the Swedish weaver; other areas were brightened by the striking colors of large Navajo rugs. The walls were hung with Sandzén's works as well as works of friends and other artists. There was glowing color in the paintings from the Grand Canyon and the Rocky Mountains, the charm of paintings and prints from Wild Horse Creek and the Smoky Valley, and attractive landscapes from Europe and Mexico. A few portraits, principally of Swedish immigrants, provided variety, and a Zorn print reminded Birger Sandzén of student days in Stockholm. The visitor to the studio was attracted also to other items: Chinese paintings, an Aztec God 1,000 years old, a Chinese Buddhist shrine featuring oriental woods and hammered iron, and old bronzes, pottery, and stone sculpture. Along one wall were hundreds of art books and literary classics, and the whole studio gave silent testimony to the achievement and interests of its kind and talented occupant.

Toward the eastern end of the studio stood the much-used easel; nearby were tubes of good quality paint and a large number of various-sized brushes, some worn down to the metal ferrule. On dark days illumination came from copper electric-light fixtures that augmented the highly prized natural light. A few comfortable chairs and three tables, one of considerable size, constituted the essential furniture.

But something else was there, something difficult to describe adequately; and it was there not only when Birger Sandzén, in the quietness of solitude, applied paint to canvas in order to create a testament of beauty but also when guests and visitors came to behold, almost with wonderment, the beauty and peace that surrounded them. A great quiet prevailed, even if the visitors were numerous, because the milieu called for quietness. Yet, again and again the quietness was broken as the good and great man answered a question or made a comment about the painting on the easel or shared his keen sense of humor. To be

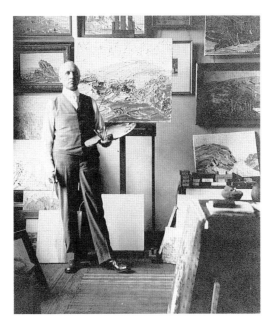

Sandzén studio interior

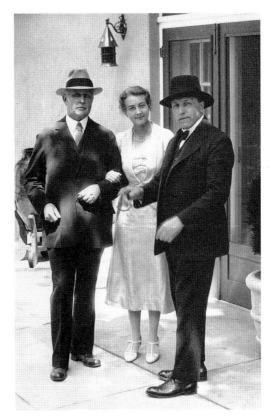

Birger Sandzén, Margaret Sandzén, and Carl Milles in front of Sandzén's studio

with Birger Sandzén in his studio was more than an experience—it was an event to be long remembered.

Several large leatherbound books were filled with the names and addresses of people who visited the Sandzén studio. They came from all walks of life and from all sections of the United States and from Europe and other continents. In 1938 Sandzén wrote to Carl Milles that 3,000 visitors had come to see Milles's *Little Triton* and view the contents of the studio.[32] Although Sandzén did not mention it, they had come primarily to meet the kindly man who was so dearly loved and esteemed.

Ordinary men, women, and children, unknown and unheralded, made up the majority of the visitors; but famous guests, such as Prince Wilhelm of Sweden, William Allen White, and Carl Sandburg, shared in the stimulating conversation and charming hospitality. When Sandburg returned to Chicago following his lecture at Bethany College, he wrote to Sandzén on May 22, 1923, from his office in the *Chicago Daily News* editorial room: "Thank you for that book, *'The Smoky Valley'* [volume of prints published in 1922]. It has the feel of that country as known to those who love it so well they can live and die in it with no regrets. It is poetry, this book is, and shall stand among the books I keep near by. You are one of the artists I expect to see battle on like an old timer of a Viking." Carl Milles's sixtieth birthday was celebrated in the studio and in the Sandzén home. College and community residents and many visitors, individually or in groups, were entertained there, and art history classes met regularly in the studio. If the walls could talk, willing listeners would be glad to hear their story.

10

Exhibitions and the Response of Art Critics

Although Birger Sandzén lived and painted in Lindsborg, Kansas, his works were exhibited at several major galleries and museums in the United States and in Europe. Art critics and other people in a wide area thus had an opportunity to view his paintings and prints, and their response is recorded fully and clearly in many newspapers and periodicals. Records indicate that Sandzén sent his paintings, water colors, and prints to more than 600 exhibitions, ranging from one or two items shown in a collective exhibition to one-man shows. In the United States his works were shown in at least thirty states and the District of Columbia; they were also exhibited on several occasions in Sweden and at times in Italy, England, and France.

Sandzén's works were presented in well-known museums and galleries that sponsored annual and special exhibitions involving long-standing traditions of excellence in art. His great and continuous interest in bringing art to the people where no such traditions and facilities existed, however, resulted in his works also being shown in a variety of other places—assembly halls, classrooms, churches, and commercial and public buildings. Improvised arrangements were made in a multitude of places in Kansas and elsewhere.

The first public exhibition of Sandzén's paintings occurred in 1893 when six of his canvases were sent to Göteborgs Konstfören-

ing (Gothenburg Art Society) at the urging of his former teacher Richard Bergh.[1] Although Sandzén exhibited on a modest scale at Bethany College shortly after his arrival there in 1894, 1899 is a landmark date because in spring of that year, Carl Lotave, G. N. Malm, and Sandzén organized a formal art exhibition at the college in association with the annual *Messiah* festival during Holy Week. The exhibition became an annual event; later known as the Midwest Art Exhibition, it is the oldest continuous art show in Kansas and the surrounding area. The works of past and contemporary artists were hung on these occasions, but Sandzén's paintings and prints were always featured.[2]

Sandzén's first one-man exhibition outside of Lindsborg was held at Martin's Art Shop, Wichita, about 1909; Ralph Martin brought Sandzén's paintings and drawings there at the suggestion of C. A. Seward, who had moved to Wichita after studying with Sandzén at Lindsborg. The Wichita public schools still have in their collection of Sandzén's works one of the canvases shown in this first exhibition, a gift from one of the graduating classes (see Plate 36).[3] Sandzén's works were also featured at the art exhibition of the McPherson city schools for about three decades, beginning in 1911 when George Pinney, school superintendent, supported by Carl J. Smalley, a McPherson art enthusiast and later

owner of the Smalley art shop, launched the first of a long series of annual exhibitions that brought large numbers of people to view old masterpieces, mainly etchings and engravings, and contemporary art. Sandzén was also always represented in the art shows sponsored by the Lindsborg public schools for many years.[4]

Sandzén's earliest participation in metropolitan exhibitions was sponsored by Swedish-American organizations. In 1905 he was represented by five paintings in the exhibition of the Swedish-American Art Association at Anderson's Gallery in Chicago, and in 1910 the Swedish Club of Chicago sponsored the first of a series of exhibitions by Swedish-American artists; the Lindsborg artist generally sent works to these shows.[5] An important result of Sandzén's association with these exhibitions was that he became known outside of Kansas. In 1914 and 1915 his works were hung in shows of the Chicago Artists Guild, in 1917 his work was shown for the first time at the Art Institute of Chicago, and in 1919 his prints were included in the exhibition of the Chicago Society of Etchers. He exhibited in Chicago intermittently for almost three decades, including one-man shows in 1918 and 1926, and he has been represented in about fifty exhibitions in the Chicago area. In addition, Sandzén participated in many exhibitions in Kansas City, Missouri, and the Kansas City Art Institute played an important role in his professional career. He first took part in an exhibition there in 1915; by 1940 he had been involved in twenty-five, including two joint events. He often lectured in Kansas City on art subjects, and he held a master class in painting under the auspices of the Art Institute in 1921. Sandzén's works were shown a number of times in Washington, D.C., beginning with a one-man show at the Washington Art Club in 1920. West Coast exhibitions included several shows in Los Angeles, Oakland, and San Francisco.

Early reviewers were almost unanimous in their response to the individualistic character of Sandzén's work. M. T. Oliver, writing in the *Chicago Sunday Record-Herald* in April 1913, set the theme for reviews in this early period: "Watching the shows come and go,

one becomes personally interested in the producers of certain distinctive works." Oliver thought that "it was certainly a unique situation that a foreigner would come to Kansas and produce such paintings of brilliant achievement," interpreting his new milieu and "standing quite alone in his brush work, employing pure color . . . mindful always of atmosphere, poetic and even dramatic at times, a painter who is a painter, first and last, individual."[6]

Mary E. Marsh referred to Sandzén in the *American-Scandinavian Review,* June 1916, in somewhat exaggerated language, as "an archrevolutionist against all formulas and rules, good or bad." In her further assessment she wrote, "He believes that each individual must discover or rediscover certain truths before these truths can mean anything to him. . . . The paintings and drawings of Sandzén, although directly inspired by nature, are never 'view' paintings. He shuns the panoramic atrocities affected by some of those who paint the mountain scenery of the West. . . . In summing up the work of this original painter, the thing which most impresses me is his utter lack of superficial cleverness, sentimentality and insincerity. By studying honestly and perseveringly the simple form and color of primitive landscapes, he has gradually learned the great fundamental principles of landscape design and color treatment."[7]

Sandzén's use of distinctive color soon attracted the attention of the art world. R. J. Block, describing *Arapahos, Sunset,* and *In the Painted Desert* (see Plate 10), wrote in the *Kansas City Star,* "These mountains have mass and contours. The color is intense and they hold the light. It vibrates a living vapor playing over rugged surfaces. There is about the pictures a swinging and adventurous freedom of the brush as if the artist was so sure of himself that he could preserve the white fires of creative excitement and still not go wrong in his labor."[8] Earlier, in reviewing the Sandzén exhibition at the Kansas City Art Institute, this critic had described *Hour of Splendor* (see Plate 35), which had won the S. W. Moore prize, as "a subjective expression of the Bryce Canyon, vivid in color with an organization in form which is wholly individual. . . . We are in-

clined to favor Mr. Sandzén's viewpoint; his stepping away from mere representation, his license to his subjective mind."[9]

The distinctive quality of Sandzén's paintings was frequently identified by critics. Leila Mechlin wrote in February 1917: "Birger Sandzén is essentially a modern and an independent, but in the best sense of these words. He draws and paints with force and individuality; he follows none. His pictures are personal interpretations rendered with much directness and great virility. He has something to say and he says it strongly. The Kansas country is not considered picturesque, but he has found it so, and has made others see its beauty. The Rocky Mountain region he has also found immensely attractive, and his pictures painted there set forth its beauty and bigness."[10]

Given Sandzén's enthusiasm about the Southwest as a source for his paintings, it is understandable that his works were exhibited there. In January of both 1918 and 1919 his paintings were shown at the New Mexico Museum of Art at Santa Fe. In 1918 the critic for the *Santa Fe Daily New Mexican* wrote that "Sandzén is represented by some of his best work—bold, self-assertive and splendid. As one gets near to the pictures, the canvas fairly reeks with paint, a jumble of mosaics that given the proper vistas melts into lush green meadows, majestic mountains, scintillating skies, blue glacial lakes, tall poplars and pines, a wonderful lesson in color and perspective [see Plate 12]."[11] The response to his 1919 exhibition was equally good:

His paintings hang in galleries abroad as well as in the United States and critics, even though they may quarrel with his technique, count him among the nation's leading landscape artists. . . . No other technique has thus far reproduced the feeling, the massiveness and ruggedness of the rock formations of the Rocky Mountains, of the Garden of the Gods, of the canyons of the Southwest, of the desert buttes as do Sandzén's paintings. . . . One may trace an increasing boldness in treatment from his earlier paintings. . . . The themes range from *Storm at Sea* [1918], to superb "Still Life" studies of flowers, whose scarlet vibrates against a still blue background. Included in the riches are a few landscapes from the Scandinavian Peninsula and de-

lightful pictures of forests and plains. It is an exhibit over which art lovers will linger for hours and visit day after day.[12]

The decade of the 1920s was a great era in the growing appreciation of the excellence of Sandzén's works. Laura Bride Powers, in the *Oakland Tribune,* was enthusiastic about an exhibition in San Francisco. After referring to it as "one of the big shows in the winter of 1920," she wrote, "It is glorified with color presentations of nature in her noblest aspect—the great planes of mountains rising from an enchanted valley-floor; strong-limbed tree lines against a brilliant sky that comes to gladden the earth in the fall and spring; sweeps of swirling water; mountain and plain in the purpling garments of lowering day—all tales of the West, told in strong sweeping strokes that never misfire. . . . How nobly he handles his color, fresh as dew."[13] At the same time, the art critic of the *Washington Star* described the Sandzén exhibition at the Art Club as being "out of the ordinary and exceedingly worthy of attention."

The colors used are rather vivid but they are superb and the work has the bigness of the country which is represented. The technique is peculiar and quite remarkable, but the paintings are structurally fine. . . . Furthermore, the colors, while vivid, are perfectly attuned and their values are nicely related. The effects, while startling, are intensely significant and the illusion of light and atmosphere is admirably set forth [see Plate 20].

The kind of simplification that one finds in these canvases is what the modernists have apparently sought but have, to the present time, secured only clumsily. It is the simplification of nature with a broad vision. It is founded on tradition and it has the basic qualities common with all great art. . . . It is modern. It is contemporary. It is essentially American. It breathes the spirit of the West and it opens new vision. Here is a painter who is worth remembering and whose experimentation must be regarded with utmost respect [see Plate 16].[14]

In January 1921 Effie Seachrest reported in the *American Magazine of Art* about her delightful visit to the Sandzén exhibition in McPherson, Kansas. In describing one room of his paintings of the Rocky Mountains she wrote: "His big overpowering, structural

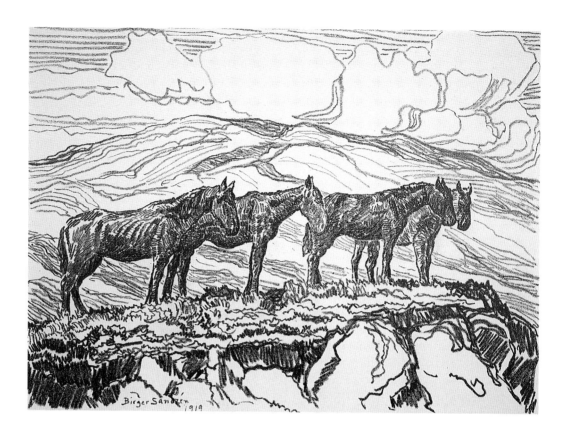

Figure 12

Horses in a Hilly Pasture
(1919) lithograph,
16 × 22 inches

treatment of rocks and mountains bathed in sunlight or flooded with moonshine, his glowing colors dashed on with an impetuosity that reminds one of his master, Zorn, arouse the critic's wonder and admiration and cause him to cry: 'Here at last is a true interpreter of the majesty and stupendous grandeur of the Rocky Mountains.' "[15]

In 1922 a one-man show was held at the Babcock Gallery in New York from January 30 to February 11. The exhibition included thirty-one oil paintings, twenty water colors, and forty lithographs (Figure 12) under the sponsorship of the American Scandinavian Foundation. Two people were mainly responsible for promoting this important event— Henry Goddard Leach, a longtime leader of the foundation and editor of *Forum,* and Christian Brinton, art critic and author. Brinton had seen some of Sandzén's works in the National Academy of Design in New York the previous year and had been greatly impressed, and he consulted Leach and William Henry Fox, director of the Brooklyn Museum, about the possibility of having a one-man show in New York. Sandzén was known to Fox through

some of his paintings that had been exhibited in the Brooklyn Museum, but the first plan, to present the Sandzén exhibition at that museum, did not materialize.[16] C. Babcock, however, owner of an art gallery, had seen a Sandzén painting owned by Ernest Davis, a Bethany College graduate and a well-known professional singer in New York, and had been enthusiastic about it. When Brinton approached Babcock about sponsoring a Sandzén exhibition, Babcock immediately consented, waiving the normal $600 fee. Leach provided $500 for a catalog, which Brinton agreed to write.

The Babcock exhibition received both praise and criticism, but with far more of the former. Henry McBride in the *New York Herald* observed:

Those who have encountered chance paintings of Birger Sandzén in the exhibitions will have a higher opinion of the artist after a visit to his show in the Babcock Galleries. . . . He paints with fiery, tempestuous colors quite unlike any native who has gone west to paint. As a rule the glare of the light in the Sierras and among the Rockies makes them blink, and they mix so much white into their color

to get the light that by the time they get back East they give the impression that there is no color at all in the West. But Mr. Sandzén is different. He says there is more color than light. He defies the Grand Canyon to do its worst, knowing that he has more vermillion in his color box than nature can afford to spend upon sunsets. . . . It is all very vehement, splendid and very western.[17]

A reviewer in *American Art News* wrote, "Reports coming from the Middle West that Sandzén was an artist of real magnitude are more than justified by the first comprehensive exhibition of his work shown at the Babcock Galleries. To those who know Sandzén only through an occasional canvas, a surprise is in store. His work in water color, woodcuts and lithographs . . . makes him stand out as a bigger and more rounded personality than even reports made him."[18] Peyton Boswell wrote in the *New York American*, "Since Kansas, Colorado, New Mexico, and California are the source of Sandzén's landscapes, it is only natural that they should be big and broad and abounding in color. But he surpasses all expectations of what such landscapes should be by the vigor of his technique, the rightness of his compositions, and the gorgeousness of his color schemes that burn as brightly as the face of those many-hued lands." Boswell was especially impressed with the canvas *Wild Horse Creek* (also known as *Creek at Moonrise* [see Plate 21]), which held all those elements in full. "However, Sandzén was not averse to portraying less dramatic features of the West as was evident in *Moonlight,* painted at Santa Fe in 1919. In *The Old Homestead* (1921) [see Plate 24], the painter has caught the melancholy atmosphere of the place."[19]

Lula Merrick observed in her review that "like Cézanne, he [Sandzén] has searched for 'significant form,' disregarding details and extreme realism, but with direct brushwork and a love of brilliant color has adapted nature to express artistic emotion." She liked especially the canvas *Afterglow,* painted at Manitou, Colorado, which was "brilliant, almost dazzling, with powerful trees and verdure of varied tones. . . . The observer will find sentiment and poetry enveloped in the great masses of pigment. . . . *In the Black Canyon* [1920]

[Plate 18] is more convincing of the vastness, the scintillant color and giant forms that one usually encounters in renditions of this subject because he has lived the rugged life of the locale, and has studied it in every phase. *Two Cedars* [1919] shows decided simplification of design."[20]

The Babcock Gallery exhibition of 1922 attracted art critics from cities other than New York, and the Boston art critic of the *Christian Science Monitor* was favorably impressed, expressing his response in interesting language:

[Sandzén's] pictorial array has startled New York like the banners of his ancestral Vikings. If anyone else has had such massive vision of the scenic West, it has remained cloistered, like Sandzén's, until now. Others have taken in wide horizons and have visualized mountain and plain with more or less force. Sandzén focused his powers on individual rocks, a clump of cedars, a snowbound approach [see Plate 31], a bend in a torrential creek, with far greater effect.

Sandzén so touches the imagination with isolated items that held him as to rouse in the beholder something of the art that must have beset him in his wanderings. . . . Here without mistake is the wild Nordic impulse, transplanted and recharged with the old vigor in the atmosphere of western America. It has brought a breeze from the West that has not been felt here before. . . . There is no actual sweep of scene in anything, but in everything the sense of suggestion is vast and profound.[21]

Among critics in the West, W. G. Bowdoin wrote, "Sandzén sees his motifs in a modern but not an ultra modern way, but he avoids, as he would a plague, any approach to the photographic idea. He carries his message with the highest confidence, which means conviction, and he does not seem to pause to find out whether his observers are for or against him. He is never hackneyed or conventional, and not having any convention to live down or hold him back, he dresses his Colorado trees and landscapes with ultra coloring and frequently with a most unusual pigment."[22]

Giuseppe Pellettieri, a European art critic who was in New York at the time of the Babcock exhibition, summed up his impression: "Birger Sandzén is a solitary who sits on a far-off mountain peak, enveloped in sunlight. He

is a Wagner driven to paint in order to express his vision. Although he is Swedish by birth and European by training, he is unique in that he is individual in method and viewpoint. He is the poet-painter of immense sun-washed spaces, of pine-crowned, luminous, gigantic rocks, and of color-shifting desert sands. . . . This dreamer-painter is truly a master."[23]

There were strong dissenting opinions about Sandzén's painting in the 1922 Babcock exhibition as well. The *New York Times* art critic observed that the paintings "have brilliancy and freshness and a loud, breezy cordiality of approach that immediately claims attention . . . but sometimes concealing defects of fundamental structure, but oftener merely expressing a singularly invariable mood. . . . With all deductions made, it is a manly and personal art, still struggling between reality and imaginative generalization, but firmly founded upon the study of nature in its grander aspects."[24] The interest of Hamilton Easter Field, art critic of the *Brooklyn Eagle,* had been aroused because, as he wrote, "for two or three years past it seems to me that no account of what was going on in the art world of the Mississippi Valley was complete if it did not contain reference to Birger Sandzén." Field offered both praise and criticism: "His best work is as near to being great art as any living American often gets, but he often loses his feeling for color, for arrangement, even for the relative values of different subjects as material to paint. There are things which are not paintable; others which lend themselves to painting. Sandzén's *Rocks and Snow* [1922] is thoroughly paintable, and Sandzén has known how to bring out the quality of color and the rhythm of the lines of construction magnificently [see Plate 25]."[25]

The most critical appraisal of Sandzén's paintings at the 1922 New York exhibition came from Royal Cortissoz in the *New York Tribune:* "[Sandzén] paints the rocky scenes of the West, great, picturesque masses, and there is no denying the largeness that he manages to communicate in his impressions of them. Unfortunately, he deals in a harsh, dry impasto and fairly brutalizes the surface of his canvas. . . . It is the familiar crudity of the Scandinavian school that robs his sincere, sweeping paintings of the beauty that so strong a temperament ought to secure."[26]

Ultimately, however, the principals involved with the exhibition were thrilled with the response. In March 1922 Brinton wrote to Sandzén, "The main result has been to give you an absolutely solid position in the East. Your exhibition which closes Saturday, both socially and professionally, made a really profound impression."[27]

A second Sandzén exhibition was held in the Babcock Gallery January 28 to February 9, 1924, and in the introduction to the catalog for this exhibition, Christian Brinton wrote:

It is a different Sandzén who greets us upon the present occasion. The themes are the same, the same strongly personal accent is there, but the aesthetic significance of this work has broadened and deepened. It is as though the artist, after his initial intoxication at the primitive sweep and power of the Western scene, had settled down to study it more intimately and more subjectively. . . . This work has in brief become imbued with that synthesis which alone makes for enduring art. . . . The oil paintings, water colors, lithographs and woodcuts here assembled represent the fullness of the present development. . . . Neither academic nor modernist, Sandzén resists all temptations toward standardization, and the various appeals of a clamorous sensationalism.[28]

Understandably, the second Babcock exhibition did not result in as many reviews as the one two years earlier when he was introduced to New York viewers, although the number was representative. *American Art News* reported, "As forceful and colorful as ever, his interpretations of the landscape of Kansas and Colorado continue to impress with their comprehensiveness. A broad technique—superlative broad—enable him to express the rugged spirit of the country he paints."[29] The *New York Times,* which had been critical of his works in the first exhibition, printed the following observation: "Birger Sandzén paints Western landscapes in splendid design, a little crowded, not too sensitive, in an unvarying mood in brilliant rather than restrained color."[30]

Sandzén's works were exhibited quite extensively in the decade following the two shows in New York. In Philadelphia, where

Sandzén was eventually represented in approximately forty exhibitions of various types and three one-man shows, the Art Alliance was the setting for one exhibition of his works in 1927; Francis J. Ziegler responded in the *Philadelphia Record:* "Sandzén's own individuality is so strong that a painting by him impresses itself on the memory and is not readily forgotten. . . . He is apt to handle the brush, whether it be dipped in oil paint or in water color, much as if it were a piece of chalk, building up his compositions with line rather than with masses, ignoring the half-tones and nuances of color. This does not sound very attractive in print, but the result of this method in Mr. Sandzén's hands is a virile, entertaining canvas or a strong water color."[31]

Basic elements of Sandzén's work were summarized during this period by Elisabeth Jane Merrill in the *American Magazine of Art:*

Sandzén's art is elemental. Breadth of vision and native vigor are mental qualities expressed in his work. One feels the fundamentals underlying the surface of his art—water colors, oil, wood engraving and lithography. Nearly always concerned with landscapes, he is a designer in the broad sense, with orderly arrangement of tones, measures and shapes. There is frequently a decided feeling for pattern but his design is not confined to the surface of two dimensions; the receding planes are as carefully arranged in linear pattern. In the feeling for design, a strong Scandinavian trait as we all know, Mr. Sandzén does not forget form. . . . In all media Mr. Sandzén expresses himself in a simple direct way. His work carries at goodly distances, not ostentatiously, but holding its place in strong individuality.[32]

Sandzén's paintings did (and do) induce a variety of responses, as suggested by the headline "Sandzén's Art as a Call for Courage," which appeared in the *Detroit Sunday News* in December 1931. After viewing Sandzén's work in the Detroit Institute of Arts, the observer wrote in the context of the growing gloom of the Great Depression, "The art of Birger Sandzén is a challenge to everyone who is tempted to give up the fight and take a tired view of life. For there is nothing weary about Sandzén; he is all force and vigor and brave assurance. To him, nature is seldom mellow, sleepy or sentimental, but always full of drama, color and power . . . color with him is something with a brave vitality; and line is always full of vivid movement, never inert."[33]

In March 1932 the walls of the gallery of the Kansas City Art Institute "were ablaze with color on the opening day of the Sandzén exhibition," but the writer in the *Kansas City Times* found more than vivid colors, observing that many of the landscapes had been "painted since his style took on new grace and subtlety and since his compositions became more rhythmical."[34] The *Kansas City Journal* described with pleasure the growing interest in Sandzén's paintings: "It is interesting to observe how gradually the work of Sandzén has come to grip the imagination of art lovers. In the beginning there was misunderstanding. But the painter never deviated from his course. Some shrugged their shoulders and said the work was freakish. Others were fascinated by his choice of color, his technique, his fancy. Yet Sandzén kept on with an admirable fearlessness in painting subjects that others would not consider. As a result today he enjoys an enviable reputation. . . . With each year he seems to have found a new power in his innermost being, which is the more remarkable, for Sandzén has served the cause of art with devotion and intelligence for many a moon."[35]

The popularity of Sandzén's works in Kansas City is demonstrated by the many exhibitions that were held there. When the William Rockhill Nelson Gallery opened in 1933, Sandzén was included in the "Loan Exhibition of American Painters Since 1900," he was represented in an exhibition in 1938, and in 1947 the Nelson Gallery sponsored a retrospective exhibition of his water colors. Looking back, a critic in the *Kansas City Star* in 1936 identified recent developments in the art world and at the same time indicated how Sandzén continued to put himself on the line of discovery for subjects of this art. In the context of the former he wrote, "There are times when one wonders if Sandzén is not the only great colorist surviving from the years when painters strove for color with all their might and when the most successful exhibitions were

those which provided their own illumination." He also pointed out the artist's interest in new subjects: "His two new canvases, *Mexican Mountain Town* (1935) [see Plate 43] and *The Land of Quetzalcoatl* (1935) had expressed with great success the radiance of the mountains of Mexico."[36]

The works of Sandzén were exhibited in the 1940s but not as extensively as in the previous two decades. At the beginning of the decade Philadelphia art lovers had an opportunity to view a comprehensive collection of paintings and prints at the American Swedish Historical Museum. The *Philadelphia Inquirer* reviewed the exhibition in considerable detail, recognizing Sandzén's achievement in still lifes and portraits as well as in landscapes:

There may be seen a large group of oils, water colors, lithographs and etchings [dry points], all created in the highly individual fashion by which Mr. Sandzén has been for some time familiar to Philadelphia gallery devotees. . . . In the glowing color qualities of his oil, in his rich impasto and methods of composition, especially in respect to trees, Mr. Sandzén is reminiscent of van Gogh. . . . The three oil still-lifes made up of fruit, flowers, pottery and vegetables, beautifully assembled, are among the most striking of these canvases, with their strong carrying power and their vividness. . . . The only portrait on view is that of *Pete Ellerson,* blue shirt accentuating the intense Norse blue of the man's eyes, and broad brimmed hat setting off a face which to most beholders will denote strength of character despite the Shakespearean dictum that "there is no art to read the mind's construction of the face [see Plate 44]."[37]

A few years later, in 1947, Florence Berryman in the *Washington Star* described Sandzén's painting as "a modern adaptation of impressionism" in a review of the exhibition at the International Gallery in Washington, D.C.: "He prefers to place pure color side by side so that their vibratory value is retained. He eliminated details, paints broadly and vigorously. Seeing Birger Sandzén's work one is reminded of his own words: 'Good art is the fruit of adequate craftsmanship and esthetics vision. . . . To interpret we must go deep, give ourselves, all our love, all our energy.' "[38] In the same year a writer for the *Santa Fe News,*

after viewing Sandzén's works in the New Mexico Museum of Art, observed, "The impressionistic landscapes of Birger Sandzén are masterly, beautifully rendered interpretations of nature. Here is a painter who has mastered a highly personal technique and employs it in the service of emotional and visual truths. The paint surfaces are rich, and the words of Fredrick Price written about the late Ernest Lawson apply to Sandzén: 'He paints with a palette of crushed jewels.' "[39]

Sandzén's works were shown in a number of exhibitions in Sweden. His first public showing in 1893 at Göteborg was followed by exhibitions in 1896 and 1923. His paintings and prints were seen in Malmö in 1920 and in joint exhibitions in Skara (1924), Uppsala (1934), and Lidköping (1937). Sandzén's works were exhibited in Stockholm in 1897, 1911, 1931, 1948, and 1957, with the important one-man show at Gummesons Konsthall in 1937.

Although no reviews are available for the earliest period, Prof. Evert Wrangel of Lund University discussed an exhibition of Sandzén's painting in that university city in 1912: "The unusual landscape in the interior of the American continent—dreary and immense—shows forth clearly. In his paintings Mr. Sandzén has become a follower of the school of the pointillists. His canvases are singularly interesting. . . . At the outset one is perhaps quite amazed at the unusual result, but soon one feels at home in the landscape. His red and blue tones give a fantastic impression, his trees are airy and illusory, and the cloud formations arouse wonderment. The American landscape has a completely different perspective from the European. The air is thin and light."[40]

In 1924 the art critic in *Skara Posten* found that "there is often something rugged both in the choice of motifs and in the technique of Sandzén's paintings. The individual who views his paintings hurriedly and superficially will not understand them. . . . He wishes to assist the viewer to perceive a full view of the greatness in nature . . . not only where he presents large masses of rock from wild nature in the Rocky Mountains but also when he paints rather small motifs like a few birches or pines

by a little forest lake. . . . His art rests upon the foundation of a sound realism."[41]

The art critic for *Skånska Dagbladet*, Malmö, presented interesting comparative views, based upon two exhibitions of Sandzén's work over seven years apart. In 1923 he wrote that the Lindsborg painter was "the outstanding participant in the Swedish Artists Abroad Exhibition in Göteborg" and described him as "an impressionist in life and spirit [who] unites great technical ability with sound understanding of nature." In 1931 the same critic wrote that "the evaluation which was given in 1923 applies today but in a greater degree. The sixty years behind him marks a steady forward and upward development." Sandzén was described as "different but he has had the courage to continue along on the path he has chosen." After pointing out that Sandzén was principally a landscape painter, the critic wrote, "He gladly chooses his motifs from the wild mountain districts with precipitous gorges between high ridges. These barren rocks shine in a mass of color as the sun blazes with its full power over them, while bluish-black shadows descend with little accents between the peaks. . . . His well-developed color sensitivity keeps the joyous color combination within reasonable boundaries, and regardless of how loud the chord rings, the notes are never false or shrieking."[42]

Sandzén's works at the Gummeson exhibition at Stockholm were received by a mosaic-like pattern of some praise, considerable wonderment, and much criticism. Large numbers of viewers came to the exhibition, and one writer described Sandzén's fine ability to capture the atmosphere of the prairies and to be inspired by the glowing colors of the Rocky Mountains, New Mexico, and Arizona, observing that "no one has reflected the poetry in the Kansas landscape, the greatness of the Colorado mountains, or the hidden beauty of the Grand Canyon like Sandzén. He presents in his paintings not only the motif, which has captured his attention but even his deep love for the land which he has made richer by his art."[43]

In seeking the sources for Sandzén's unique quality as a painter, the critic for the *Social*

Demokraten affirmed that Sandzén "was somewhat dependent on the education he received in *Konstnärsförbundet*, Stockholm. The synthetic-decorative style of his landscapes may very well have a certain connection with the influence of Nordström's [Karl Nordström, 1855–1923] and Kreuger's [Nils Kreuger, 1858–1930] paintings of the Varberg School. From a purely technical point of view he appears to me otherwise closest to our disciples of the French neo-impressionists whose tendency for breaking up colors according to the law of complementary colors, he also adapts himself to, perhaps with a little degree of coarseness."[44]

The Swedish critics struck unanimity on a variety of points. Hans Wåhlin stated that "the artist has a feeling for, and a creative response to the landscape. In contrast the color has a glaring and disharmonious tone. . . . The fault must in part be the Rocky Mountains; some water colors from Sweden are more pleasant. The best items are the lithographs which often produce a monumental effect."[45] Another Stockholm critic felt that "the paintings, designed to reproduce an excessive degree of sun, color and verdancy . . . have something about them that is parched and limited because of their uniformity,"[46] and similar criticism appeared in *Stockholms Tidning* and *Dagens Nyheter*.[47]

Carl Milles, in his introduction to the catalog of Sandzén's 1937 Stockholm exhibition, showed great understanding of the paintings and of the problems that confronted Swedish viewers. In prophetic anticipation of the response of Swedish critics he wrote, "When a native Swede comes into contact with Sandzén's paintings, he does not believe that the colors are true. Sandzén's fantastic bright colors are strange for Swedish eyes. . . . He has become the interpreter of the world he loves. Sandzén is not Paris, not even Sweden, but he is America [see Plate 29]."[48] Some years earlier Milles had written about his view of Sandzén's paintings, at the same time explaining why it was difficult for Swedes to understand fully his technique and use of color. "I wish to say that in landscape painting Kokoschka, the Hungarian [Oskar Kokoschka, 1886–1980],

Nolde, the German [Emil Nolde, 1867–1950], and Birger Sandzén are quite simply the great names in modern landscape painting." Milles agreed that "Sandzén's coloring is not like that of anyone else. In order to understand him one should have seen Kansas, Oklahoma and Texas, and most of all the Grand Canyon and the wild region from which he so gladly chooses his motifs. . . . The coloring which one meets there is so amazingly yellowish-red that it almost seems to be brighter than the sunlight." He pointed out that on automobile journeys he had increasingly to convince himself that it was not a hallucination when he took the soil in his hands because it gleamed so brightly. "The rugged mountains, the bright sunlight and the unusual colors created the sources for Sandzén's painting."[49] This milieu was unknown to Sweden and the Swedes.

Well-known Swedish art historians have evaluated Sandzén's works over the years. Folke Holmér, art historian and former curator of the National Museum in Stockholm, has referred to the influence of Sandzén's early years with Anders Zorn, Richard Bergh, and others at Konstnärsförbundet and also stated that "Sandzén can be said to be the original transplanter of Scandinavian landscape poetry in the spirit of the Varberg School to the rugged scenery of the Rocky Mountains. . . . As a painter he is revealed as a cultivated pointillist, more radical and more of a worshipper of light than the pointillist Kreuger in Sweden. His painting radiates the spectrum incisively and ringingly."[50]

The comprehensive and authoritative *Svensk konstnärslexikon* (Swedish Art Encyclopedia), appraises Sandzén's painting: "He never draws away from what is experienced in nature but magnifies the expression of nature through vigorous line formation and a highly exuberant palette. This is a nationally romantic, gripping, magnanimous art, which has taken into consideration the implications of the Varberg school of painting in the decidedly more rugged Rocky Mountains. He sought to capture this character in a definite and clear vision which required great effort, but above all he wished to grapple with the light and color."[51]

Retrospective exhibitions of Sandzén's work in 1985 at the Ulricehamn Museum and the Länsmuseet, Skara (see Plate 19), were enthusiastically received and widely reported in the Swedish press, and the response to his works was more favorable then than in 1937. Bertil Andrén, for instance, presented a comprehensive and sensitive review. At the outset he cited the importance of Sandzén's association with Anders Zorn and the Konstnärsförbundet's "spirit of freedom in painting in contrast with the conventional academic emphasis. Proof of it is found in the lustre of the vivid colors in Sandzén's charming portrait, *Fröken Rosenqvist* [1893]." Andrén emphasized the French influence in the artist's distinctive use of color, especially the impact of Seurat. During his Paris stay, "Sandzén had developed strengthened use of light," and according to Andrén, this change resulted in "the emergence of a technique more radical than that of his former Swedish associates. It appeared in an intensified form whereby the otherwise sturdy brush strokes received a virulent van Gogh-like character." Andrén then turned to the developments following Sandzén's emigration to America: "This was clearly a time of artistic adjustment, with new colors, in responding to the new and strange forms of nature. The use of color became increasingly intensified." Some of the early canvases with only a few trees "give an impression of uncertainty and a sense of strangeness." Yet by the beginning of the second decade of the twentieth century the view had cleared, and the motifs had gained in form and beauty. "The strong French influence is again apparent in his canvases as illustrated by the iridescent character of *Morgonrödnad över heden* [Morning Redness over the Moor]." The critic believed that the Rocky Mountain landscapes of the 1920s and early 1930s brought Sandzén's painting to its climax: "Sandzén uses the strongest color effects and the most decisive brush work in response to his exciting impression of nature. But it does not result in an anarchic whirl of structure and color. The mass dynamics is tightly disciplined within the boundaries of the motif. The entire effect is a lofty, symphonic-colored landscape which

resounds in a major key like a hymn to nature's greatness and beauty."[52]

Other newspapers described various aspects of Sandzén's works. *Ulricehamns Tidning* pointed out that the exhibition was organized chronologically, thus showing the artist's growth "from modest originality to the period of his maturity, with his confident commitment to expressionist color. The monumental work that Sandzén created in the early 1930s used color that reminds the viewer of van Gogh."[53] Rune Larsson, editor of *Borås Tidning,* was pleased that "through a wide selection of Sandzén's paintings we can follow the development of his distinctive individuality as he became a pointillist. He was also a fine water colorist and print maker."[54] After citing the high points of Sandzén's career in Sweden and America, *Stockholm Dagens Nyheter* affirmed that "he developed a style of van Gogh and used colors that are reportedly found in the Rocky Mountains."[55] The writer in *Skaraborgs Läns Tidning* referred to a "fantastic exhibition" after viewing the paintings and prints at the Länsmuseet at Skara, concurring with the American critic who wrote, "One is almost overwhelmed by the enticing beauty of Sandzén's paintings. This dreamer is truly a master."[56]

In addition to the Swedish exhibitions, Sandzén's paintings and prints were represented in the Palace of Fine Arts, Rome, in 1924 and 1926, at the Uffizi, Florence, in 1927, and in the American Pavilion in Venice in 1923. His works were also included in Paris exhibitions at the Bibliotheque National, 1928, the Salon des Tuileries, 1933, and the Salon des Artistes Francais, 1937.

But it was in Kansas that Sandzén's works were exhibited most extensively. Besides the annual shows at Bethany College and McPherson, many one-man shows were held in Kansas cities and at colleges and universities, especially at the Wichita Art Association, the Wichita Art Museum, and Kansas State University, Manhattan, where Sandzén had several close friends and admirers. Available records indicate that people in approximately 100 towns and cities in Kansas had the opportunity of viewing Sandzén's paintings and prints, often in one-man shows, when the artist would be present and would also deliver a lecture on some phase of art.

Bethany College has provided annual and permanent exhibitions of Sandzén's works from the 1890s to the present. The Midwest Art Exhibition every year during Holy Week has been a central factor, and the Swedish Pavilion provided exhibition space for many years until the dedication of the Birger Sandzén Memorial Gallery in 1957. A memorable retrospective showing of ninety-three oil paintings, fifteen water colors, and ninety prints and drawings was held in 1971, commemorating the 100th anniversary of Sandzén's birth, and in 1981 his lithographs (209 in all) were exhibited for the first time.

A representative and comprehensive retrospective exhibition of Sandzén's oil paintings was held at the Wichita Art Museum, May 4–June 9, 1985, under the leadership of Howard E. Wooden, director, and a catalog with a splendid forty-page essay was written for the occasion by Howard DaLee Spencer, curator. Eighty-five oil paintings dating from 1893 to 1953 had been assembled, and the catalog provided biographical data, a description of Sandzén's career as a painter, and a discussion of the development of his technique, use of color, brush work, and so on. Valuable commentaries about the paintings represented by illustrations in the volume present interpretations that contribute to greater knowledge and understanding of Sandzén's works. This publication, *Birger Sandzén: A Retrospective, Essay and Catalogue,* is the most meritorious work about Sandzén of this type that has been published.

Although more oil paintings than water colors are found in the legacy that Sandzén has left, he painted a substantial number of water colors with excellent results. The subjects were very much like those of his canvases, and the technique was similar except for the striking differences found in the other medium. His water colors were exhibited occasionally in one-man shows, and they formed a vital segment of exhibitions that also included his other works.

A representative selection of water colors

formed one section of the Babcock Gallery exhibition in New York in 1922, and Peyton Boswell wrote in the *New York American,* "That [Sandzén] has delicacy of touch, as well as strength, is shown in his colors. The blue and white of *The Breakers* is washed in with unerring accuracy and his mountain studies show how color and form can have the same quality in spite of bulk and kaleidoscopic variety. . . . The twenty water colors reveal not only supreme command of pure wash . . . but a delicate sense of color perception as benefits this medium."[57]

Critics have often cited *The Breakers* as a fine example of Sandzén's achievement in water color. Robert Eskridge in the *Chicago Herald-Examiner* in 1918 made an interesting comparison of this water color with a lithograph of the same subject: "The water color gains by use of color, which is handled with great restraint though with much force and decision. Pure color subordinated to line gives to this water color rhythmic distinction, while the lithograph displays the fundamental use of line in a masterly fashion."[58] Several years later the art critic of the *Kansas City Times,* in reviewing a Sandzén exhibition at the Kansas City Art Institute, compared Sandzén's oil paintings and water colors: "The colors in the latter are more kaleidoscopic and more resonant than in the oils and the sense of form is pronounced. There is unerring grace . . . and in the mountain views, bulk so majestic that the delicacy of the color nuances brings surprises."[59]

Sandzén's participation in an exhibition at the Pennsylvania Academy of Art, Philadelphia, in 1920 attracted the attention of C. Charbrier, who wrote in the *Revue du vrai et du beau arts et lettres,* "I highly admired a series of water colors by Birger Sandzén. They are works of agitated execution, at once free and very expert, full of vigor and of an uncommon virtuosity. They have in them great character, original and very personal impressions, a very beautiful feeling for nature; there emits from them a sober but very powerful and picturesque eloquence, a profound and infinitely engaging emotion."[60] Two years before the first New York exhibition in 1922, Laura

Bride Powers commented on Sandzén's water colors, exhibited in a one-man show in San Francisco: "In the current exhibition there are several charming *aquarelles* treated in the same broad manner of the oils, revealing even more clearly the painter's sense of design, or pattern. Indeed in some of these is a feeling of orientalism in the design, and a rhythm that is suggestive of the old Chinese forms."[61]

In 1927 Elisabeth Jane Merrill described Sandzén's water colors in considerable detail by selecting two of his works in this medium:

In *The Foothills* [c. 1922] he has given a masterful rendering of brute mass lifting itself up through its reaches of glowing color; the mountains and a few boulders, that is all, but what immovability, what strength are portrayed. The rocks are in orange key, singing against the mountain, dark and blue in shadowed and distant parts, highlights strong in color, here and there tones of violet. . . . Entirely subordinated to the theme is the sky with clouds expressed by strokes of color on the white paper. Who could paint such a subject but one big enough to be attuned to the theme, with the technique masterly enough to render it so as to be seen and felt by others?

In *Birches by the Sea* [1924] the white of the paper does duty for the silver trunks, the horizontal grain being indicated with intense vermillion and cobalt blue. Tree-top green and orange tones of boulders, stand colorfully against a sea of varied blues, distant violets, and a sky much the same in tone, the whole washed on broadly with sure, loose technique.[62]

The Sandzén Retrospective Exhibition at the William Rockhill Nelson Gallery, Kansas City, Missouri, in 1947 presented works in various media, and the twenty-three water colors elicited favorable responses by a writer for the *Kansas City Star,* who emphasized "the usual Sandzén vividness" and observed that "a strong portrait of the gaunt lean head of *Rene Costa*" was especially interesting.[63] A Sandzén exhibition in the following year at the Santa Barbara Museum of Art also pleased the local art critic, who commended the water colors: "The pictures are painted in strong washes of rather vivid color which imparts a feeling of brilliance in light which pervades the patterns and the masses of trees, gigantic rocks and the

other forceful attributes of the mountain terrain. Sandzén understands the merciless rain of light on the mountain country, the unbelievable bulk of rock structure which also measures the scale of the country. . . . His painting hinges between Impressionism and a kind of Expressionism, both of them absolutely personable."[64]

Special recognition must be given to the singularly remarkable achievement of Birger Sandzén, who sent so many of his paintings, water colors, and prints from the small town of Lindsborg to famous museums and galleries and to lesser known places, doing so without a professional agent and without the support of a local metropolitan press. Friends and reviewers responded with their support, and recognition increased, but the gratifying result was really an incredible personal effort by the Lindsborg artist. It was accomplished, moreover, in the midst of a busy schedule of teaching, lecturing, and writing and with no secretarial help. The record books of exhibitions and extensive correspondence of all types are in his own handwriting. Often he packed the materials for exhibition himself and carried them to the post office for mailing, although for the larger exhibitions of later years he was assisted in the preparation for shipping by two loyal Lindsborg men, John Altenborg and Carl A. Teed.

The most common pattern of Sandzén's participation was the showing of one to three paintings, water colors, or prints, though frequently a larger number were shown. Available records indicate that one-man shows were held in the following cities, exclusive of many places in Kansas, and at a large number of colleges and universities in various sections of the United States: Chicago (five); Cranbrook Foundation, Bloomfield Hills, Michigan; Dallas; Denver; Des Moines; Detroit; Fort Worth; Grand Rapids, Michigan; Houston; Jamestown, New York; Kansas City, Missouri (five); Los Angeles; Madison, Wisconsin; Memphis; Mobile; Milwaukee; Muskegon, Michigan; New York (two); Oakland; Omaha; Philadelphia (four); Pittsburgh, Pennsylvania; Rochester, New York; Rockford, Illinois (two); Santa Barbara; San Francisco (three); Santa Fe (two); and Washington, D.C. (two). Joint exhibitions were held in Chicago, Santa Fe, Kansas City, and Wilmington, Delaware.

Sandzén was a member of several societies and clubs related to painting, including the American Water Color Society, the New York Water Color Club, the Philadelphia Water Color Club, the California Water Color Society, and the Society of Independent American Artists. He was an associate member of the Taos Society of Artists, in which full membership required residence in Taos. He was the founder and a member of the Prairie Water Color Painters and the Smoky Hill Art Club. He served as honorary president of and was extremely active in Delta Phi Delta, the national honorary collegiate art fraternity.

Honorary degrees were conferred upon Sandzén by Augustana College, Rock Island, Illinois; Midland College, Fremont, Nebraska; the University of Nebraska, Lincoln; and Kansas State University, Manhattan. He was made a Knight of the Royal Order of Vasa by the King of Sweden for his promotion of cultural relations between Sweden and the United States.

Sandzén's oil paintings and water colors are found in the galleries of many public collections, including the Brooklyn Museum; the Museum of New Mexico, Santa Fe; Kansas State University, Manhattan; the University of Kansas, Lawrence; the University of Nebraska, Lincoln; the University of Oklahoma, Norman; the University of Rochester; the University of Tulsa; Utah State University, Logan; Wichita State University; the Wichita Art Association; the Wichita Center for the Arts; and the Nelson-Atkins Museum of Art, Kansas City, Missouri. Oil paintings and water colors can be viewed in Sweden at Göteborg Konstmuseum; Lidköping Museum; Lund University; the National Museum, Stockholm; Smålands Museum, Växjö; and Millesgården, Lidingö. The largest collection of Sandzén's paintings and water colors is found in the Birger Sandzén Memorial Gallery, Lindsborg. The Richard Gordon Matzene Collection in the Ponca City, Oklahoma, Public Library contains a goodly number of Sandzén's oil paintings. Additional information about Sandzén's paintings and prints in selected public collections is listed in the Appendix.

11

The Graphic Work

Although Birger Sandzén is best known as a painter, he also did fine graphic work, creating 209 lithographs, 94 block prints, and 38 dry points. Landscapes formed the principal subject matter, but he produced a substantial number of still lifes and portraits as well.

Sandzén's first lithograph was made in 1916. In a letter to Evelynn Johnson (Mrs. Theodore W. Anderson), a former student, in February 1916, he described the background factors: "There are hardly any of my charcoal drawings left, but I have something new which I know will interest you. I have done two experiments in lithography and I am glad to say they are a perfect success. Carl Smalley, a good friend from McPherson, has been after me a long time to do some work of this kind. When I did not get started quickly enough, he bought an outfit of lithographic crayons and sent it to me. I drew two landscapes—*Colorado Pines* (1916) and *Dry Creek* (1916) [Figure 13], sent them, or rather Carl Smalley sent them to a lithographic printing house in Philadelphia, which transferred them on stone and made proofs, which I received a couple of days ago."[1] This interesting statement is verified by Carl Smalley's article in the *Print Connoisseur:* "In February 1916 I asked Mr. Sandzén to make some lithographs for me as I had long felt that he could easily become a master of this medium. In a short time *Colorado Pines* and *Dry Creek* were ready. During that year nine

lithographs were made including the much sought after *Solitude* [Figure 14]."[2]

The success of Sandzén's early lithographs encouraged him to develop this medium. In November 1916 Joseph Pennell (1857–1926), a famous English printmaker, wrote a letter to R. G. Leinroth, manager of Ketterlinus Lithographic Manufacturing Company, Philadelphia, who had sent a group of Sandzén's lithographs to Pennell in London. The printmaker wrote, "I am very glad to have Mr. Sandzén's lithographs—save Stearns—they are the only ones I have seen done in the United States which have any character—and these have—and I shall send them to the next exhibition of the Senefelder Club, which opens early in January. . . . Send more Sandzéns."[3]

Sandzén's lithographs soon attracted the attention of art critics. R. J. Block especially appreciated the graphic work in an exhibition at the Finlay Gallery in May 1916, writing that "the lines were reminiscent of Forain [1852–1931] and Daumier [1808–1875] in its refined power" and "the power of drawing gives a good deal of illumination." There was "something reassuring in the knowledge that Western artists are not remaining satisfied with the obvious form of art, the easily accepted ones, but are turning their attention toward forms of expression that add richness and variety to the field of art."[4]

Responding to the Sandzén lithographs at

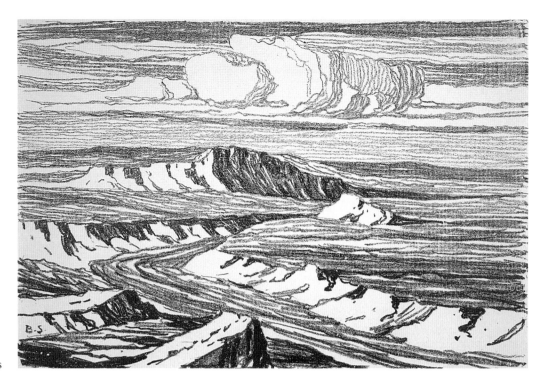

Figure 13
Dry Creek (1916)
lithograph, 12 × 18 inches

Figure 14
Solitude (1916) lithograph,
7 × 10 inches

Figure 15
Road in the Wilderness
(1918) lithograph,
16 × 24 inches

the Art Institute of Chicago in May 1918, Robert Eskridge of the *Chicago Herald-Examiner* compared him with Cézanne (1839–1906), van Gogh (1853–1890), and Pissarro (1830–1903) "in the freedom from academic restraint." *The Breakers* received commendation "for its use of line in a masterly fashion." Moreover, "Sandzén has gradually developed a style and means of expression that has won him an enviable place on the roster of artists who are adding to the mental as well as the artistic treasures of the age."[5] The art critic of the *Chicago Tribune* complimented Sandzén as "a believer in the divine right of artists to know no kings, no masters and to be restricted to no limited sphere in their visualizations of the wonders of the world."[6] Mary E. Marsh pointed out that Sandzén's *Gray Day in the Mountains* "expresses much better than words the mastery of form and the feeling of strength which are typical of his best work."[7]

The 1920s provided unusual opportunities for Sandzén's lithographs to become widely known. Two volumes, *The Smoky Valley* and *In the Mountains,* published by Carl J. Smalley, provided representative reproductions of Sandzén's work in this medium. In 1922 and 1924 the important exhibitions in

the New York Babcock Gallery and shows in other cities in the years following introduced his lithographs to many people (Figure 15). The lithographs in *The Smoky Valley* were described by William H. Downes in the *Boston Transcript* in 1923 as "admirable to an unusual degree." Interestingly, he compared the poetry of T. S. Eliot to the art of Sandzén: " 'I will show you fear in a handful of dust,' wrote T. S. Eliot from the arid region of his much debated *Waste Land*. But his is a sophistication that does not know the healing winds and the strong sunlight of the prairie. Birger Sandzén, on the other hand, instead of being involved in the debris of the old world ruin, with the hardy spirit of the pioneer seeks strength and sinew from life in the open among Kansas' hilly pastures and rolling acres. Eliot's *Waste Land* represents the mental and moral disintegration of European chaos, while Sandzén's art has all the simplicity of the man who lives near the soil and roots of growing things." Downes added that the lithographs, "though sometimes representations of bold rocky table lands that seem suspended midway between heaven and the earth, are conceived in no spirit of dismay that sees 'only a heap of broken images where the sun beats' but in the

Figure 16
Pines and Foothills (1922)
lithograph, 7 × 10 inches

hardy spirit of the explorer who has at length found a vantage point from which to gaze forward."[8]

The New York Babcock Gallery show in 1922 introduced forty Sandzén lithographs to a new circle of viewers. Peyton Boswell wrote that "the artist's water colors establish Sandzén's distinction as an artist; and yet he adds effect to effect, power to power, by his lithographs and wood cuts."[9] In the *American Art News,* which Boswell edited, he pointed out, "Vigor and breadth of lines are the dominant notes in the woodcuts and lithographs."[10]

After viewing Sandzén's lithographs in Chicago in June 1923, Margaret Williams wrote in the *Chicago Daily News,* "Anyone who thinks that we have no strictly national art which has come out of the West should examine the lithographs and woodcuts on display this month at Rouiller's Gallery." She was impressed with "Sandzén's complete mastery of the medium, imparting a beautiful quality of living line that has given his works technical charm" and wondered "if this artist's fame will not some day depend on his prints rather than on his paintings."[11] The *New York Times,* in reviewing the 1924 Babcock Gallery exhibi-

tion, appraised Sandzén's prints: "It is in the black and whites, with a vigorous suppression of detail, that he translates a spacious West of powerful rocks and mountains [Figure 16]."[12]

Further interest in Sandzén's lithographs was stimulated when Carl J. Smalley published his second volume, *In the Mountains,* which included nineteen reproductions of lithographs of subjects in the Rocky Mountains. Included were the well-known *Solitude, Gray Day in the Mountains,* and *Cathedral Spires.* In her review of the book, Lena M. McCauley emphasized that just as a Sandzén painting "carries a personality, his sense of color and his personal way of picturing what nature represents" so also "his lithographs hold their individuality in as strong a sense with contrasts of shades of black and white." She found that in "turning leaves of the book the Rockies seemed to loom outside the windows. . . . Expressing the dramatic aspect of the mountains in a bold fashion there is an endearing fascination in the pictures which leads us to look again and again. . . . Mr. Sandzén is favored by the gods of art in that he can picture in a way of his own that which means so much. It is comparable to

Figure 17
Glimpse of the Grand Canyon
(1918) lithograph,
16 × 24 inches

an epic poem, stately in its content and in its measures."[13]

Elisabeth Jane Merrill described Sandzén's lithographs in a feature article in the *American Magazine of Art* in 1927: "In the world field there are few whose landscapes in lithography would bear comparison with those of this artist. His line is virile; his values are rendered with understanding, his blacks are rich. His arrangements of light and dark create design, strong enough though sometimes combined with delicacy of tenderness [Figure 17]."[14] She discussed in considerable detail Sandzén's greatly admired lithograph, *Giant Cedars* (Figure 18), finding in it "the portrayal of great strength. The great trunks of cedars in various planes of light and dark express the elemental, akin to the wind against which they have buffeted many years." Merrill was impressed by "how understandingly he has set down each change of tree surface and tree angle in tortuous accent, how beautifully felt are the tree masses and open spaces. . . . [It is] a powerful composition set forth in excellent draftsmanship with clear sensing and rendering of value." She also identified a special trait in his lithographs, "the artist's ability to design a landscape, subordinating everything else to that

which is of supreme importance" and related this quality "to what some of the great Orientals have accomplished in other media, in the grasping of character essential in great trees and other nature forms and in the forceful rendering of this character in the natural form through strong design."[15]

Almost one-half of Sandzén's lithographs (103 of 209) were created during the first decade of his use of this medium. They were made on limestone, grained or sensitized zinc plate, or transfer paper, and the quality continued to be on a high level. Later subject matter, structure, and technique were generally in keeping with that of the first decade, and enthusiastic reviews continued although his work was not exhibited as extensively as in the earlier period. His last lithograph was completed in 1952.

Willard Hougland described Sandzén's *Temple of Quetzalcoatl* (Figure 19) as "a masterful production of a finished artist and technician. I wonder if any artist, other than Sandzén, will ever be able to flood a black and white print with as much sunshine as he has put into his prints of Kansas, Colorado, and Mexico."[16] In 1945 Florence Berryman commented on Sandzén's lithographs at the Inter-

Figure 18

Giant Cedars
(1922) lithograph,
22 × 16⁷/₈ inches

Figure 19

Temple of Quetzalcoatl
(1935) lithograph,
16 × 20 inches

national Gallery in Washington, D.C.: "But admirable as are his paintings, some critics feel that he has perhaps reached his pinnacle in lithography. His forceful direct line, his sensitive rendering of values, rich blacks, effective contrasts and patterns of light and dark, give his prints much distinction. Trees and rocks, mountains and rivers, skies and clouds are his subjects." She also remarked on a new element in his work: "In the present show there are several lithographs done in Mexico, in which architecture with old world charm and picturesqueness is captured as surely as the unadorned face of Kansas and other parts of the West."[17]

In 1916 Sandzén began experimenting with woodcuts. In September of that year the *Lindsborg News-Record* reported that

Professor Sandzén has recently added the fascinating art of wood engravings, or woodcuts, as they are commonly called, which were exhibited some time ago here in Lindsborg. He decided to try his luck with this difficult medium. His first two experiments, of which the second, a decorative Colorado landscape entitled *Pines* [1916] [Figure 20] was finished last week, were decidedly successful and will be shown at the coming fall exhibition here at Lindsborg and at several other places. . . . For the benefit of other artists who wish to experiment with wood engraving we wish to mention that splendid tools are being made here in Lindsborg by Hall Olof Olsson or "Dal-Olsson" as we generally call him, and that Paul Gustafson of the *Lindsborg News-Record* will print the engravings on most artistically and carefully selected paper. Early copies were printed in the Sandzén kitchen when the artist stepped on the block, since he had no press.[18]

In making block prints Sandzén usually selected hardwood, but he also enjoyed working on the surface of heavy linoleum (Figure 21). Although many prints were made with the end of a nail (Figure 22), the majority were fashioned with a V- or U-shaped burin manipulated with bold and powerful strokes, which, according to Pelham Greenough, gave "something of an oriental flavor to the print. There is a rhythmic vitality about many of the prints that brings to mind the linear rhythms of some Chinese art."[19] Between 1916 and 1925 Sandzén produced more than half of the block

Figure 20
Pines (1916) woodcut,
15$\frac{1}{2}$ × 10$\frac{7}{8}$ inches

Figure 21

Republican River (1945)
linoleum block,
12⅛ × 16 inches

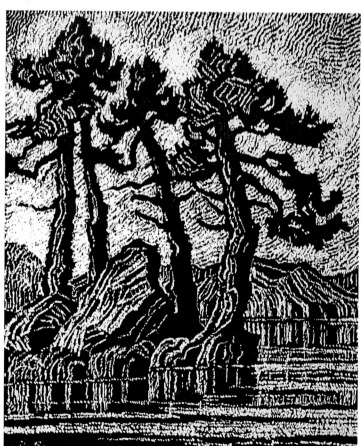

Figure 22

Lake in the Rockies (1921)
woodcut (nailcut),
11⅞ × 9¹⁵⁄₁₆ inches

prints that he created during his lifetime (forty-nine of ninety-four); his first linoleum block print appeared as one of three in 1921—he made a total of forty.

Sandzén's block prints gained fine recognition in a wide area. According to Elisabeth Jane Merrill, "In the wood engravings one especially feels the art of the designer. As the composer uses little themes in a variety of ways, the designer uses simple lines and masses, repeating, inverting, balancing them, achieving results that are fresh, new and beautiful. . . . His *Sentinel Pines* (1919), outposts of tree growth, stand alone on a high rolling plateau, gnarly trunks and branches strongly expressed, foliage masses and open spaces, forming patterns against the billowing clouds."[20] A few years earlier, Robert Eskridge had expressed his esteem for Sandzén's work: "In a wood block called *Late Moonrise* [Figure 23] there is expressed by the simplest means a mood that is delicate and vital in its appeal. This is perhaps the finest in his wood blocks and ranks among the greatest achievements in that art."[21]

Malcolm Salaman, an English authority on modern prints, reproduced Sandzén block prints in his two volumes *The Woodcut Today* and *The New Woodcut.* In the first volume Salaman wrote, "When we turn to Professor Birger Sandzén's startling impressive print *The Great Spires,* we are face to face with a very virile artistic personality, a great natural subject and a new technique to interpret it." He found it interesting "to compare *The Great Spires* [Figure 24], pictorially defined by the vibrant accents of light, with the splendid lithograph of the same gigantic rocks, *Cathedral Spires,* made four years earlier.[22] In *The New Woodcut,* Salaman wrote about Sandzén's "interesting personal touch whether as a painter, lithographer or wood engraver. His technique on the wood is curiously interesting, for he appears to use some sort of roulette to flick out the wood in curved series of dots until the picture takes shape with an atmospheric impression. *The River Nocturne* (1928) has been personally felt as it is expressed with a new strangeness. This is typical of Mr. Sandzén's expression but there are fresh motifs in *Sentinel Pines* (1919), *Summer* (1922) [Figure 25], and *Smoky River at Twilight* (1920)."[23] Margaret

Greenough recalls that when she was invited to tea in Salaman's London apartment in 1933 the drawing room contained prints by famous artists, including a Sandzén lithograph on a special wall, and that Mr. Salaman verbally expressed his admiration for her father's work.[24]

Sandzén had made an intensive study of the history and process of lithography prior to producing his first lithographs in 1916, and the results of that study were summarized in a Swedish article "En Renaissance" (A Renaissance) published in that year.[25] In it, he traced the background factors in the discovery and development of this important art form by Alois Senefelder (1771–1834) in Munich. A landmark in that history was the publication in 1818 of Senefelder's important volume, *A Complete Course of Lithography,* which described the process fully. Sandzén was certain that there would be a great future for lithography, pointing out the current revived interest in creating lithographs. Realizing the potential of lithography, he won wide recognition for his achievements in that medium.

Sandzén's interest in making woodcuts in 1916 was followed two years later by his first dry points. In March 1918 he wrote to his friend and former student, Oscar Jacobson, "I have done my first two experiments in etching dry point on zinc plate. They turned out quite well. The printing was done in Chicago since I do not have a press here. Sometime in the future I may get a press."[26] These first two dry points were *Light and Shadows* and *Rocks and Clouds;* Sandzén used this art form for the last time in 1938 after making thirty-eight dry points. Pelham Greenough believes that his best ones were made on copper. The subject matter was typical of his paintings and other print forms. Although the dry points are interesting by way of contrast with his paintings, lithographs, and block prints, they do not attain the quality associated with his other work. Two dry points are illustrated in Greenough's volume on Sandzén's graphic work—*Green River Rocks* and *Red Rocks and Cedars* (Figure 26).[27]

Critics who viewed exhibitions of Sandzén's drawings were generally favorably impressed. Evert Wrangel of Lund University observed in 1912 that "his drawings are in a

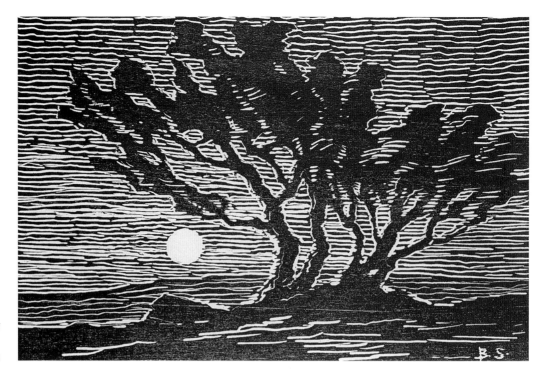

Figure 23

Late Moonrise,
also known as *Evening*
(1917) woodcut,
5¹⁵/₁₆ × 11¹⁵/₁₆ inches

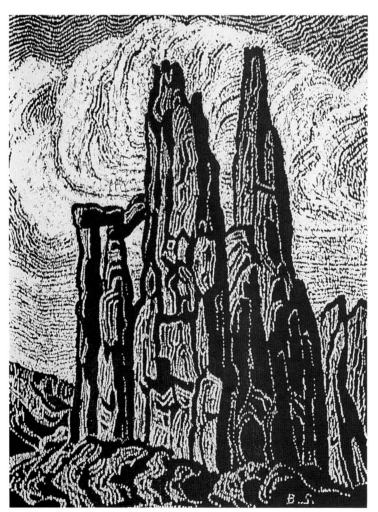

Figure 24

The Great Spires (1922)
woodcut (nailcut),
15¹⁵/₁₆ × 12 inches

Figure 25
Summer (1922)
lithograph, 7 × 10
inches

firm stroke style showing a certain eye and sure hand."[28] Twenty-five years later, a Stockholm critic commented that "Sandzén's ability in drawing is powerful."[29] American critics also praised Sandzén's drawings. A Chicago writer in 1918 declared, "The essential thing in Mr. Sandzén's art is his knowledge of the use of line,"[30] and when his drawings were exhibited at the Kansas City Art Institute in 1920, the *Kansas City Star*'s critic responded by describing *Pawnee Creek:* "The delicacy of his treatment of cloud forms, the firmness of the rolling land and the fissured clay banks prove that he is, first of all, a sure draftsman."[31] Royal Cortissoz, who was critical of the pigmentation and brush work in Sandzén's paintings at the Babcock Gallery in 1922, nevertheless wrote, "The drawing in them is good and the tone is pure."[32] Critics generally agree that drawing was a source of strength in Sandzén's paintings and prints (see Plates 33A, 33B, 33C).

Nominated by John Taylor Arms, a well-known American printmaker, Sandzén was a member of the Society of American Etchers, Gravers, Lithographers and Wood Cutters. He also belonged to the Society of American Graphic Artists and the Chicago Society of Etchers and was a charter member and the first president of the Prairie Print Makers. When John Taylor Arms received a copy of Greenough's book, *The Graphic Work of Birger Sandzén,* he wrote to Sandzén that he cherished the volume and would place it in his library

among my prized souvenirs of artists, past and present, whose work I most admire and respect. . . . You are, I believe, one of the few men of our day, who has made a contribution of lasting significance to graphic art. . . . I have been familiar with your work ever since I began my own and I have studied it in all its aspects. For the work itself I have great admiration, first for technical and compositional skill, but far more important because far rarer—for the "oneness" of the whole work, its complete honesty and unwavering truth. This quality of integrity seems to me the foremost (and the highest) that any artist can seek to attain. Many of us attain it sometimes, a few often, very few as steadfastly as you have done. . . . So, maestro, I salute you and congratulate you and, for my part, as an individual, thank you very humbly for the example that you have set.[33]

Sandzén's prints and drawings are in hundreds of private and public collections in the

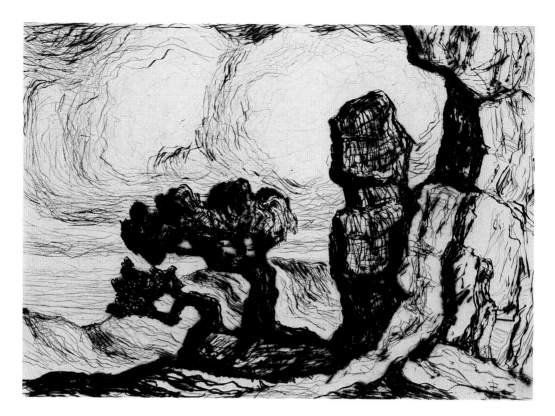

Figure 26

Red Rocks and Cedars, also known as *Cedars and Red Rocks* and as *Rocks and Cedars* (1922) drypoint, 5 × 7 inches

United States and in Europe. Public collections in America are found at the Art Institute of Chicago; the Brooklyn Museum; the Corcoran Gallery, Washington, D. C.; the Los Angeles Museum; the Museum of New Mexico, Santa Fe; the Joslyn Memorial Museum, Omaha; the New York Public Library; the Nelson-Atkins Museum of Art, Kansas City, Missouri; the Smithsonian Institution; the Metropolitan Museum, New York; and Yale University. Museums, galleries, colleges, and universities in Kansas that have collections of Sandzén's prints include the Spencer Art Museum at the University of Kansas, Lawrence, Kansas State University at Manhattan, the Wichita Art Association, the Wichita Center for the Arts, and the Edwin A. Ulrich Museum of Art at Wichita State University. The Birger Sandzén Memorial Gallery, Lindsborg, has the most complete collection. European museums with Sandzén prints include the Bibliothéque Nationale, Paris; the British Museum, London; the National Museum, Stockholm; and the Gothenburg Museum in Sweden.

12

Sharing Views of Art with Two Friends: Carl J. Smalley and Carl Milles

Although Birger Sandzén carried on extensive correspondence with many people, the letters exchanged with Carl Milles and Carl J. Smalley contain particularly interesting comments about his view of art and the joys and problems associated with his career as a painter and printmaker. Milles, the Swedish sculptor, spent considerable periods of time in Italy and the United States. Smalley, an enthusiastic and knowledgeable art promoter and dealer, lived for many years in McPherson, Kansas, and for a brief period in Kansas City, Missouri, before moving to Santa Barbara, California, in his later years. Although Smalley was not an artist, he played an important role in the development of Sandzén's career. Geographical distance meant that there were more letters to Milles than to Smalley, but when circumstances made personal contact between Sandzén and Smalley impossible, a steady stream of correspondence ensued.

Carl Smalley's interest in art can be traced to his boyhood years when he collected and mounted reproductions of masterpieces of paintings; he acquired his first original work at the age of fifteen. While still in his teens, he persuaded his father to permit him to exhibit and sell prints in the elder Smalley's feed store in McPherson. This endeavor led to Smalley's art and book shop, an unusually fine force for promoting cultural interests in McPherson and in a wider area.

In *For the Sake of Art,* Cynthia Mines describes the manner in which Mary Marsh, a Sandzén pupil, reported to her teacher about Carl Smalley's interest in art and the important resource of Smalley's art and book shop. The two men met and soon initiated a close and long-lasting friendship,[1] Sandzén's letters to his friend serve as eloquent testimony to their relationship. In a reminiscent tone, the Lindsborg painter wrote to his friend in California, "As I sit here alone and remember the good times we used to have together, I can see you, Carl, with a lot of prints under your arm. We talked about art and life and a little of everything. All of a sudden the Union Pacific train made a terrible noise. You crossed the park and reached the train in a minute and a half. Sometimes you would need two minutes, depending on the load of print."[2]

Margaret has written about Smalley's frequent Sunday afternoon visits to the Sandzén home in Lindsborg:

Those were exciting times. What would Carl bring next? One Sunday there would be Daubigny, Jacques, Legros, Millet, and Forain. Another Sunday Daumier was featured. The British and Scottish print makers Austin, Strang, McBey, Bone, Leighton and Gill, the Americans by Whistler, Haskell, Nordfeldt and the Halls of Kansas. Sometimes the company would be more distinguished and include Rembrandt, Dürer, Meryon, and Zorn. The time always passed too quickly and before anyone realized it, the jitney

had given the return whistle, Carl had grabbed his hat and portfolio, streaked his way across the park and caught the chugging motor at the crossroads.[3]

The exact date of the first meeting between Sandzén and Smalley is not known although it preceded the first art exhibition that Smalley sponsored in cooperation with the McPherson city schools in 1910. No letters written before 1920 are extant, but after that the correspondence provides a steady chronicle of the cooperation of these two friends in seeking to stimulate interest in art. Smalley's book and art shop played a central role. From its early beginnings in 1905, when Smalley received his first consignment of prints after visiting the St. Louis World's Fair, the McPherson art lover made available European and American masterpieces to eager patrons in modest numbers. A second aspect of Smalley's leadership resulted in exhibitions by well-known artists, first in McPherson and later in various other towns and cities. Art critics from metropolitan newspapers and art periodicals came to see what was happening in this relatively small Kansas town and returned to describe and praise their findings.

Although substantial progress was made, the path was not without difficulties, and Sandzén often met with Smalley to plan strategy. For example, a concentrated effort to enlist schools throughout Kansas to stage art exhibitions resulted in considerable success. Smalley was fully occupied with this effort, his book and art store, and his role as a publisher's representative. This last pursuit, though time consuming, brought him in contact with potential art lovers. He was truly a pioneer in breaking ground for art appreciation, and Sandzén was his ardent and knowledgeable co-worker. Smalley has been described appropriately as a "John the Baptist of Art" in separate articles by both Sandzén and Margaret.[4]

The Sandzén-Smalley papers present both the hopes and the disappointments of the two friends. The various art exhibitions and the growing interest in the purchase of prints and paintings gave validity to their hopes; their disappointments are found in excerpts from Sandzén's letters. In May 1920 Sandzén closed a letter to Smalley: "Well, old boy, let's fight it out. We will break through yet."[5] Other letters indicate that progress was not always as great as they had hoped. In December 1934 Sandzén described negotiations that were in progress to sell a painting to an affluent individual who had expressed interest in it but who was not yet willing to pay the price. In picturesque language he wrote to Smalley, "I have a large good painting, *Kansas Farm*, in the exhibit. I wonder if it would be well to make him another proposition, but he is possibly bullet proof, so it may only be a waste of time."[6] It is not really surprising that the two friends met obstacles in their quest to promote beauty through art appreciation; on the other hand, it is gratifying that great gains were made.

Smalley's papers include a detailed list of the sales of Sandzén's paintings and prints that the McPherson art dealer made between 1925 and 1933. The prices ranged from $1.25 to $10.00 for woodcuts and lithographs, oil paintings generally sold in the range of $40 to $100, and water colors brought $12 to $15. The vast majority were purchased by individuals, only a modest number were sent to art dealers, and prints greatly outnumbered water colors and oil paintings.[7]

Although the Sandzén correspondence with Smalley centers principally on exhibitions, promotion of art appreciation, and sales of paintings and prints, the artist also wrote his friend about other subjects. A letter to Smalley in February 1924 when Birger, Frida, and Margaret were en route to Sweden on the SS *Kungsholm* describes a variety of their experiences, including the attempt of friends in New York City to persuade him to take up residence there: "How artists are able to work in the confusion of New York is a mystery to me. New York has the best and the worst of the world's art. . . . Babcock, like everybody else, except Christian Brinton [art critic and author] who sees clearly the dark side of the metropolis, advises me to spend a great deal of my time in New York in order to get in." After commenting appreciatively on their advice and interest, Sandzén wrote, "My individuality and freedom I cannot give up. I

intend, naturally, to be in touch with New York, but my main field of activity will be the Great West. I do hope that I shall be permitted to work in good health and delightful freedom for some years to come, and that my great old friend Carl Smalley and I may be able to cooperate and carry out our plans for the future." Sandzén also observed, "The delightful frankness with which New York dealers tell us Westerners that they send out West what they cannot sell in the East, is very amusing. They tell it frankly and joyously and without meanness or superiority. I wish that the innocent art patrons of the West could hear what they say. If they did they would be willing to give you a hearing, old boy." Sandzén then discussed his response to what he had seen during his visits to New York and Washington: "I saw a lot of modernist work in New York, Picasso, Duran and others. It seemed very empty to me. But I also saw some glorious Rembrandt and Cézanne. Some sections of the Metropolitan Museum are marvelously fine, for instance, the Altman collection of Chinese art. The Freier Museum in Washington is a dream, a fairyland. I cannot tell you how much we three enjoyed its glorious treasures of the Far East. . . . Well, old boy, good luck to us!! There will be a longer letter soon."8

Sandzén's correspondence with Carl Milles quite naturally differed from his letters to Carl Smalley as he discussed with the sculptor his view of art, those factors he considered vital to his own creativity, and developments in the world of painting. A painter lives in two artistic worlds—his own and that of his contemporaries. There will be times when he is at home in both worlds, and then again he may feel almost wholly alienated. One factor that determines the degree of alienation is the individual's view of life and art in contrast to the views of his contemporaries. For Birger Sandzén, his decisive individualism, his distinctive technique, his striking use of color, and the subject matter of his landscapes—rugged mountains and wide horizons—all demonstrated his views. The changing trends in painting, sometimes quite abrupt and with an emphasis that ran counter to Sandzén's view of basic princi-

ples, widened the breach. He was fully aware of these two worlds and shared his views on contemporary art in his correspondence with the sculptor.

In a February 1933 letter to Milles, Sandzén summarized his situation: "Although I lived in little out-of-the-way Lindsborg, I was for several years in the midst of the liveliest art scene with both painting and graphic work. For example, I was officially invited to the San Francisco Exhibition and the Pan-American Exhibition [in Los Angeles] in 1925, the International Exhibition in Rome in 1926, the Uffizigalleriet in Florence in 1929, London, Paris, etc. In addition I had one-man exhibitions at several places. . . . Then came that strange change in taste which made it cramped and difficult for many of America's and Europe's best painters. The taste swung real quickly to small restricted motifs and to a highly restricted color scale. My thickly painted canvases seemed harsh and strange and did not fit in anywhere. Now there is approaching, according to all signs, reconsideration of a strong use of color and large motifs. That is beginning to happen in Paris and will arrive here in a few years."9 Sandzén's letters provide clear evidence that he was a vital part of the American art scene shortly before the 1920s, during that decade, and for a few years following. The "strange change in taste" was undoubtedly the principal factor in his lesser prominence in art circles later.

As early as 1922, and in the context of his first New York exhibition at the Babcock Gallery, he wrote to his brother Gustaf: "One thing is quite clear to me: My decisive and distinctive Nordic artistic temperament does not precisely conform with Anglo-Saxons here. . . . Except for three years in Stockholm and Paris, I have worked alone all my life on the Järpås hills, on the Kansas prairie, and in the Colorado mountains. That situation has set its stamp on my paintings. My personal peculiarities remain, whether they be drawbacks or merits."10 Perhaps this comment resulted from his sensitivity to critics, as the reviews of the 1922 Babcock exhibition included both commendation and criticism.

The Lindsborg artist painted far from the

art centers of the world most of the time, and although he sought to keep in contact with other artists, his heavy teaching assignment impaired his mobility. Nevertheless, there were some advantages in this situation. He developed his own technique and use of color; his motifs were new, fresh, and original; and he was not impeded by pressures close at hand. Sandzén owed allegiance only to his conscience and to his integrity. He was not limited by the conscious or subconscious influence of cliques or schools.

Isolation and individualism created problems, as he fully recognized. He confided to Milles: "The terrible problem of my life is that I do not belong anywhere among our many groups. I am too 'radical' or too 'conservative,' or my use of color is 'strange.' However, joy in color is something normal." In March 1934 he repeated the same concern: "I do not fit in with either the conservatives or the moderns. I am described as 'different' and here they have a way of rejecting everything in painting which is not in the latest style. . . . It may be that it is my fault. . . . I must work in my profession during the months or years that I have left."[11]

Sandzén also felt that the subject matter of his paintings contributed to some of the criticism, explaining in a letter to Milles in May 1924: "It is clear that one cannot precisely paint the immense mountain motifs, where the shapes and lines of the structures are so sharp and salient, in the old familiar tone and atmospheric style. They require, according to my view, a clear, almost strident treatment, which will convey the landscape's sculpturesque and monumental character. . . . Nature gives support for this kind of handling. The tone and atmosphere should harmonize with the powerful form and line construction which the mountain motifs require."[12]

There were times when Sandzén was discouraged, although he maintained a fine spirit and was determined to carry on with his painting. In December 1931 he had a successful exhibition at the Detroit Institute of Arts, and in a letter to Milles, he cited a review with the heading "Sandzén's Art as a Call for Courage." He then wrote, "If the critic who writes

so beautifully about my 'courage' knew how terribly alone and defeated I generally feel as an artist, he would leave out such a word. But whatever happens I will work as best I can."[13]

There were more disappointments to come during the 1930s. In October 1935 Sandzén wrote to Milles that he had sent three of his best paintings and four lithographs to two exhibitions at the Art Institute of Chicago but that "they have been altogether rejected. I have a little difficult time understanding that I am as poor a painter as they consider me."[14] He had been regularly represented at the Art Institute since 1917, including three one-man shows, and although Sandzén continued to exhibit his works rather widely after 1935, he did not again attain the degree of favorable recognition that had previously come to him.

Birger Sandzén's experience of the fluctuations of favor and disfavor among critics is not unique in the history of art. Yet Sandzén's popularity has not diminished with the general public. Substantial evidence indicates that increasingly larger numbers of people are interested in acquiring a Sandzén, and those who have his works continue to enjoy them. If more opportunities were available for viewing his paintings and prints, it is reasonable to expect that the number of favorable responses would increase. Time alone will furnish the evidence of his place in American art history, although his distinguished role in his own region is well established for posterity.

Birger Sandzén did not belong to any school of art, and he continued his individualistic emphasis; still, he was fully aware of the trends in modern art. Some developments he applauded, but often there were regrets and criticism. Sandzén's concern was not with the great modernists, whose works he respected; his lamentations were reserved principally for the imitators of their works. He wrote to Milles in 1928: "At most large exhibitions the 'modernists' triumph, most of whom imitate some outstanding 'modernist'; for example Matisse or Derain. . . . We rejoice naturally over all honest attempts to find new means of expression, but there is an endless, immature, cheap, and shabby impersonation in our art

production which reaps gold and promotes the popular faction's influence. The most curious factor with these artists and critics, who preach about art's 'redemption and liberation,' is that they are just as academic and bigoted as those whom they ridicule. The great and the noble gradually attain their place, and the shabby and the impersonal will be weeded out. The best will always be 'modern.' Old Dürer [1471–1528] remains 'modern.' "[15]

Sandzén's views on the modernists described by Gertrude Stein in *The Autobiography of Alice B. Toklas* were expressed in a letter to Milles in December 1933, and clearly he was growing disillusioned with the trends: "I cannot honestly say that I admire them any more. They are undeniably brilliant talents, but there is nevertheless a boundless difference between a talent, let alone a mixed talent, and a creative artist." He felt that even Picasso and Matisse, whom he fully recognized as great figures in the art world, were, according to his understanding, at times "somewhat superficial and shallow, although often interesting. . . . The creative genius is at times eccentric, but just as often he is clear and logical, as for example, Donatello [1368–1466] and Raphael [1483–1520]. . . . There is always an immense difference between eccentric efforts and deep originality. . . . I saw a few years ago an exhibition of Picasso's works and I received no further profit from them."[16] Yet Margaret Greenough recalls that her father bought a Picasso color print that he liked very much. Even so, he had written earlier to Milles, "I, like you, love the late Gothic and early Pre-Renaissance painting. One of my dearly beloved painters is Antoine Watteau [1684–1721]. His art is real painting, and there is the melancholy blending of joy and vanities, which one's short life is. Sandrio Botticelli [1444–1510] also gives us this wonderful feeling of melancholy."[17]

Further pursuing the subject, Sandzén wrote, "I will naturally not deny that there is much that is beautiful and worthy in what is done, but it does not outweigh the sad mass production of rubbish which is gladly accepted as 'beautiful' by our museums, exhibitions, and philanthropists." He pointed out that "American motifs are the watchword today. It would be good and well if they were beautiful and splendid American motifs, but those are forgotten and they waste time instead with praise, money, and medallions for what is small, paltry, and lamentable—for example still lifes with rotten fruit, withered flowers, cracked plates, gray and brown cabbages. I have seen several exhibitions of that kind, and I have rushed through as fast as my legs can carry me in order to come out again and get a breath of fresh air."[18]

In another letter to Milles the generally mild-mannered Sandzén expressed his dismay when he considered certain aspects of the new trends in painting: "There is much in the painting of our time that isn't painting at all. It is entertaining anecdotal or smart journalistic art which pleases but has no greater worth than an entertaining newspaper article. Thus we have artists who think in black and white and only use a little color to fill in a drawing. They cannot really be called painters. . . . True painters are extremely few—those who know how to build up color artistically."[19]

Although the letters show that Birger Sandzén felt deeply about some of the developments in contemporary art, he was far more moderate in his public response to the trends he lamented. Similarly, his deep feeling of discouragement about the criticism of his own work was not shared with people who were closest to him. Sandzén quietly maintained high levels of personal civility and never lost confidence in his own work.

13

The Birger Sandzén Memorial Gallery and Foundation: A Dream Fulfilled

When the Birger Sandzén Memorial Gallery was dedicated in October 1957, the artist's dream that his little Lindsborg would have a gallery to exhibit his works and those of other artists became a reality. The gallery has been described as "a thing of the Spirit" and "a gem of a place" in which the spirit of Birger Sandzén "lives and breathes and has its being."

Sandzén's expectations that the gallery would receive a hearty response from artists, art lovers, and the general public have been realized as individuals and groups of various ages and from all walks of life visit in substantial numbers. Artists cooperate by making possible a succession of interesting and attractive exhibitions, and the gallery serves a valuable educational purpose as students from public schools, colleges, and universities view exhibitions from the permanent and traveling sources.

The one-story gallery has two print corridors, two large rooms, four smaller rooms, a sculpture hall, and a library. In addition to many works by Sandzén, the permanent collection includes canvases of Henry Varnum Poor, John Steuart Curry, Doel Reed, Marsden Hartley, B. J. O. Nordfeldt, Raymond Jonson, Lester Raymer, Margaret Greenough, John Bashor, and other painters. The gallery also has a complete collection of lithographs, block prints, and dry points created by Sandzén and prints by Rembrandt, Dürer, Zorn, Pennell, John Taylor Arms, and others.[1]

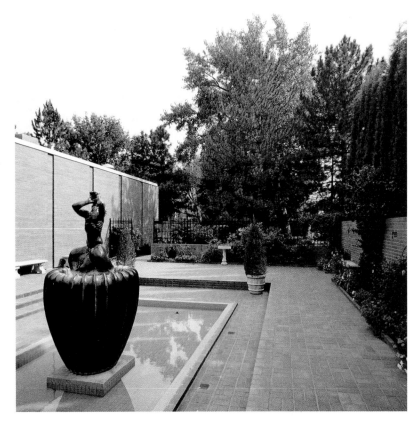

Little Triton fountain in courtyard of Birger Sandzén Memorial Gallery

The entrance corridor of the gallery leads to an attractive and well-landscaped courtyard, which contains Milles's sculpture *The Little Triton*. The corridor presents to the viewer a variety of other sculptures, including *Playing Greyhounds* by Ann Hyatt Huntington and two *Chinese Lion Dogs*. Some oriental art is

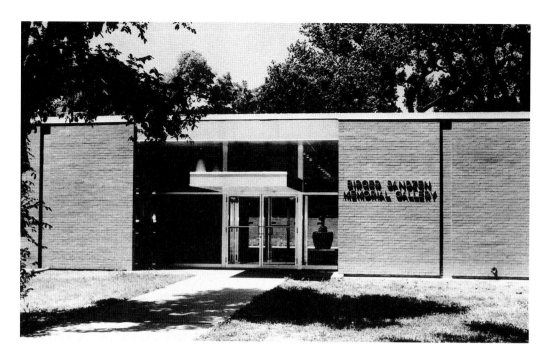

Birger Sandzén
Memorial Gallery (1957)

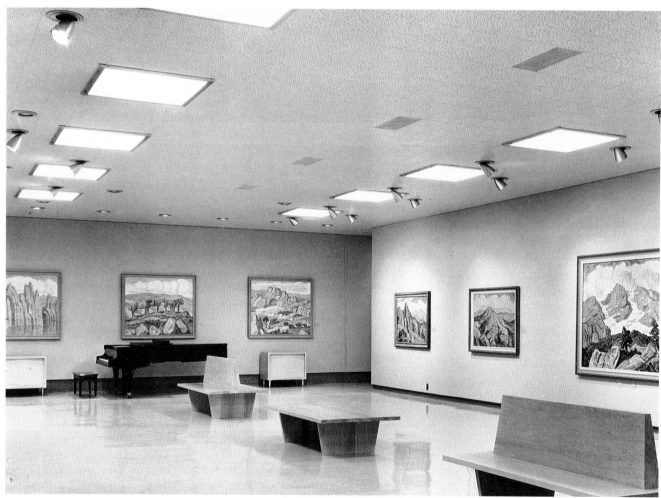

Interior view of Birger
Sandzén Memorial Gallery

owned by the gallery, and also available for exhibition is a collection of Chinese paintings and Japanese color prints and a varied assortment of eighteenth- and nineteenth-century textiles, bronzes, porcelains, and pottery. Since 1957 a collection of contemporary pottery has been formed that includes an outstanding collection of ceramic sculpture by Rosemary Laughlin Bashor.

Approximately 700 exhibitions have been held since the gallery's opening. Birger Sandzén's works are always on exhibit, and paintings and prints by local and regional artists are viewed periodically. Highlights among traveling exhibitions have been a group of large oils by the late Rico Lebrun, Goya's complete *Disasters of War,* a group of Edvard Munch's graphics loaned by the Museum of Modern Art, an exhibition of the prints of Anders Zorn, seventeenth-century Dutch paintings, eighteenth-century English paintings, special Christmas exhibitions of Lester Raymer's toys and related items, and a large Swedish arts and crafts exhibition sent out by the Swedish government. Other shows have included African, Mexican, South Pacific, Central American, Australian, and American Indian arts and crafts.

The idea for a gallery to honor the Lindsborg artist was given a new impetus by the Kansas Federation of Women's Clubs at their sixtieth annual meeting at Wichita in April 1955. Earlier, a resolution of the Women's Club of Goddard to the Fifth District Convention had set the stage for action by the state group, and the clubs had agreed to solicit voluntary contributions of funds from organizations and individuals. The decisive factor in making the Birger Sandzén Memorial Gallery possible, however, was a generous gift from Charles Pelham Greenough 3d.

The gallery is the principal responsibility of The Birger Sandzén Memorial Foundation, Lindsborg, which was formed as a nonprofit corporation under the laws of the state of Kansas on March 10, 1955; its purpose is to promote art and an interest in art. The board of directors is a self-perpetuating body, although the president and the treasurer of Bethany College must always be members. Funds for

Charles Pelham Greenough 3d

the operation of the foundation come from a modest endowment income, gifts, membership fees, and admissions and sales at the gallery. Although the foundation and the gallery are independent entities, they have a close relationship with Bethany College. Charles Pelham Greenough 3d served as president of the foundation from its organization in 1955 until his death in January 1983, and Gene Larson of Lindsborg has been president since that time. Margaret Sandzén Greenough has been intimately associated with the gallery and the foundation and continues to serve as vice-president and as a hearty supporter.

The vision and benefaction of Pelham Greenough made the dream of Birger Sandzén a reality. Born in Boston and educated at Groton, Greenough became a professional collector of coins and prints. This generous and talented man was widely traveled and well versed in the arts. His high level of scholarship is clearly seen in his excellent book, *The Graphic Work of Birger Sandzén,* and his manuscript catalog of more than 2,890 Sandzén oil paintings provides a vital source of information. Greenough's achievement was recognized by Bethany College when the honorary degree Doctor of Humane Letters was conferred on him in 1956. He was made a Knight of the Royal Order of Vasa, First Class, by the King of Sweden in 1963. He will be held in kindly remembrance for his distinguished contribution to the Birger Sandzén Gallery and to the foundation.[2]

The gallery has the largest and most repre-

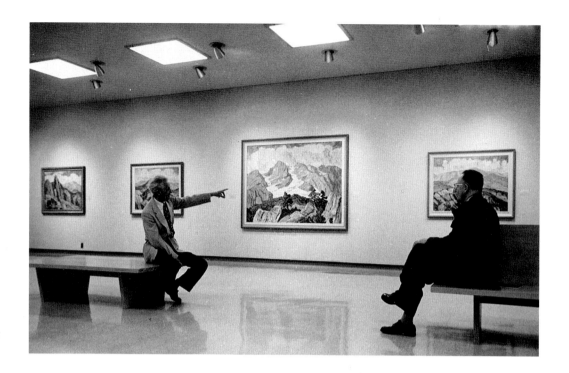

Oscar Thorsen in the Thorsen Room of Birger Sandzén Gallery

sentative collection of Sandzén paintings and prints anywhere. The Thorsen Room, one of several rooms named after Sandzén's friends and colleagues on the Bethany College faculty, contains some of the paintings on permanent exhibition. There are several large and vigorous canvases of distinction, especially of Kansas landscapes and Rocky Mountain scenes, "including six canvases from the so-called silhouette period with trees and rocks in deep sienna and blues against evening and sunset skies. The *Hour of Splendor* vibrates with violets, oranges, and yellows of equal intensity while blues and earth colors predominate in the mountain landscapes."[3]

Canvases in other rooms provide both variety and an opportunity to observe changes in Sandzén's painting across the years. Early paintings have subdued colors and show a

modest use of pigment as well as examples of pointillism; later trends indicate the impact of the bright light of the artist's new milieu, and these paintings have distinctive colors, heavier use of pigmentation, and bolder brush strokes. The paintings from later years are often less distinctive in the brightness of colors but exhibit the usual excellence in drawing and strength in form and structure. Splendid portraits and still-life studies in other rooms bear witness to Sandzén's outstanding achievement in this form of painting. The gallery always offers representative examples of Sandzén's lithographs, block prints, dry points, and drawings, and the collection includes copies of all the prints he created. The Birger Sandzén Memorial Gallery and the foundation that supports it are living tributes to the artist and will continue to be so across the years.

Concluding Observations

Any attempt to describe the physical appearance of Birger Sandzén is really not difficult because a collection of fine photographs and a sensitive portrait by his daughter convey a remarkably accurate impression of him. In his mature years, he was a rather robust, well-proportioned man of average height with a kindly face and pale blue eyes. His person suggested confidence combined with a delightful tentativeness that eliminated any trace of an aggressive element. With a voice level of medium to high, the normal quality of a tenor soloist, his accent reflected his Scandinavian antecedents, his use of several languages since youthful years, and his cosmopolitan culture. His bodily movements were deliberate, although quite precise, and his bearing showed a good coordination of physical resources. He had a marvelous poise and calmness, which suggested that he had mastered the fine art of living, a quality soon conveyed to a stranger and cherished by those who knew him well.

There was nothing ostentatious or pretentious about Birger Sandzén; he loved the simple things of life. In one letter to his brother Gustaf he wrote, "I am glad that the Christmas gifts arrived in time. Children should have Christmas gifts but also older people. When everything is taken into consideration there is not much difference between elders and children in some aspects of life." Then he listed the many small events that he hoped would live long: pleasant conversation, the exchange of ideas and thoughts with friends, coffee parties, small trips, family festivities. "They keep the spirit healthy, vital and youthful." He often reminisced about the wonderful hospitality of his wife's parents and their friends during his and Frida's "unsophisticated days" of visiting in western Kansas.[1]

In later years the Sandzéns would often take a short automobile ride toward the end of the day to relax. A common route was the road north and west of Lindsborg, known to the World War II generation as the "Burma road," to the twin-towered Salemsborg Lutheran Church in the area of that former village. Sandzén said about those little trips, "Just a little ride in this simple Kansas landscape, which has so many suggestions of color and form. Where else can you see such refreshing a beauty?"[2]

Sandzén cherished an attitude of understanding and reconciliation in human affairs, on one occasion remarking, "Only one thing is important—that we have a life together of love and understanding." His was a spirit of goodwill, and he often said to Margaret, "Above all go ahead cheerfully, regardless of the circumstances." He shunned friction and arguments, saying, "Life is too short, it is not worth it."[3]

Religious values and worship were important to Sandzén. Young Birger had received thorough instruction in the Bible, church history, and Martin Luther's catechism. He became a member of the Bethany Lutheran Church in Lindsborg during his first year there and remained an active member throughout his life. He loved the old hymns and chorales of the Lutheran church as well as some of the famous songs of the immigrant evangelical movement, including Lena Sandell Berg's "Blott en dag, Ett ögonblick i sänder" (Day by Day Thy Mercies, Lord, Attend Me). Although he was religious, as his life and correspondence indicated clearly, there was no dogmatism in his views. On one occasion he wrote to a friend, "There are unfortunately too many small and narrow-minded ministers

and influential laymen who have a perfectly pitiful conception of Christian culture. Life is short. Why make it narrow, sad and hard, instead of beautiful, kind, joyful and forgiving. You remember the great Victor Rydberg's words: 'Människörs uppgift är att drömma och tänka' [Mankind's mission is to dream and think]."[4] He was not able to understand the narrow-minded views of some people and wrote to Gustaf in October 1935: "I occasionally have people in my studio who call my magnificent Chinese figures 'idols.' To classify works of art as 'idols' testifies to ignorance and crudeness of mind that is shocking. It takes not so little self-control to avoid throwing such people out of the studio."[5]

Sandzén was sensitive to the needs of people. In an era when many men were forced for lack of money to catch rides on freight trains in search of work, especially during the wheat harvest, many transients came to Lindsborg. It was customary for them to go to homes seeking food when they were short of money, and they were never turned down at the Sandzéns. One elderly transient told Sandzén that he had walked from the river, where he had camped, and had sought help in vain at several residences. When describing the episode, Sandzén observed, "It is strange how some of our church members don't understand the first principle of Christianity—love and mercy." One cold December day, Frida and Margaret were walking home after shopping downtown when they met a man coming from the opposite direction. When he had moved on, Mrs. Sandzén asked Margaret, "Isn't that man wearing your father's new overcoat?" The question was soon answered with Birger's calm explanation: "I think he needs it more than I do."[6]

Birger Sandzén had a keen sense of humor. He especially liked the drawings and stories of Albert Engstrom (1869–1940), a native of Småland and a member of the Swedish Academy, and often retold the story about a man who met an old friend he had not seen for a long time. His friend now had identical twin sons. When the sons were introduced, the man responded, "It's wonderful how much you two look alike, you, Carl and you,

Erik—especially you, Carl." Sandzén enjoyed the ridiculous in humor. One favorite story was about two men whom some might have called transients looking at a fancy funeral procession with a black shiny hearse, carriages with fringes, and so forth. One of the men said to his companion, "Just look at that. We'll probably have to walk to ours." Friends also recall Sandzén's story about an elderly couple at home, seemingly quite discouraged about life and the future, when the husband broke the silence by saying, "When the Lord takes one of us home to Himself, I'm going to California."[7]

Sandzén, in the midst of a busy life, found time to do much reading. He kept abreast of contemporary literature, but he liked best the older French writers, observing, "Daudet's writing is absolutely effortless, never forced, and has such charm. He is marvelous, and then there is Balzac, a giant, and of course, Maupassant." He loved the stories of Hans Christian Andersen, and one of his favorite books was Ernst Josephson's *Svarta rosor och gula* [Black and yellow roses]. Sandzén subscribed to and read regularly the *New Republic,* a liberal economic and social journal, the *Forum,* and the *Kansas City Star.* The response of the Lindsborg painter to literature and cultural values is reflected in a letter to Gustaf in 1924: "It is enlightening to encounter the noblest art, literature and life. These great experiences and values become what Dostoevsky calls our 'eternal contemporaries.' "[8]

The great personal qualities and professional achievements of Birger Sandzén were shared generously for six decades in Lindsborg and elsewhere. His name was known far and wide in art circles, and many people admired him greatly. In June 1946, after fifty-two years of distinguished service to Bethany College, he chose to retire although he maintained a close relationship with the college as artist-in-residence and professor emeritus of art. He still painted and exhibited his works, but on a more modest scale than previously, and he continued to be an inspiration personally and professionally.

In February 1946, his seventy-fifth birthday was celebrated by friends and admirers. A

Margaret Sandzén
Greenough, Frida
Sandzén, and Charles
Pelham Greenough 3d

portfolio of works by Kansas artists, planned
by Sandzén's good friend, Prof. John F. Helm,
Jr., of Kansas State University, was presented
to him with esteem and affection. Bethany
College art students sponsored a festive birth-
day party for the beloved professor, and col-
leagues, students, and friends expressed their
appreciation for his many years of distin-
guished service.

Birger Sandzén worked hard and long
across the decades and from time to time under
the stress of precarious health. Even from early
adult years he was troubled with what was
described as a nervous heart, but he disci-
plined himself well and paced his life accord-
ingly. In the 1940s he was afflicted with an
inflamed nerve in his right cheek. On August
11, 1953, while showing a painting in his stu-
dio to two ladies from McPherson, he had a
light stroke. He was taken to the Lindsborg
Hospital where he stayed two days and then
lived with Margaret and Pelham for two weeks
before returning to his own home.

During those last days Birger Sandzén
spoke of many things. He would say to Frida,
"Oh, if I could only show my gratitude in
some way. I love you in French, Spanish,

Italian, German, Swedish and English." He
shared with those closest to him his plans
for the next painting: "It's up in the highest
mountains. The Sky is in a clear pattern. The
mountains are wild and far enough away to be
blue and red. Then there is a region of pine
forest—and to the left a wedge of aspen, and
then rocks—and water and rocks. I'll admit
the composition sounds simple, but the colors
are very sensitive." After a brief silence the
thoughtful artist said, "I realize that I am get-
ting Old and shouldn't expect much—but if I
could just paint a few more paintings. I would
be happy. Maybe I could paint two more
years—no, ten more, or fifteen," and then he
laughed softly to himself. All of his thoughts
were about those he loved—Frida, Margaret,
Pelham—and about the weather, the coming of
spring, warmth, and the end of bare trees.[9]

Fortunately, Birger Sandzén was able to
be in his home during his last illness, where he
was surrounded by familiar things—his favor-
ite paintings and prints, his own and those of
others; his precious books; and the Steinway
piano on which Frida had played his favorite
compositions. Not only was he surrounded
by loved ones close to him but his temple of

Birger Sandzén in his studio (1940)

memory was full of portraits—portraits from childhood days in Blidsberg and Järpås, school years at Skara, Lund, Stockholm, and Paris, his decades at Bethany College, travel in Mexico, Europe, and the United States, visits to great museums and galleries. And there were great processions passing in review—friends on two continents, special friends at Lindsborg and elsewhere, colleagues, painters, printmakers, and a surging, almost endless procession of students and admirers, people glad to have known him.

Birger Sandzén's desire for the "coming of spring, warmth and the end of bare trees" was granted as his earthly pilgrimage came to an end at Lindsborg on June 22, 1954. A large congregation of friends assembled shortly thereafter at the Bethany Lutheran Church to pay their respects. To say that Birger Sandzén has gone to accept the promises of God about life and death is true but not the whole truth; as long as men, women, and children can see and respond to beauty, he will be alive

through his paintings and prints. Others will also have their own special treasures—memories of his kindness, humility, generosity, patience, optimism. Some people say that great as Birger Sandzén was as an artist, he was still greater as a person.

The official proclamation of "Birger Sandzén Week, May 4–10, 1985," by Gov. John Carlin, three decades after the artist's death, is an interesting example of the continuing appreciation for the Lindsborg artist. In the proclamation, the governor declares, "Birger Sandzén has been seen by generations of Kansans as their ideal of an artist and teacher and has beyond a doubt had the greatest influence upon the art of Kansas of any artist, and through his art and life work has left a legacy that is an artistic treasure and an immeasurable cultural resource for the State of Kansas."[10]

A generous oral tradition about Birger Sandzén will continue even after the lives of those who knew him most intimately have come to an end. Yet that will diminish

with the passing of time, and then proclamations and memorials to his greatness may remain largely in archives. But Sandzén will live through his paintings and prints in many places—in the permanent collection of the Birger Sandzén Memorial Gallery, in museums and galleries, especially in the United States and Sweden, and in literally hundreds of churches, schools, public buildings, private collections, and homes. It is quite likely that people will continue to exclaim with pleasure, "That's a Sandzén!"

Of the many tributes to Birger Sandzén, only two are cited here. A Kansas columnist wrote in 1939 with deep love for the Kansas landscape and with high esteem for Birger Sandzén: "We are being treated to a rare privilege this season, as if nature is attempting to make up for the lack of rainfall with beauty. It's been a long time since the trees have been such a riot of color. And what a background the glorious sunsets are! Too bad we haven't more Birger Sandzéns to have this beauty always near us."[11]

When Carl Milles wrote the introduction to the catalog describing Sandzén's works in the Stockholm exhibition in 1937, he expressed his feeling about the Lindsborg artist, his friend: "Sandzén himself. A fine Swedish type, seems to be calm—but is the opposite, a great humorist—human to the greatest degree, loves to be helpful—and is helpful. . . . A brilliant mind with a heart too large for a man. The collaboration between heart and mind is brilliant, always full of hope for himself and for others, every second of his life revolving about the problem of art. . . . One loves to listen to him since his marvelous view of life always sees light for both art and mankind."[12]

Appendix:
Works in Selected Public Collections

The numerals indicate the number of oil paintings (OP), water colors (WC), lithographs, woodcuts, and dry points (PR), and drawings (DR) in each collection.

American Swedish Historical Museum, Philadelphia: OP 2, WC 2, PR 3

American Swedish Institute, Minneapolis: OP 3, PR 6

Art Institute of Chicago: PR 8

Augustana College, Rock Island, Illinois: OP 2, WC 1, PR 11

Belleville, Kansas, United States Post Office: Mural 1

Bethany College, Lindsborg, Kansas: OP 4, PR 166

Bethany Home, Lindsborg, Kansas: PR 4

Bethany Lutheran Church, Lindsborg, Kansas: Altar Paintings 2

Bibliothéque National, Paris: PR 1

Birger Sandzén Memorial Gallery, Lindsborg, Kansas: OP 45, WC 5, PR 330, DR 3

British Museum, London: PR 26

Brooklyn Museum: OP 1

Colorado Springs Fine Arts Center: PR 3

Corcoran Gallery, Washington, D.C.: PR 2

Denver Art Museum: PR 37

Des Moines Art Museum, Iowa: PR 3

Detroit Public Library: PR 4

Emigrant Institutet, Växjö, Sweden: OP 1, PR 21

Falun Lutheran Church, Falun, Kansas: Altar Painting 1, OP 2, PR 3

Friends University, Wichita, Kansas: OP 1, PR 2

Göteborgs Konstmuseum, Sweden: OP 2, PR 14

Gustavus Adolphus College, St. Peter, Minnesota: OP 2, PR 3

Halstead, Kansas, United States Post Office: Mural 1

Hiawatha, Kansas, Unified School District #415: OP 3, PR 4

Highland Park Town, Texas: OP 2, PR 10

Hutchinson, Kansas, Unified School District #308: OP 3, PR 3

Immanuel Lutheran Church, Salina, Kansas: Altar Paintings 2

Joslyn Memorial Art Museum, Omaha, Nebraska: PR 5

Kansas City Art Institute, Missouri: PR 5

Kansas State Historical Society, Topeka: PR 4

Kansas State University, Manhattan: OP 5, WC 1, PR 10

Library of Congress, Washington, D.C.: PR 12

Lidköpings Hantverks och Sjöfartsmuseum, Sweden: OP 1

Lindsborg, Kansas, Unified School District #400: OP 5, PR 23

Lindsborg, Kansas, United States Post Office: Mural 1

Los Angeles County Museum: PR 6

Lund University, Sweden: OP 3, PR 25

McPherson College, Kansas: OP 2, PR 6

McPherson Museum, Kansas: OP 1, PR 23

McPherson Public Library, Kansas: OP 2, PR 3

McPherson, Kansas, Unified School District #418: OP 11, WC 2, PR 39

Metropolitan Museum, New York: PR 1

Millesgården, Lidingö, Sweden: OP 1

Museum of New Mexico, Museum of Fine Arts, Santa Fe: OP 2, PR 17

National Museum, Stockholm: OP 2, PR 43

National Museum of American Art, Smithsonian Institution, Washington, D.C.: PR 3

National Museum of American History, Smithsonian Institution, Washington, D.C.: PR 2

Nelson-Atkins Museum of Art, Kansas City, Missouri; OP 2, WC 1, PR 14

New York Public Library: PR 12

North Park College, Chicago: OP 3, PR 3

Oklahoma Art Center, Oklahoma City: OP 1, PR 7

Ottawa University, Kansas: OP 3, PR 1

Philadelphia Museum of Art: PR 4

Pittsburg State University, Kansas: OP 3, PR 1

Ponca City Public Library, Richard Gordon Matzene Collection, Oklahoma: OP 7, PR 17

Portland Art Museum, Oregon: PR 5

Riksföreningen för Sverigekontakt, Göteborg, Sweden: OP 2, PR 3

Roswell Museum and Art Center, New Mexico: PR 4

Salina Public Library, Kansas: OP 2, PR 8

Salina, Kansas, Unified School District #305: OP 3, PR 7

Smålands Museum, Växjö, Sweden: OP 3

Springville Museum of Art, Utah: OP 1

Stephens College, Columbia, Missouri: OP 5, PR 23

Tabor College, Hillsboro, Kansas: OP 1

Thomas H. Bowlus Fine Arts Center, Iola, Kansas: OP 1, WC 1

Topeka Public Library, Gallery of Fine Arts: OP 1, PR 4

Trinity United Methodist Church, Lindsborg, Kansas: Altar Paintings 2

University of Colorado Art Gallery, Boulder: PR 2

University of Kansas, Helen Foresman Spencer Museum of Art, Lawrence: OP 4, PR 22

University of Nebraska, Sheldon Memorial Art Gallery, Lincoln: OP 1, WC 1, PR 7

University of New Mexico, Raymond Jonson Gallery, Albuquerque: PR 14

University of Oklahoma, Fred Jones, Jr., Memorial Art Center, Norman: OP 2, WC 1, PR 22

University of Rochester, Memorial Art Gallery, New York: OP 1, PR 3

University of Tulsa, Oklahoma: OP 3, DR 1

Utah State University, Nora Eccler Harrison Museum of Art, Logan: OP 1, PR 1

Wichita Art Association, Kansas: OP 8, WC 1, PR 22

Wichita Center for the Arts, Kansas: OP 7, PR 2

Wichita-Sedgwick County Historical Museum, Kansas: OP 1, PR 4

Wichita State University, Edwin A. Ulrich Museum of Art, Kansas: OP 4, PR 2

Wichita, Kansas, Unified School District #259: OP 6, WC 1, PR 6

Yale University Art Gallery, New Haven, Connecticut: PR 10

Sandzén's works are found in additional places—galleries and museums, colleges and universities, public and private schools, churches, public buildings, and business and professional offices in the United States and Sweden. His paintings and prints are also located in many private collections, ranging from one or two to a substantial number, both in the United States and in Sweden. Members of the Sandzén family in Sweden possess a goodly number of canvases and prints, especially from the early years.

Notes

Chapter 1. Early Years at Home and in School

1. The genealogical information presented is found in the following sources: Pehr Henrik Törngren, *Lovisa Maria Hjelms ättlingar 1772–1971, En släktbok utgiven av G. Bendz, B. von Hofsten, B. Sjögren* (Lund: Berlinska Boktryckeriet, 1921), pp. 264–65, 274–75; "En släktskildring av prosten C. G. Sandzén" (Båreberg); "En släkttavla för Gustaf Sandzén, Forskningen utförd av Paul Meijer Granqvist samt komp. av länsarkitekt A. Berglund," Sandzén Papers, Birger Sandzén Memorial Gallery, Lindsborg, Kansas (hereafter cited as BSMG).

2. Birgitta Sandzén Sjöholm to Emory Lindquist, April 1, 1980, Emory Lindquist Papers, Bethany College Archives, Lindsborg, Kansas.

3. Margaret Sandzén Greenough, "Notes on the Life of Birger Sandzén" (n.d.), pp. 45, 63, Sandzén Papers, BSMG. This personal document of seventy-three pages consists of statements and observations made by Birger Sandzén to his daughter at various times and then recorded by her.

4. Ibid., pp. 1, 4, 6.

5. Gustaf Holmstedt, *Skara Läroverk 1641–1941: Festskrift* (Stockholm: P. A. Nordstedt och Söner, 1941), pp. 122–24; *Katalog öfver Skara högre allmäna läroverk, 1891* (Skara, 1891); Margaret Greenough, "Notes," pp. 11–12.

6. "Skara högre allmäna läroverk. Mogenhetsbetyg, June 12, 1890," Sandzén Papers, BSMG.

7. *Skaradjäknen* (Skara) 5:1 (1920): 5–8; Holmstedt, *Skara Läroverk,* pp. 155–56.

8. Birger Sandzén to Johan Peter Sandzén, February 28, 1887, and Birger Sandzén to Johan Peter Sandzén (n.d.), Sandzén Papers, BSMG; Margaret Greenough, "Notes," p. 2.

9. Margaret Greenough, "Notes," p. 47.

10. Ibid., pp. 23, 33.

11. "Birger Sandzén," *Svensk biografisk lexikon,* vol. 5 (Stockholm, 1925), pp. 91–93.

Chapter 2. Study in Stockholm and Paris

1. Birger Sandzén to Johan Peter Sandzén, September 11, 1891, October 5, 1891, Sandzén Papers, BSMG, and Birger Sandzén, "Något om svensk konst i Amerika," *Prärieblomman kalender för 1902* (Rock Island, Ill.: Augustana Book Concern, 1902), p. 115.

2. Birger Sandzén to Johan Peter Sandzén, October 5, 1891, Sandzén Papers, BSMG; Birger Sandzén, "Något om svensk konst i Amerika," p. 115. For detailed information about Konstnärsförbundet see the index.

3. Birger Sandzén to Johan Peter Sandzén, October 5, 1891, Sandzén Papers, BSMG.

4. Birger Sandzén to Johan Peter Sandzén, October 5, 1891, and October 17, 1891, Sandzén Papers, BSMG; Sixten Strömbom, *Nationalromantik och radikalism: Konstnärsförbundets historia 1891–1920* (Stockholm: Albert Bonniers förlag, 1965), p. 371.

5. Malcolm C. Salaman, "Anders Zorn," *Modern Masters of Etchings* (London: The Studio, 1925), p. 1.

6. Birger Sandzén to Johan Peter Sandzén, October 3, 1891, Sandzén Papers, BSMG.

7. Ibid.

8. Ibid., November 21, 1891.

9. "Richard Bergh," *Svensk biografisk lexikon,* vol. 3 (Stockholm, 1922), pp. 534–43; Elisabeth Jane Merrill, "The Art of Birger Sandzén," *American Magazine of Art* 18 (January 1927): 3; Birger Sandzén to Carl Milles, January 27, 1937, Sandzén Papers, BSMG; and Margaret Sandzén Greenough, "Notes on the Life of Birger Sandzén" (n.d.), p. 1, Sandzén Papers, BSMG.

10. Birger Sandzén to Johan Peter Sandzén, October 14, 1892, Sandzén Papers, BSMG.

11. Margaret Greenough, "Notes," pp. 31, 43–44.

12. Birger Sandzén to Johan Peter Sandzén, October 14, 1892.

13. Birger Sandzén, "Något om svensk konst i Amerika," *Prärieblomman kalender för 1902* (Rock Island, Ill.: Augustana Book Concern, 1902), p. 102.

14. Birger Sandzén, "En kamrat [Olof Sager-Nelson]," *Prärieblomman kalender för 1905* (Rock Island, Ill.: Augustana Book Concern, 1905), pp. 46–59, contains an interesting article about Sandzén's friend.

15. Birger Sandzén to Johan Peter Sandzén, October 14, 1892.

16. Anders Schön, "Svensk-Amerikansk konstnär," *Ungdomsvännen* 9 (May 1904): 148.

17. Birger Sandzén to Johan Peter Sandzén, June 28, 1893, Sandzén Papers, BSMG.

18. Birger Sandzén to Carl Sandzén, November 6, 1893, Sandzén Papers, BSMG.

19. Ibid.

20. E. Bénézit, "Edmond-François Aman-Jean," *Dictionnaire critique et documentaire des peintres, sculpteurs, dessinateurs et graveurs, vol. 7* (Paris: Libraire Gründ, 1962), p. 136, and Margaret Greenough, "Notes," p. 13.

21. Elizabeth Jane Merrill, "Art of Birger Sandzén," p. 3, and Margaret Greenough, "Notes," p. 2.

22. Birger Sandzén to Johan Peter Sandzén, March 21, 1894, Sandzén Papers, BSMG.

23. Ibid., April 15, 1894.

24. Ibid., May 12, 1894.

25. Ibid., April 15, 1894.

Chapter 3. Emigration and Early Years in America

1. Birger Sandzén to Carl A. Swensson, February 10, 1894, Sandzén Papers, BSMG.

2. Ibid.

3. Florence Edith Janson, ed., *The Background of Swedish Immigration 1840–1930* (Chicago: University of Chicago Press, 1931), p. 497.

4. Birger Sandzén to Johan Peter Sandzén, April 1, 1894, Sandzén Papers, BSMG.

5. Ibid., April 10, 1894.

6. Ibid.

7. Ibid.

8. Birger Sandzén to Carl A. Swensson, July 16, 1894, Swensson Papers, Bethany College Archives, Lindsborg, Kansas.

9. Birger Sandzén (on board SS *Camio*) to Johan Peter Sandzén, August 31, 1894, September 13, 1894, Sandzén Papers, BSMG.

10. Ibid., September 13, 1894.

11. Ibid., October 7, 1894.

12. Ibid., October 10, 1894.

13. Ibid., March 11, 1895, April 15, 1895.

14. Ibid., October 22, 1895.

15. Ibid., October 22, 1895, November 4, 1895.

16. Ibid., October 7, 1894, December 29, 1894.

17. Birger Sandzén, "Något om svensk konst i Amerika," *Prärieblomman kalender för 1902* (Rock Island, Ill.: Augustana Book Concern, 1902), p. 115.

Chapter 4. Teaching at Bethany College and Elsewhere

1. Frances Hafermehl to Emory Lindquist, April 16, 1980, Lindquist Papers, Bethany College Archives, Lindsborg, Kansas.

2. Birger Sandzén, "The Technique of Painting," *Fine Arts Journal* 32 (January 1915): 23.

3. Ibid., p. 15.

4. Ibid.

5. Ibid., p. 27.

6. Ibid.

7. Margaret Greenough to Emory Lindquist, February 28, 1980, Lindquist Papers.

8. Ibid.

9. Ibid.

10. Ibid.

11. Elizabeth Farrar Green Love, "Student Remembrances of Birger Sandzén," pp. 27–28, Lindquist Papers.

12. Dolores Gaston Runbeck, "Student Remembrances," pp. 31–32, Lindquist Papers.

13. Myra Biggerstaff Holliday, "Student Remembrances," pp. 15–17, Lindquist Papers.

14. Carl Wm. Peterson, "Student Remembrances," pp. 13–14, Lindquist Papers.

15. Charles B. Rogers, "Student Remembrances," p. 29, Lindquist Papers.

16. C. Louis Hafermehl, "Student Remembrances," p. 5, Lindquist Papers.

17. Ibid.

18. Dale Oliver, "Student Remembrances," pp. 3–4, Lindquist Papers.

19. Ray Stapp, "Student Remembrances," pp. 34–39, Lindquist Papers.

20. Sue Jean Hill Boys, "Student Remembrances," p. 33, Lindquist Papers.

21. *Detroit News,* May 12, 1931.

22. Zona Wheeler, interview with author, Wichita, Kansas, September 6, 1981, Lindquist Papers.

23. For additional information about Sandzén and art instruction at Bethany College, see Emory Lindquist, *Bethany in Kansas: The History of a College* (Lindsborg, Kans.: Bethany College Publications, 1975), pp. 178–81.

24. Allison Chandler to Birger Sandzén family, June 20, 1954, Sandzén Papers, BSMG.

Chapter 5. Art Appreciation and Personal Opinions

1. Birger Sandzén, "Något om svensk konst i Amerika," *Prärieblomman kalender för 1902* (Rock Island, Ill.: Augustana Book Concern, 1902), pp. 106–7.

2. Birger Sandzén, "Våra Svensk-Amerikanska konstskolar," *Prärieblomman kalender för 1903,* (Rock Island, Ill.: Augustana Book Concern, 1903), pp. 49–53.

3. *Bethany College Catalogue, 1913–1914* (Lindsborg, Kans.), p. 25, and *American Art Annual, 1934* (Washington, D.C.: American Federation of Arts, 1955), p. 157.

4. C. A. Seward, "Bulletin of the Prairie Print Makers" 5 (Wichita, Kans., December 1930), and Margaret Whittemore, *Topeka Capital,* December 6, 1931.

5. C. A. Seward, "Annual Report of the Prairie Print Makers for the Season 1936–37."

6. Barbara Thompson O'Neill and George C. Foreman in cooperation with Howard W. Ellington, *The Prairie Print Makers* (Topeka: Kansas Arts Commission, 1981), pp. 3, 5, 10, 58.

7. Ibid., p. 1, and Howard W. Ellington to Emory Lindquist, May 21, 1986, Lindquist Papers, Bethany College Archives, Lindsborg, Kansas.

8. M. K. Powell, "In Gallery and Studio," *Kansas City Star,* January 14, 1933.

9. *Bulletin of the Kansas State Federation of Art* 40 (1946), and *Bulletin of the Kansas State Federation* 57 (1963).

10. "By-Laws of the Kansas State Federation of Art," *Bulletin of the Kansas State Federation of Art,* October 11, 1947, and *American Art Annual, 1934,* p. 155.

11. Chester C. Bruce, "Birger Sandzén, Distinguished Kansas Artist and Swedish-American: A Study of a Prairie Viking's Career at Bethany College" (Master's thesis, University of Kansas, 1971).

12. Birger Sandzén, "A Message to Delta Phi Delta," *Delta Phi Delta Palette* 18 (December 1937): 4–5.

13. Birger Sandzén, "A John the Baptist of Art [Carl J. Smalley]," *International Studio* 77 (April 1923): 65–69. The valuable volume by Cynthia Mines, *For the Sake of Art: The Story of an Art Movement in Kansas,* with drawings by Salvador Estrada, provides important and interesting material about the close association of Carl J. Smalley and Sandzén.

14. Margaret Sandzén Greenough, "Notes on the Life of Birger Sandzén" (n.d.), p. 37, Sandzén Papers, BSMG.

15. *Bethany Messenger,* April 10, 1925.

16. *Lindsborg News-Record,* October 31, 1946.

17. Margaret Greenough, "From Sweden to Kansas," *American Artist* 25 (January 1961): 28–29.

18. Naboth Hedin, "Artist of the Prairie: Birger Sandzén," *American Swedish Monthly* 51 (August 1957): 12. The Mechlin quotation is found in this article.

19. Birger Sandzén to Oscar Jacobson, March 17, 1917, Sandzén Papers, BSMG.

20. Ibid., April 26, 1917.

21. Birger Sandzén to Gustaf Sandzén, April 8, 1923, Sandzén Papers, BSMG.

22. Birger Sandzén to Carl Milles, June 20, 1932, Sandzén Papers, BSMG.

23. Birger Sandzén to Fritiof M. Fryxell, February 12, 1933, Sandzén Papers, BSMG.

24. Birger Sandzén to Gustaf Sandzén, April 24, 1934, Sandzén Papers, BSMG.

25. Ibid., November 19, 1938.

26. Birger Sandzén to Carl Milles, November 27, 1938, Sandzén Papers, BSMG.

27. Ibid., January 27, 1940.

28. Ibid., March 27, 1943.

29. Margaret Greenough, "Notes," pp. 30, 63, 34, 53.

Chapter 6. Travel at Home and Abroad

1. Birger Sandzén to Raymond Jonson, October 30, 1922, Sandzén Papers, BSMG.

2. Birger Sandzén to Frida Sandzén, July 15, 1915, Sandzén Papers, BSMG.

3. Ibid., July 27, 1915.

4. Ibid., July 30, 1915, and Birger Sandzén to Raymond Jonson, November 2, 1915, Sandzén Papers, BSMG.

5. Birger Sandzén to Carl Milles, July 5, 1930, July 22, 1930, and June 30, 1950, Sandzén Papers, BSMG.

6. Birger Sandzén to Raymond Jonson, September 16, 1919, Sandzén Papers, BSMG.

7. Birger Sandzén, "The Southwest as a Sketching Ground," *Fine Arts Journal* 33 (August 1915): 340.

8. Margaret Sandzén Greenough, "Notes on the Life of Birger Sandzén" (n.d.), p. 68, Sandzén Papers, BSMG, and Birger Sandzén to Raymond and Vera Jonson, March 7, 1949, Sandzén Papers, BSMG.

9. "Art Gift to Gallery," *Kansas City Times,* March 7, 1938.

10. Birger Sandzén to Gustaf Sandzén, on board the SS *Mongolia,* June 8, 1897, and Birger Sandzén to Frida Leksell, on board the SS *Mongolia,* June 7, 1897, Sandzén Papers, BSMG.

11. Birger Sandzén to Johan Peter Sandzén, June 13, 1897, and Birger Sandzén to Frida Leksell, June 14, 1897, Sandzén Papers, BSMG.

12. Birger Sandzén to Frida Leksell, June 25, 1897, Sandzén Papers, BSMG.

13. Ibid., July 23, 1897.

14. Ibid., July 18, 1897, July 27, 1897.

15. Gustaf Sandzén to Birger Sandzén, September 6, 1897, Sandzén Papers, BSMG.

16. Birger Sandzén, "Pennteckningar från en resa i Sverige," *Svea* 45 (Worcester, Mass.: 1905).

17. Birger Sandzén, "Pennteckningar," *Svea* 14 (1905), and *Från helgedom till muséum: svältornas fornminnesförening 1905–1975* (Vårgård, 1975), pp. 14–15.

18. Birger Sandzén, "Pennteckningar," *Svea* 14 (1905), and *Från helgedom till muséum*, pp. 15–16, 24.

19. Birger Sandzén, "Pennteckningar," *Svea* 14 (1905), and *Från helgedom till muséum*, pp. 16–17.

20. Birger Sandzén, "Pennteckningar," *Svea* 20 (1905).

21. Birger Sandzén to Mrs. Eric Leksell, November 22, 1905, Sandzén Papers, BSMG.

22. Frida Sandzén to Mrs. Eric Leksell, December 28, 1905, Sandzén Papers, BSMG.

23. Ibid.; Margaret Greenough, "Notes," p. 32.

24. Frida Sandzén to Mrs. Eric Leksell, December 28, 1905, and Birger Sandzén to Frida Sandzén, January 1, 1906, Sandzén Papers, BSMG.

25. Frida Sandzén to Mrs. Eric Leksell, January 17, 1906, Sandzén Papers, BSMG.

26. Ibid., April 21, 1906, and May 10, 1906.

27. Ibid., July 10, 1906, and July 23, 1906; also Margaret Greenough, "Notes," p. 34.

28. Frida Sandzén to Mrs. Eric Leksell, August 18, 1906, and September 2, 1906, Sandzén Papers, BSMG.

29. *Lindsborgs-Posten*, April 2, 1924.

30. Ibid., April 9, 1924.

31. Ibid., April 23, 1924, and Frida Sandzén to Mrs. Eric Leksell, March 12, 1924, Sandzén Papers, BSMG.

32. Birger Sandzén to Gustaf Sandzén, April 9, 1924, Sandzén Papers, BSMG.

33. E. E. Ryden, "Birger Sandzén: Poet-Painter of the Great West," *Lutheran Companion* (Rock Island, Ill., July 8, 1937); Margaret Greenough to Carl Milles, May 30, 1937, Sandzén Papers, BSMG; and Birger Sandzén to Gustaf Sandzén, December 5, 1924, Sandzén Papers, BSMG.

34. Birger Sandzén to Carl Milles, April 5, 1924, and December 5, 1924, Sandzén Papers, BSMG.

35. Frida Sandzén to Mrs. Eric Leksell, April 14, 1924, Sandzén Papers, BSMG.

36. Frida Sandzén to Hedda Sandzén, June 8, 1924, Sandzén Papers, BSMG.

37. Unless otherwise designated, the content for the 1899 trip to Mexico is taken principally from Birger Sandzén's book, *Med pensel och penna: Berättelser, studier och stämningar* (Rock Island, Ill.: Augustana Book Concern, c. 1905).

38. Birger Sandzén to Johan Peter Sandzén, July 13, 1899, Sandzén Papers, BSMG.

39. Birger Sandzén, "A Letter from Mexico," *Lindsborg News-Record*, August 8, 1935.

40. Birger Sandzén, "A Letter from Mexico," and Birger Sandzén to Raymond Jonson, August 9, 1935, Sandzén Papers, BSMG.

Chapter 7. Family and Friends

1. Birger Sandzén to Carl Milles, March 27, 1943, Sandzén Papers, BSMG.

2. Margaret Sandzén Greenough, "Notes on the Life of Birger Sandzén" (n.d.), p. 50, Sandzén Papers, BSMG.

3. Birger Sandzén to Frida Sandzén, August 12, 1917, Sandzén Papers, BSMG.

4. Birger Sandzén to Gustaf Sandzén, July 2, 1909, Sandzén Papers, BSMG.

5. Ibid., July 31, 1916.

6. Ibid., March 20, 1912.

7. Ibid., February 22, 1914.

8. Ibid., March 29, 1920.

9. Birger Sandzén to Fritiof M. Fryxell, May 3, 1933, and March 27, 1933, Sandzén Papers, BSMG.

10. Margaret Greenough, "Notes," p. 53.

11. Ibid., p. 42.

12. Margaret Greenough, "Notes," p. 42, and Birger Sandzén to Gustaf Sandzén, January 7, 1940, Sandzén Papers, BSMG.

13. Birger Sandzén, "Foreword," *Exhibition of Paintings, Lithographs, Block Prints, and Drawings by Birger Sandzén,* Omaha Society of Fine Arts, March 10-30, 1922, and Margaret Greenough, "Notes," p. 59.

14. Birger Sandzén to Gustaf Sandzén, August 4, 1912, Sandzén Papers, BSMG.

15. Ibid., December 31, 1924.

16. Ibid., November 19, 1938.

17. Ibid., July 14, 1907; May 24, 1912; and February 22, 1920; also Birger Sandzén to Mrs. Johan Peter Sandzén, July 12, 1908, Sandzén Papers, BSMG.

18. Carl J. Smalley, "The Prints of Birger Sandzén," *Print Connoisseur* 3 (July 1923): 214-20, and Birger Sandzén, "A John the Baptist of Art," *International Studio* 77 (April 1923): 65-69. For a discussion of the relationship of Smalley and Sandzén see Cynthia Mines, *For the Sake of Art: The Story of an Art Movement in Kansas* (McPherson, Kans.: McPherson Foundation, 1979).

19. Mrs. Tom L. Irby, *The Richard Gordon Matzene Collection,* Ponca City Library (Ponca City, Oklahoma, 1963). This publication provides biographical information about Gordon Matzene.

20. "Annotation," *Exhibition of the Edmund L. and Faye Davison Collection,* Wichita Art Museum (Wichita, Kansas, June 1986).

21. Birger Sandzén to Gustaf Sandzén, July 3, 1911, Sandzén Papers, BSMG.

22. Birger Sandzén to Carl Milles, January 15, 1936, and January 1, 1937, Sandzén Papers, BSMG.

23. Birger Sandzén to Gustaf Sandzén, February 11, 1926, Sandzén Papers, BSMG.

24. Birger Sandzén to Raymond Jonson, January 4, 1923, Sandzén Papers, BSMG. For a discussion of the paintings of Raymond Jonson see Ed Garman, *The Art of Raymond Jonson: Painter* (Albuquerque: University of New Mexico Press, 1976).

25. John Taylor Arms to Birger Sandzén, June 25, 1952, Sandzén Papers, BSMG.

Chapter 8. Background Factors and Influences in the Paintings and Water Colors

1. Alrik Gustafson, *A History of Swedish Literature* (Minneapolis: University of Minnesota Press, 1961), pp. 288, 335.

2. Sixten Strömbom, *Nationalmuseum utställning nr 42, Konstnärsförbundet 1891–1920* (Stockholm, 1948), pp. 6–7.

3. Sixten Strömbom, *Nationalromantik och radikalism. Konstnärsförbundets historia 1891–1920* (Stockholm: Albert Bonniers förlag, 1965), p. 352.

4. Ibid., pp. 371, 374.

5. Carl Milles, "Introduction," *Birger Sandzéns utställning,* Gummesons konsthall, Stockholm, May 1–18, 1937.

6. Evert Wrangel, *Sydsvensk Dagbladet Snällposten* (Malmö), March 2, 1912, and April 22, 1930; Folke Holmér, in H. Sallberg and G. Jungmarker, *Grafik från tre sekler* (Stockholm, 1957), p. 210; and Katarina Dunér och Bengt Olvång, "Birger Sandzén," *Svensk konstnärslexikon,* vol. 5 (Stockholm, 1960), p. 47.

7. Birger Sandzén, "Något om svensk konst i Amerika," *Prärieblomman kalender för 1902* (Rock Island, Ill.: Augustana Book Concern, 1902), p. 113; H. W. Janson, *History of Art: A Survey of the Major Visual Arts from the Dawn of History to the Present Day* (Englewood Cliffs, N.J.: Prentice-Hall, and New York: Harry N. Abrams, 1962), p. 151; and Evert Wrangel, *Sydsvensk Dagbladet Snällposten,* April 22, 1930.

8. Margaret Sandzén Greenough, "Notes on the Life of Birger Sandzén" (n.d.), pp. 32, 54, Sandzén Papers, BSMG.

9. Ibid., p. 2.

10. *Kansas City Times,* July 8, 1934.

11. Birger Sandzén to Johan Peter Sandzén, October 22, 1895, and Birger Sandzén to Raymond Jonson, July 11, 1921, Sandzén Papers, BSMG; also Margaret Greenough, "Notes," p. 42.

12. Birger Sandzén, "The Southwest as a Sketching Ground," *Fine Arts Journal* 33 (August 1915): 341.

13. Ibid., pp. 348–49.

14. Richard Bergh, *Om konst och annat* (Stockholm: Albert Bonniers förlag, 1919), p. 151.

15. Margaret Greenough interview with author, Lindsborg, February 4, 1972, Emory Lindquist Papers, Bethany College Archives, Lindsborg, Kansas, and Margaret Greenough, "Notes," p. 72.

16. Margaret Greenough, "Notes," p. 8.

17. Laura Bride Powers, "Birger Sandzén's Show Glowing with Vitality," *Oakland Tribune,* February 1, 1920.

18. Charles Pelham Greenough 3d, *The Graphic Work of Birger Sandzén* (Manhattan: Kansas Magazine, 1952), p. 7.

19. "Midwestern Artists Exhibition," *Kansas City Star,* February 5, 1933.

20. C. Louis Hafermehl, "Student Remembrances of Birger Sandzén," p. 11, Lindquist Papers, Bethany College Archives, Lindsborg, Kansas.

21. Birger Sandzén to Gustaf Sandzén, July 3, 1911, Sandzén Papers, BSMG, and G. N. Malm, "Inom brusten förlåt," *Svenska Tribunen Nyheter* (Chicago), July 4, 1911.

22. Birger Sandzén to Gustaf Sandzén, January 23, 1924, Sandzén Papers, BSMG.

23. "Birger Sandzén," *American Art News,* May 17, 1919, p. 1.

24. "Sandzén Art Is Displayed at Museum," *Philadelphia Inquirer,* June 2, 1940.

25. Claes Sturm, "Profet i USA—Okänd i Sverige," *Stockholm Dagens Nyheter,* March 30, 1985.

26. William H. Gerdts, *Art across America: Two Centuries of Regional Painting 1710–1920,* vol. 3 (New York: Abbeville Press, 1990), p. 70.

27. Clark S. Marlor, *The Society of Independent Artists: Exhibition Record* (Park Ridge, N.J.: Noyes Press, 1984), p. 480; "Armory Show," *Encyclopedia of World Art,* 15 vols. (New York and London: McGraw-Hill, 1959–1968), vol. 1, p. 303; and "Armory Show," *Phaedon Dictionary of Art* (Oxford: Phaedon Press, 1970), pp. 13–14, 358.

Chapter 9. The Painter and His Craft

1. Birger Sandzén, "Foreword," *Catalogue of the Exhibition of the Paintings, Lithographs, Block Prints, and Drawings of Birger Sandzén,* Omaha Society of Fine Arts, March 10–30, 1922.

2. Birger Sandzén, "Något om svensk konst i Amerika," *Prärieblomman kalender för 1902* (Rock Island, Ill.: Augustana Book Concern, 1902), pp. 99–100, and Birger Sandzén to Gustaf Sandzén, March 20, 1902, Sandzén Papers, BSMG.

3. "Sandzén's Lithographs Charm Exhibition Visitors," *Missourian Magazine* 20 (October 22, 1927): 1–3.

4. Margaret Greenough and Charles Pelham Greenough 3d, "Introduction," *Catalogue: Centenary Retrospective Exhibition of Birger Sandzén,* Lindsborg, Kansas, 1971.

5. "Sandzén's Art as a Call for Courage," *Detroit Sunday News,* December 6, 1931.

6. Birger Sandzén, "Svensk-Amerikanska konstnärernas utställning i Chicago 1912," *Prärieblomman kalender för 1913* (Rock Island, Ill.: Augustana Book Concern, 1912), pp. 34–36.

7. *Kansas City Star,* April 25, 1915.

8. Birger Sandzén, "The Technique of Painting," *Fine Arts Journal* 32 (January 1915): 26–27.

9. Margaret Greenough interview with author, Lindsborg, February 4, 1972, Emory Lindquist Papers, Bethany College Archives, Lindsborg, Kansas, and Margaret Greenough to Emory Lindquist, March 25, 1980, Lindquist Papers.

10. Birger Sandzén, "Technique of Painting," p. 27.

11. Birger Sandzén to Johan Peter Sandzén, February 28, 1887, Sandzén Papers, BSMG.

12. *Brage,* a publication of the Idun Society (Skara: Skaraborgs länsbibliotek, 1884–1889).

13. Margaret Sandzén Greenough, "Notes on the Life of Birger Sandzén" (n.d.), pp. 5–12, Sandzén Papers, BSMG.

14. Ibid., p. 22, and Birger Sandzén to Johan Peter Sandzén, October 5, 1891, and October 17, 1891, Sandzén Papers, BSMG.

15. Nina Stawski, "The Drawings and Sketchbooks of Kansas Art Patriarch Birger Sandzén" (Master's thesis, University of Missouri, Columbia, 1982), pp. 19–38. Two additional sketchbooks in pen and ink, located in Sweden, are devoted to studies of the Västergötland landscape. Stawski's article, "The Sketchbooks and Drawings of Birger

Sandzén," *Swedish-American Historical Quarterly* 37 (April 1986): 94–104, presents an important discussion of sketching and drawing in the work of Sandzén.

16. Mary E. Marsh, "The Work of Birger Sandzén," *International Studio* 69 (January–February 1920): xcix, and Mary E. Marsh, "Birger Sandzén," *American Scandinavian Review* 4 (May–June 1916).

17. Margaret Greenough, "Notes," p. 68.

18. Birger Sandzén to Carl Milles, November 3, 1935, Sandzén Papers, BSMG.

19. Nina Stawski, "Drawings and Sketchbooks of Birger Sandzén," p. 39.

20. Margaret Greenough, "Aspects of the Paintings of Birger Sandzén" (n.d.), pp. 1–2, Sandzén Papers, BSMG.

21. C. Louis Hafermehl, "Student Remembrances of Birger Sandzén," p. 12, Lindquist Papers.

22. Margaret Greenough interview with author, February 4, 1972.

23. Margaret Greenough, "From Sweden to Kansas," *American Artist* 25 (January 1961): 72.

24. Ibid.

25. Margaret Greenough, "A Lecture on Birger Sandzén," p. 7, Sandzén Papers, BSMG.

26. Margaret Greenough, "Aspects of the Paintings of Birger Sandzén," p. 6.

27. Margaret Greenough, "From Sweden to Kansas," p. 73.

28. Paul Murphy, "Birger Sandzén Left Behind a Treasure of Beauty on Canvas," *Hutchinson News-Herald,* August 8, 1954.

29. Margaret Greenough, "Notes," p. 59.

30. Ken Yarber, " Challenge in Youth Gave Birger Sandzén to Kansas," *Wichita Eagle Sunday Magazine,* February 14, 1954, and Margaret Greenough, "Notes," p. 31.

31. Allison Chandler, "An Art Center in Lindsborg," *American-Scandinavian Review* 22 (March 1934): 21–23, and Jennie Small Owen, "Kansas Folks Worth Knowing: Birger Sandzén," *Kansas Teacher* 45 (Topeka, 1937): 30–32.

32. Birger Sandzén to Carl Milles, October 19, 1938, Sandzén Papers, BSMG.

Chapter 10. Exhibitions and the Response of Art Critics

1. Birger Sandzén to Carl Sandzén, November 6, 1893, Sandzén Papers, BSMG.

2. Sandzén has described the origin of this series of art exhibitions in his article, "Våra svensk-amerikanska konstskolar," *Prärieblomman kalender för 1903* (Rock Island, Ill.: Augustana Book Concern, 1903), pp. 49–53.

3. *Museum News: Wichita Art Association* 2:2 (November 1922), p. 3.

4. Cynthia Mines, *For the Sake of Art: The Story of an Art Movement in Kansas* (McPherson, Kans.: McPherson Foundation, 1979), pp. 8–18.

5. Chester C. Bruce presents valuable and interesting information chronologically about Sandzén's exhibitions in "Birger Sandzén, Distinguished Kansas Artist and Swedish-American: A Study of a Prairie Viking's Career at Bethany College" (Master's thesis, University of Kansas, 1971).

6. M. T. Oliver, "Exhibition of Sandzén's Paintings and Prints," *Chicago Sunday Record-Herald,* April 27, 1913.

7. Mary E. Marsh, "Birger Sandzén," *American-Scandinavian Review* 4 (May–June 1916): 176–77.

8. "R. J. B.," "The McPherson Art Show," *Kansas City Star,* October 18, 1916.

9. "R. J. B.," "News of the Fine Arts," *Kansas City Star,* April 7, 1916.

10. Leila Mechlin, "Birger Sandzén: Painter and Lithographer," *American Magazine of Art* 8 (February 1917): 148.

11. "The Sandzén Exhibition at the New Mexico Museum of Art," *Santa Fe Daily New Mexican,* January 5, 1918.

12. *Santa Fe Daily New Mexican,* January 11, 1919.

13. Laura Bride Powers, "Birger Sandzén's Show Glowing with Vitality," *Oakland Tribune,* February 1, 1920.

14. "Notes of Art and Artists," *Washington Star,* February 22, 1920.

15. Effie Seachrest, "The Smoky Valley Art Center," *American Magazine of Art* 12:1 (January 1921): 15–16.

16. Christian Brinton to Birger Sandzén, August 21, 1921, and November 24, 1921, Sandzén Papers, BSMG. See Henry Goddard Leach, *My Last Seventy Years* (New York: Bookman Associates, 1956), for information about the life of this key figure in promoting Sandzén's career.

17. Henry McBride, "Paintings of the West by Sandzén," *New York Herald,* February 5, 1922.

18. Peyton Boswell, "East Finds Sandzén up to Expectations," *American Art News* 20 (February 4, 1922): 1.

19. Peyton Boswell, "Sandzén's Bow to the East Is Great Success," *New York American*, February 5, 1922.

20. Lula Merrick, "Sandzén's Paintings and Prints," *New York Morning Telegraph*, February 5, 1922.

21. From *Christian Science Monitor*, reprinted in *Bethany Messenger*, February 25, 1922.

22. W. G. Bowdoin, "Notable Work by Swedish Artist," *Rocky Mountain News* (Denver), February 22, 1922.

23. *Museum News: Wichita Art Association* 2:2 (November 1922), p. 4.

24. "Western Studies," *New York Times*, February 5, 1922.

25. Hamilton Easter Field, "Birger Sandzén's Exhibition of Paintings and Prints," *Brooklyn Eagle*, February 5, 1922.

26. Royal Cortissoz, "Paintings, Examples of the Old School and the New," *New York Tribune*, February 5, 1922.

27. Christian Brinton to Birger Sandzén, December 19, 1921, and March 7, 1922, Sandzén Papers, BSMG; also Birger Sandzén to Gustaf Sandzén, January 18, 1922, Sandzén Papers, BSMG.

28. Christian Brinton, "Introduction," *Catalogue of the Exhibition of Works of Birger Sandzén*, Babcock Galleries, New York, February 1924.

29. "Sandzén's Dynamic Landscapes," *American Art News* 2 (February 2, 1924): 1.

30. "Western Studies," *New York Times*, February 3, 1924.

31. Francis J. Ziegler, "Sandzén in Philadelphia," *Philadelphia Record*, January 1, 1927.

32. Elisabeth Jane Merrill, "The Art of Birger Sandzén," *American Magazine of Art* 18 (January 1927): 5-6, 7.

33. "Sandzén's Art as a Call for Courage," *Detroit Sunday News*, December 6, 1931.

34. "Sandzén's Exhibit," *Kansas City Times*, March 7, 1932.

35. "Sandzén's Paintings and Prints at the Kansas City Art Institute," *Kansas City Journal Post*, March 6, 1932.

36. "Midwestern Artists Exhibition," *Kansas City Star*, February 2, 1936.

37. "Sandzén Art Is Displayed at Museum," *Philadelphia Inquirer*, June 2, 1940.

38. Florence Berryman, "Exhibition of Birger Sandzén's Works Inaugurates New Art Gallery Here," *Washington Star*, October 28, 1947.

39. *Santa Fe News*, reprinted in *Lindsborg News-Record*, December 4, 1947.

40. Evert Wrangel, "Birger Sandzén," *Sydsvensk Dagbladet Snällposten* (Malmö), March 2, 1912.

41. "Birger Sandzéns utställning," *Skara Posten*, June 21, 1924.

42. "G. T.," *Skånska Dagbladet*, (Malmö), August 1, 1923, and February 4, 1931.

43. "R.-r.," "Gummesons utställning," *Svenska Dagbladet* (Stockholm), April 25, 1937.

44. "R. H.-e.," "Gummesons utställning," *Social Demokraten* (Stockholm), May 12, 1937.

45. Hans Wåhlin, "Konstutställning: Birger Sandzén," *Nya Dagliga Allehanda* (Stockholm), May 14, 1937.

46. "Birger Sandzén," *Konstrevy* 3 (Stockholm, 1937): 106.

47. *Stockholm Tidning*, May 2, 1937, and *Dagens Nyheter* (Stockholm), May 2, 1937.

48. Carl Milles, "Introduction," *Birger Sandzén utställning*, Gummesons konsthall, Stockholm, May 1-18, 1937, pp. 1-2.

49. Carl Milles, interview in *Svenska Dagbladet* (Stockholm), April 19, 1930.

50. Folke Holmér, in H. Sallberg and G. Jungmarker, *Svensk grafik från tre sekler* (Stockholm, 1957) pp. 210-11.

51. Katarina Dunér and Bengt Olvång, *Svensk konstnärslexikon*, vol. 4 (Stockholm 1966), p. 5.

52. Bertil Andrén, "Från Ulricehamn till Klippiga Bergen," *Tidningen Västgöta Demokraten* (Lidköping), March 22, 1985.

53. "BC," "84 verk av Sandzén i unikutställning," *Ulricehamns Tidning*, March 16, 1985.

54. Rune Larsson, *Borås Tidning*, March 10, 1985.

55. *Dagens Nyheter* (Stockholm), May 2, 1985.

56. Hans Menzing, "Skarautställning om djäknen som blev mästare på västernskildring," *Skaraborgs Läns Tidning*, April 4, 1985.

57. Boswell, "Sandzén's Bow to the East Is Great Success," and "East Finds Sandzén up to Expectations," p. 1.

58. Robert Eskridge, *Chicago Herald and Examiner*, May 18, 1918.

59. *Kansas City Times*, March 7, 1932.

60. C. Charbrier, "Birger Sandzén," *Revue du vrai et du beau arts et lettres* 3 (July 10, 1924): 28–29.

61. Laura Bride Powers, "Birger Sandzén's Show Glowing with Vitality," *Oakland Tribune*, February 1, 1920.

62. Elisabeth Jane Merrill, "Art of Birger Sandzén," pp. 6–7.

63. "Water Colors of Birger Sandzén, Lindsborg Artist, Are Shown," *Kansas City Star*, July 4, 1947.

64. "Sandzén Exhibition at Museum of Art," *Santa Barbara News-Press*, May 9, 1948.

Chapter 11. The Graphic Work

1. Birger Sandzén to Evelyn Johnson, February 16, 1916, Sandzén Papers, BSMG.

2. Carl Smalley, "The Prints of Birger Sandzén," *Print Connoisseur* 3 (July 1923): 215.

3. Charles Pelham Greenough 3d, *The Graphic Work of Birger Sandzén* (Manhattan: Kansas Magazine, 1952), p. 5.

4. "R. J. B.," "The McPherson Art Show," *Kansas City Star*, May 6, 1916.

5. "Birger Sandzén," *Chicago Herald and Examiner*, May 10, 1918.

6. *Chicago Tribune*, May 19, 1918.

7. Mary E. Marsh, "The Work of Birger Sandzén," *International Studio* 69 (January–February 1920): cii.

8. "H. P.," "A River and an Artist," *Boston Evening Transcript*, March 23, 1923.

9. Peyton Boswell, "Sandzén's Bow to the East Is Great Success," *New York American*, February 5, 1922.

10. Peyton Boswell, "East Finds Sandzén up to Expectations," *American Art News* 20 (February 4, 1922): 1.

11. Margaret Williams, *Chicago Daily News*, June 23, 1923.

12. "Western Studies," *New York Times*, February 3, 1924.

13. Lena M. McCauley, *Chicago Evening Post, Magazine of the Art World*, October 13, 1925.

14. Elisabeth Jane Merrill, "The Art of Birger Sandzén," *American Magazine of Art* 18 (January 1927): 7.

15. Ibid., p. 9.

16. Willard Hougland, "Prints in the Middle West," *Prints* 6 (June 1936): 266–71.

17. Florence Berryman, *Washington Star*, October 28, 1945.

18. *Lindsborg News-Record*, September 15, 1916.

19. Charles Pelham Greenough 3d, *Graphic Work of Birger Sandzén*, p. 7.

20. Elisabeth Jane Merrill, "Art of Birger Sandzén," p. 7.

21. Robert Eskridge, "Birger Sandzén, Master of Line," *Chicago Herald and Examiner*, May 18, 1918.

22. Malcolm C. Salaman, *The Woodcut Today at Home and Abroad* (London and New York: The Studio, 1927), pp. 174–80.

23. Malcolm C. Salaman, *The New Woodcut* (London and New York: The Studio, 1930), pp. 174–75.

24. Margaret Greenough interview with author, Lindsborg, February 4, 1972, Emory Lindquist Papers, Bethany College Archives, Lindsborg, Kansas.

25. Birger Sandzén, "En Renaissance," in *God Jul*, ed. E. W. Olson (Rock Island, Ill.: Augustana Book Concern, 1916), pp. 8–11, 14.

26. Birger Sandzén to Oscar Jacobson, March 4, 1918, Sandzén Papers, BSMG.

27. Charles Pelham Greenough 3d, *Graphic Work of Birger Sandzén*, pp. 6–7.

28. *Svenska Dagbladet*, February 21, 1912.

29. Ibid., May 7, 1937.

30. Eskridge, "Birger Sandzén, Master of Line."

31. *Kansas City Star*, December 19, 1920.

32. Royal Cortissoz, "Paintings, Examples of the Old School and the New," *New York Tribune*, February 5, 1922.

33. John Taylor Arms to Birger Sandzén, June 25, 1952, Sandzén Papers, BSMG.

Chapter 12. Sharing Views of Art with Two Friends: Carl J. Smalley and Carl Milles

1. Cynthia Mines, "For the Sake of Art" (McPherson, Kans.: McPherson Foundation, 1979), pp. 23–40.

2. Birger Sandzén to Carl Smalley, December 25, 1945, Sandzén Papers, BSMG.

3. Margaret Sandzén, "John the Baptist of Art: A Short Biographical Sketch of Carl J. Smalley," *Kansas Magazine 1939* (Manhattan: Kansas State College Press, 1939), pp. 7–8.

4. Birger Sandzén, "A John the Baptist of Art," *International Studio* 77 (April 1923): 65–69, and Margaret Sandzén, "John the Baptist of Art," pp. 7–10.

5. Birger Sandzén to Carl Smalley, May 19, 1920, Sandzén Papers, BSMG.

6. Ibid., December 4, 1934.

7. Carl J. Smalley, "Print and Painting Account, Birger Sandzén, Lindsborg, Kansas, 1925–1933," pp. 1–24, Sandzén Papers, BSMG.

8. Birger Sandzén to Carl Smalley, February 14, 1924, Sandzén Papers, BSMG.

9. Birger Sandzén to Carl Milles, February 1, 1933, Sandzén Papers, BSMG.

10. Birger Sandzén to Gustaf Sandzén, February 12, 1922, Sandzén Papers, BSMG.

11. Birger Sandzén to Carl Milles, December 4, 1929, and March 22, 1934, Sandzén Papers, BSMG.

12. Ibid., May 13, 1924.

13. *Detroit Sunday News,* December 6, 1931, and Birger Sandzén to Carl Milles, December 20, 1931, Sandzén Papers, BSMG.

14. Birger Sandzén to Carl Milles, October 27, 1935, Sandzén Papers, BSMG.

15. Ibid., January 1, 1928.

16. Ibid., December 30, 1933.

17. Ibid., December 26, 1931.

18. Ibid., January 15, 1933.

19. Ibid., December 16, 1931.

Chapter 13. The Birger Sandzén Memorial Gallery and Foundation: A Dream Fulfilled

1. Margaret Greenough, "From Sweden to Kansas," *American Artist* 25 (January 1961): 26–31; Dale E. Johnson, "Sandzén Museum," *Motorist* 8 (January–February 1978): 4–5; and Arvin W.

Hahn, "The Sandzén Gallery: A Thing of the Spirit," *Bethany College Magazine* 73 (Winter 1978): 2.

2. Emory Lindquist, "Tribute to Charles Pelham Greenough 3d," on the occasion of the memorial service, Bethany Lutheran Church, Lindsborg, Kansas, January 22, 1983, Emory Lindquist Papers, Bethany College Archives, Lindsborg, Kansas; *Lindsborg News-Record,* January 27, 1983; and "Lindsborg Art Patron C. P. Greenough 3d Dies," *Hutchinson News,* January 19, 1983.

3. Margaret Greenough and Charles Pelham Greenough 3d, "Introduction," *Catalogue: Centenary Retrospective Exhibition of Birger Sandzén,* Lindsborg, Kansas, 1971, p. 2.

Concluding Observations

1. Birger Sandzén to Gustaf Sandzén, January 6, 1925, Sandzén Papers, BSMG, and Margaret Sandzén Greenough, "Notes on the Life of Birger Sandzén" (n.d.), p. 37, Sandzén Papers, BSMG.

2. Margaret Greenough, "Notes," p. 36.

3. Ibid., pp. 40, 69.

4. Birger Sandzén to Fritiof Fryxell, September 29, 1937, Sandzén Papers, BSMG.

5. Birger Sandzén to Gustaf Sandzén, October 18, 1935, Sandzén Papers, BSMG.

6. Margaret Greenough, "Notes," p. 38.

7. These stories are in the current oral tradition in Lindsborg.

8. Margaret Greenough, "Notes," p. 43, and Birger Sandzén to Gustaf Sandzén, June 8, 1924, Sandzén Papers, BSMG.

9. Margaret Greenough, "Notes," p. 30.

10. Proclamation of Gov. John Carlin, Topeka, Kansas, April 23, 1985, and *Lindsborg News-Record,* May 9, 1985.

11. "L. G. K.," "Talking It Over," *Hill City Tribune* (Hill City, Kansas), October 25, 1939.

12. Carl Milles, "Introduction," *Birger Sandzéns utställning,* Gummesons konsthall, Stockholm, May 1–18, 1937.

Selected Bibliography

*Contains one or more reproductions of Sandzén's paintings and prints.

MANUSCRIPTS

Bethany College Archives, Lindsborg, Kansas

Carl A. Swensson Papers

Correspondence with Birger Sandzén. 1894–1904.

"Minutes of the Meetings of the Bethany College Faculty." 1894–1946.

"Minutes of the Meetings of the Board of Directors of Bethany College." 1894–1946.

Emory Lindquist Papers

Correspondence and interviews with Margaret Sandzén Greenough. 1972–1986.

Correspondence with Birgitta Sandzén Sjöholm. 1980–1986.

Correspondence with Charles Pelham Greenough 3d. 1979–1982.

Correspondence with personnel of museums and galleries in the United States and Sweden. 1980–1986.

Extensive notes and records related to Birger Sandzén with special reference to exhibitions, reproductions, and works in public collections. N.d.

"Student Remembrances of Birger Sandzén." 1980.

Birger Sandzén Memorial Gallery Archives, Lindsborg, Kansas.

Birger Sandzén Papers

Carl Milles. "Tribute to Birger Sandzén." 1931.

Charles Pelham Greenough 3d. "Catalogue of the Oil Paintings of Birger Sandzén." 1982.

———. "Summary of Exhibitions of Birger Sandzén." 1982.

Correspondence of Birger Sandzén with Frida Sandzén. 1900–1945.

Correspondence of Birger Sandzén with Johan Peter Sandzén, Mrs. Johan Peter Sandzén, Carl Sandzén, and Gustaf Sandzén. 1885–1952.

Correspondence of Birger Sandzén with Mrs. Eric Leksell. 1910–1935.

Letters of Birger Sandzén to Carl J. Smalley. 1920–1951.

Letters of Birger Sandzén to Carl Milles. 1924–1952.

Letters of Birger Sandzén to Dr. F. M. Fryxell. 1930–1938.

Letters of Birger Sandzén to Evelyn Johnson Anderson (Mrs. Theodore W. Anderson). 1914–1935.

Letters of Birger Sandzén to Raymond Jonson. 1914–1947.

Letters of Christian Brinton to Birger Sandzén. 1921–1922.

Letters to Margaret Sandzén Greenough. 1931–1945.

Margaret Sandzén Greenough. "Aspects of the Paintings of Birger Sandzén." N.d.

———. "A Lecture on Birger Sandzén." N.d.

———. "Notes on the Life of Birger Sandzén." N.d.

Materials Related to the Smoky Hill Art Club. N.d.

"Minutes of the Meetings of the Birger Sandzén Memorial Foundation." 1955–1990.

Thornton Oakley. "Birger Sandzén." 1950.

Carl Milles Archives, Millesgården, Lidingö, Sweden

Original letters of the Birger Sandzén–Carl Milles correspondence are located here (copies are in the Birger Sandzén Memorial Gallery Archives).

The Reverend Johan Peter Sandzén Family Private Archives, Alingsås, Sweden

Original correspondence of Birger Sandzén with members of his family in Sweden (copies are in the Birger Sandzén Memorial Gallery Archives).

BOOKS

*Beall, Karel, et al. *American Prints in the Library of Congress: A Catalogue of the Collection.* Baltimore: Johns Hopkins Press, 1971.

Bell, Jonathan Wesley, ed. *The Kansas Art Reader.* Lawrence: University Press of Kansas, 1976.

Bénézit, E. *Dictionnaire critique et documentaire des peintres, sculpteurs, dessinateurs et graveurs.* New ed. 8 vols. Paris: Libraire Gründ, 1962.

Bergh, Richard. *Om konst och annat.* Stockholm: Albert Bonniers förlag, 1919.

Boethius, Gerda. *Anders Zorn: An International Swedish Artist, His Life and Work.* Stockholm: Nordisk rotogravyr, 1954.

Boström, Kjell. *Nils Kreuger.* Stockholm: Albert Bonniers förlag, 1948.

Coke, Van Deren. *Nordfeldt the Painter.* Albuquerque: University of New Mexico Press, 1972.

———. *Taos and Santa Fe: The Artist Environment.* Albuquerque: University of New Mexico Press, 1963.

*Colorado Springs Fine Arts Center. *A Show of Color: 100 Years of Painting in the Pikes Peak Region.* Colorado Springs, 1971.

Dawdy, Doris Ostrander. *Artists of the American West: A Biographical Dictionary.* 3 vols. Athens: Ohio University Press, 1974, 1981, 1985.

Dunér, Katarina, and Bengt Olvång. "Birger Sandzén." In *Svensk konstnärslexikon.* Vol. 4. Stockholm, 1966.

Encyclopedia of World Art. 15 vols. New York: McGraw-Hill, 1959–1968.

Fielding, Mantle. *Dictionary of American Painters, Sculptors, and Engravers.* Philadelphia: Printed for the Subscribers, 1929.

Garman, Ed. *The Art of Raymond Jonson: Painter.* Albuquerque: University of New Mexico Press, 1976.

Gauffin, Alex. *Olof Sager-Nelson.* Stockholm: P. A. Nordstedt och Söner, 1945.

*Gerdts, William H. *Art across America: Two Centuries of Regional Painting 1710–1920.* 3 vols. New York: Abbeville Press, 1990.

Gilbert, Dorothy B., ed. *American Art Directory, 1952.* New York: R. R. Bowker, 1952.

*Gilbert, Gregory. "Birger Sandzén." In *Kansas Printmakers,* edited by David C. King, pp. 31–42. Lawrence: Spencer Museum of Art, University of Kansas, 1981.

*Greenough, Charles Pelham 3d. *The Graphic Work of Birger Sandzén.* Manhattan: Kansas Magazine, 1952. Subsequent reprint editions published by the Birger Sandzén Memorial Gallery.

Gustafson, Alrik. *A History of Swedish Literature.* Minneapolis: University of Minnesota Press, 1961.

Havlices, Patricia. *Index to Artistic Biography.* 2 vols. Metuchen, N.J.: Scarecrow Press, 1973.

*Hildebrand, Karl, and Axel Fredenholm. *Svenskarna i Amerika.* 2 vols. Stockholm: Historiska förlaget, 1925.

Holmstedt, Gustaf. *Skara Läroverk 1641–1941: Festskrift.* Stockholm: P. A. Nordstedt och Söner, 1941.

Index to Art Periodicals. Art Institute of Chicago (compiled in Ryerson Library). Chicago: G. K. Hall, 1962.

Janson, Florence, ed. *The Background of Swedish Immigration 1840–1930.* Chicago: University of Chicago Press, 1931.

Janson, H. W. *History of Art: A Survey of the Major Visual Arts from the Dawn of History to the Present Day.* Englewood Cliffs, N.J.: Prentice-Hall, and New York: Harry N. Abrams, 1962.

*Kent, Rockwell. *Introduction to American Institute of Graphic Arts: Fifty Prints.* New York: W. E. Rudge, 1928.

*Kirn, Mary Em. "Reading Other People's Mail: Selected Correspondence of Charles Haag, Carl Milles, and Birger Sandzén." In *Härute— Out Here: Swedish Immigrant Artists in Midwest America,* edited by Mary Em Kirn and Sherry Case Maurer, pp. 39–46. Rock Island, Ill.: Augustana College, 1984.

Laird, Helen. *Carl Oscar Borg and the Magic Region.* Layton, Utah: Gibbs M. Smith, 1986.

Leach, Henry Goddard. *My Last Seventy Years.* New York: Bookman Associates, 1956.

Leighton, Clare, ed. *Wood Engravings of the 1930s.* New York and London: The Studio, 1936.

*Lindquist, Emory. *Bethany in Kansas: The History of a College.* Lindsborg, Kans.: Bethany College Publications, 1975.

———. *G. N. Malm: A Swedish Immigrant's Varied Career.* Lindsborg, Kans.: Smoky Valley Historical Association, 1989.

*———. *Smoky Valley People: A History of Lindsborg, Kansas.* Lindsborg, Kans.: Bethany College, 1953.

McGlauflin, Alice Coe, ed. *Dictionary of American Artists: 19th and 20th Centuries.* Poughkeepsie, N.Y.: Glen Oditz/Apollo Book, 1982.

*Mines, Cynthia. *For the Sake of Art: The Story of an Art Movement in Kansas.* McPherson, Kans.: McPherson Foundation, 1979.

Neuhaus, Eugene. *The History and Ideas of American Art.* Palo Alto, Calif.: Stanford University Press, 1931.

*O'Neil, Barbara Thompson, and George C. Foreman in cooperation with Howard W. Ellington. "Birger Sandzén 1871–1954." In *The Prairie Print Makers,* pp. 20–26. Topeka: Kansas Arts Commission, 1981.

Phaedon Dictionary of Art. Oxford: Phaedon Press, 1970.

*Salaman, Malcolm C. *The New Woodcut.* London and New York: The Studio, 1930.

*———. *The Woodcut Today at Home and Abroad.* London and New York: The Studio, 1927.

*Sallberg, H., and G. Jungmarker. *Svensk grafik från tre sekler.* Stockholm, 1957.

*Sandzén, Birger. *In the Mountains: Reproductions of Lithographs and Wood Cuts of the Colorado Rockies.* Introduction by William Allen White. McPherson, Kans.: Carl J. Smalley, 1925.

*———. *Med pensel och penna: Berättelser, studier och stämningar.* Rock Island, Ill.: Augustana Book Concern, c. 1905.

*———. *The Smoky Valley: Reproductions of a Series of Lithographs of the Smoky Valley in Kansas.* Introduction by Minnie K. Powell. McPherson, Kans.: Carl J. Smalley, 1922.

*Seiz, Janet Knowles. "Birger Sandzén: A Painter in His paradise." In *Härute—Out Here: Swedish Immigrant Artists in Midwest America,* edited by Mary Em Kirn and Sherry Case Maurer, pp. 56–62. Rock Island, Ill.: Augustana College, 1984.

Skara stifts herdaminne 1850–1930. Edited by L. S. Cederbom and C. O. Friberg. Stockholm: Svenska kyrkans diakonistyrelses bokförlag, 1930.

Strömbom, Sixten. *Nationalromantik och radikalism: Konstnärsförbundets historia 1891–1920.* Stockholm: Albert Bonniers förlag, 1965.

Svedfelt, Torsten. *Karl Nordströms konst.* Stockholm: Nordisk rotogravyr, 1939.

Svenska männ och kvinnor: Biografiska uppslagsbok. 8 vols. Stockholm: Albert Bonniers förlag, 1942–1955.

Svensk konstnärslexikon. 5 vols. Malmö: Allhelms förlag, 1952.

Wechsler, Herman J. *Lives of Famous French Painters from Ingres to Picasso.* New York: Pocket Books, 1952.

*Weitenkamp, Frank. *American Graphic Art.* New York and London: Johnson Reprint Corp., 1970.

Who Was Who in America. 3 vols. Chicago: A. N. Marquis, 1960.

Young, William, ed. *A Dictionary of American Artists, Sculptors and Engravers.* Cambridge, Mass.: William Young, 1968.

Zorn, Anders. *Självbiografiska anteckningar.* Presented and annotated by Hans Henrik Brummer. Stockholm: Albert Bonniers förlag, 1982.

PERIODICALS

"Birger Sandzén." *Arts* 2 (January 1922): 245.

"Birger Sandzén." *Delta Phi Delta Palette* 11 (May 1931): 10–11.

*"Birger Sandzén." *Konstrevy* 3 (Stockholm 1937): 106.

"Birger Sandzén: Death and Tribute." *Bethany College Bulletin, Alumni News* 49 (August–September 1954): 6.

*"Birger Sandzén Woodcut." *Bookman* 54 (September 1926): 123.

Boswell, Peyton. "East Finds Sandzén up to Expectations." *American Art News* 20 (February 4, 1922): 1.

Brinton, Christian. "Sven Birger Sandzén." *Museum News: Wichita Art Association* 2:2 (November 1922): 3.

*Cary, Elizabeth. "An Exhibition of Works by American Painters of Swedish Descent." *American-Scandinavian Review* 8 (August 1920): 598–605.

Chandler, Allison. "An Art Center in Lindsborg." *American-Scandinavian Review* 22 (March 1934): 21–23.

*Charbrier, C. "Birger Sandzén." *Revue du vrai et du beau arts et lettres* 3 (July 10, 1924): 28–29.

*Christensen, Erwin O. "Recent Lithographs and Woodcuts of Birger Sandzén." *Scandinavia: A Monthly Magazine* 1 (January 1924): 71–73.

*Cunningham, Clarice. "Lindsborg, Kansas: The Prairie Town Whose Art and Music Have Given It Fame." *Haldeman-Julius Quarterly* 1 (January 1927): 17–27.

*Diffily, John. "Birger Sandzén 1871–1954: Through the Corridor of Nature." *Southwest Art* 13 (August 1983): 42–51.

Downes, Erin O. "Recent Painter of Mountains." *American Magazine of Art* 25 (October 1932): 193–202.

*"Four Rocky Mountain Scenes." *Forum* 76 (November 1920): 719–23.

*Freeburg, Victor O. "Birger Sandzén." *American Swedish Monthly* 31 (January 1937): 7–10.

*Greenough, Margaret Sandzén. "From Sweden to Kansas." *American Artist* 25 (January 1961): 26–31, 72–73.

Hahn, Arvin W. "The Sandzén Gallery: A Thing of the Spirit." *Bethany College Magazine* 73 (Winter 1978): 2.

*Hedin, Naboth. "Artist of the Prairie: Birger Sandzén." *American Swedish Monthly* 51 (August 1957): 9–12.

———. "Konstnären Birger Sandzén." *Allsvensk samling* 44 (Summer 1957): 4–6.

Helm, John F., Jr. "Birger Sandzén." *Delta Phi Delta Palette* 16 (May 1936): 18–19.

*Hougland, Willard. "Prints in the Middle West." *Prints* 6 (June 1936): 266–71.

Johnson, Dale E. "Sandzén Museum." *Motorist* 8 (January/February 1978): 4–5.

Ketcham, Elizabeth. "Lindsborg Revisited." *American-Scandinavian Review* 38 (June 1950): 136–45.

Leach, Henry Goddard. "The Lindsborg Idea." *American-Scandinavian Review* 3 (July–August 1915): 242–43.

*Lindquist, Emory. "Birger Sandzén: A Painter and His Two Worlds." *Great Plains Quarterly* 5 (Winter 1985): 53–65.

*———. "Birger Sandzén: Six Decades of Artistic Achievement." *American-Scandinavian Review* 42 (December 1954): 329–35.

Lundbergh, Holger. "The Arts." *American Swedish Monthly* 39 (December 1945): 26, 38.

Lundblad, G. T. "Några ord om musik-och teckningsundervisninngen vid Skara läroverk under senare tiden av 1800 talet." *Skarad-jäknen* 5:1 (1928): 3–6.

*"The Majesty and Splendor of the West: A Group of Lithographs by the Scandinavian Birger Sandzén." *Shadowland: Expressing the Arts* 9 (September 1923): 28–29.

*Marsh, Mary E. "Birger Sandzén." *American-Scandinavian Review* 4 (May–June 1916): 172–77.

*———. "The Work of Birger Sandzén." *International Studio* 69 (January–February 1920): xcix–cii.

*Mechlin, Leila. "Birger Sandzén: Painter and Lithographer." *American Magazine of Art* 8 (February 1917): 148–53.

*Merrill, Elisabeth Jane. "The Art of Birger Sandzén." *American Magazine of Art* 18 (January 1927): 3–9.

*"Modern Wood-Block Prints by American Artists." *Century Magazine* 102 (October 1921): 897.

*Nelson, Robert J. "Lindsborg, Kansas: Town of Art and Song." *Ford Times* 45 (March 1953): 50–55.

*Owen, Jennie Small. "Kansas Folks Worth Knowing: Birger Sandzén." *Kansas Teacher* 45 (September 1937): 30–32.

Pellettieri, Giuseppe. Quoted in *Museum News of Wichita Art Association* 2 (November 1922): 4.

*Powell, Minna. "Sandzén's Lithographs of the Smoky Valley." *Print Connoisseur* 3 (July 1923): 221–36.

Reinbach, Edna. "Kansas Art and Artists." *Collections of the Kansas State Historical Society* 17 (1926–1928): 571–85.

Rogers, Charles B. "Sandzén of Our Time." *Art Scoop* (March–April 1950): 1–2. A publication of the Kansas State Art Teachers Association.

Ryden, E. E. "Birger Sandzén: Poet-Painter of the Great West." *Lutheran Companion* 45 (July 8, 1937): 877–880.

Sandzén, Birger. "Correspondence to Encourage Art." *American Magazine of Art* 10 (February 1919): 138–40.

———. "A Great Modernist [Ernst Josephson]." *Delta Phi Delta Palette* 5 (January 1925): 5–6.

———. "A John the Baptist of Art [Carl J. Smalley]." *International Studio* 77 (April 1923): 65–69.

———. "A Message to Delta Phi Delta." *Delta Phi Delta Palette* 18 (December 1937): 4–5.

———. "Nemesis." *Ungdomsvännen* 10 (May 1905): 145–47.

*———. "Our Art Problem." *Scandinavia: A Monthly Magazine* 1 (January 1924): 74–77.

———. "Sankt Peter och trubaduren." *Ungdomsvännen* 15 (April 13, 1915): 124–26.

———. "Sketching in Old Mexico." *Delta Phi Delta Palette* 16 (May 1936): 17–18.

*———. "The Southwest as a Sketching Ground." *Fine Arts Journal* 33 (August 1915): 336–51.

———. "Straffpredikan." *Valkyrian* 9 (April 1905): 239–43.

———. "The Technique of Painting." *Fine Arts Journal* 32 (January 1915): 22–27.

"Sandzén at Babcock Gallery." *Arts* 2 (January 1922): 245.

*"Sandzén in New York." *American-Scandinavian Review* 10 (April 1922): 236–37.

"Sandzén in Philadelphia." *Art Digest* 1 (January 1, 1927): 7.

"Sandzén Memorial Gallery Planned for Bethany College." *To The Stars* 11 (May–June 1956): 20.

*"Sandzén Oil Painting—Rough Sea." *Century Magazine* 102 (1921): 897.

"Sandzén's 'Challenge.'" *Art Digest* 6 (December 15, 1931): 2.

*"Sandzén's Lithographs Charm Exhibition Visitors." *Missourian Magazine* 20 (October 22, 1927): 1–3.

Schön, Anders. "Svensk-Amerikansk konstnär:

Birger Sandzén." *Ungdomsvännen* 9 (May 1904): 146–49.

*Seachrest, Effie. "The Smoky Hill Art Center." *American Magazine of Art* 12:1 (January 1921): 14–16.

*"Second Annual Art Exhibition by Birger Sandzén, Santa Fe, New Mexico." *El Palacio* 6 (July 11, 1919): 28–31.

*Seward, C. A. "American Block Prints." *American Magazine of Art* 21 (September 1930): 513–17.

Shipman, Vera Brady. "Birger Sandzén: Painter of the Desert and Prairie." *Mentor* 12 (July 1924): 56–57.

———. "A Painter of the Desert." *Social Progress* 8 (August 1924): 233–34.

*Smalley, Carl J. "Art for the Farmer." *American Magazine of Art* 14 (November 1923): 612–15.

*———. "The Prints of Birger Sandzén." *Print Connoisseur* 3 (July 1923): 214–20.

Snow, Florence. "Kansas Art and Artists: Birger Sandzén." *Kansas Teacher and Western Journal* 5 (August–September 1927): 18–19.

*Stawski, Nina. "The Sketchbooks and Drawings of Birger Sandzén." *Swedish-American Historical Quarterly* 37 (April 1986): 94–104.

*Van Stone, Mary R. "The Fiesta Art Exhibition." *Art and Archaeology* 18 (November–December 1924): 225–40.

Weitenkampf, Frank. "American Lithographers of Today." *Scribners Magazine* 73 (January 1923): 123–28.

Westmann, Eric G. "A Swedish Art Center in Chicago." *American-Scandinavian Review* 3 (September–October 1915): 303–6.

*Whittemore, Margaret. "Birger Sandzén." *Delta Phi Delta Palette* 11 (May 1931): 10–12.

*———. "Birger Sandzén: The Artist and the Man." *Jayhawk: The Magazine of Kansas* 2 (June 1920): 161–63.

ANNUALS, CATALOGS, THESES

American Art Annual, 1913–1948. 35 vols. Washington, D.C.: American Federation of Arts, 1913–1948.

Bethany College: 100 Years of Art, Introduction and Catalogue of Centennial Exhibition in Sandzén Gallery. Lindsborg, Kans.: Bethany College, 1990.

Billington, Joan S. "Birger Sandzén: Pioneer Painter of Kansas." Master's thesis, University of Kansas, Lawrence, 1958.

Birger Sandzén: A Retrospective. Wichita, Kans.: Wichita Art Museum, May 4–June 9, 1985. Essay and catalogue by Howard DaLee Spencer.

Birger Sandzén Exhibition. Babcock Gallery, New York City, 1924. Introduction by Christian Brinton.

Birger Sandzén's utställning. Gummesons konsthall, Stockholm, May 1–18, 1937. Introduction by Carl Milles.

*Brinton, Christian. *The Birger Sandzén Exhibition.* Babcock Gallery, New York City, 1922.

Bruce, Chester C. "Birger Sandzén, Distinguished Kansas Artist and Swedish-American: A Study of a Prairie Viking's Career at Bethany College." Master's thesis, University of Kansas, Lawrence, 1971.

Centenary Retrospective Exhibition of Birger Sandzén 1971. Sandzén Memorial Gallery, Lindsborg, Kansas. Introduction by Margaret Greenough and Charles Pelham Greenough 3d.

Corcoran Calendar 1980. Corcoran Gallery, Washington, D.C. Reproduction of Sandzén print, *The Republican River.*

Då och Nu. Svensk grafik, 1600–1959. Utställning i Liljevacs konsthall. Katalog 236. Stockholm: Esselte aktiebolag, October 16–November 15, 1959.

Davison, Faye. "What I Know about Kansas Art." *Kansas Magazine 1933,* pp. 41–42. Manhattan: Kansas State College Press, 1933.

*"Exhibition of American Painters of Swedish Descent." *Chicago Art Institute Bulletin* 14 (December 1920): 110.

Exhibition of Paintings, Lithographs, Block Prints, and Drawings by Birger Sandzén. Omaha Society of Fine Arts, March 10–30, 1922.

Handbook of the Collections 1917–1974. New Mexico Museum of Arts. Santa Fe: Museum of New Mexico, 1974.

*Hedin, Naboth. "Utpost för Svensk konst i Amerika." *Riksföreningen för svenskhetens bevarande i utlandet,* pp. 1–20. Göteborg, 1957.

Helm, John F., Jr. "An Appraisal of Some Midwestern Artists." *Kansas Magazine 1936,* pp. 88–90. Manhattan: Kansas State College Press, 1936.

———. "Birger Sandzén." *Kansas Magazine 1955,* p. 103. Manhattan: Kansas State College Press, 1955.

"John Taylor Arms. An American Etcher, 1887–1953." Birger Sandzén Memorial Gallery Publication, February 1982.

Kansas Magazine Supplement 1939. Verse and essay by Marco Morrow, art by Birger Sandzén.

Katalog öfver Skara högre allmänna läroverk höstterminen 1889. Skara: Pettersonska Boktryckriet, 1889.

Konstnärsförbundet 1891–1920. Utställning, Nationalmuseum, Stockholm, February–March 1948.

Matthews, Charles Walton. "Artist, Gentleman, and Scholar: Birger Sandzén." *Kansas Magazine 1938,* pp. 2–7. Manhattan: Kansas State College Press, 1938.

Nationalmuseum samling av moderna målningar och skulpturer. Stockholm: P. A. Nordstedt och Söner, 1950.

"New Exhibition of Prints." *Chicago Art Institute Bulletin* 12 (May 1918): 77.

"Print Exhibitions." *Chicago Art Institute Bulletin* 11 (October 1917): 233.

Redogörelse för läsåret 1890–1891. I. Skara högre allmänna läroverk. 1891.

Richard Gordon Matzene Collection. Edited by Mrs. Tom L. Irby, Ponca City Library. Ponca City, Oklahoma, 1963.

Sandzén, Birger. "Amerikas förste konstnär. Biografi öfver artisten Gustaf Hessellius." In *Prärieblomman kalender för 1904,* pp. 213–26. Rock Island, Ill.: Augustana Book Concern, 1904.

———. "C. A. Seward: Promoter of Kansas Art." *Kansas Magazine 1937,* pp. 1–5. Manhattan: Kansas State College Press, 1937.

———. "En kamrat [Olof Sager-Nelson]." In *Prärieblomman kalender för 1905,* pp. 46–59. Rock Island, Ill.: Augustana Book Concern, 1904.

*———. "En Renaissance," In *God Jul,* edited by E. W. Olson, pp. 8–14. Rock Island, Ill.: Augustana Book Concern, 1916.

———. "Något om Svensk konst i Amerika: I. Målarekonsten." In *Prärieblomman kalender för 1902,* pp. 99–115. Rock Island, Ill.: Augustana Book Concern, 1902.

———. "Reseminnen från södern." In *Prärieblomman kalender för 1908,* pp. 37–52. Rock Island, Ill.: Augustana Book Concern, 1907.

*———. "Svensk-Amerikanska konstnärernas utställning i Chicago 1912." In *Prärieblomman kalender för 1913,* pp. 20–38. Rock Island, Ill.: Augustana Book Concern, 1912.

———. "Sveriges moderna konst. En öfversikt: I. Målarekonsten." In *Prärieblomman kalender för 1909,* pp. 79–100. Rock Island, Ill.: Augustana Book Concern, 1908.

———. "Sveriges moderna konst. En öfversikt: II. Skulpturen." In *Prärieblomman kalender för 1910,* pp. 82–99. Rock Island, Ill.: Augustana Book Concern, 1901.

———. "Våra Svensk-Amerikanska konstskolar." In *Prärieblomman kalender för 1903,* pp. 40–55. Rock Island, Ill.: Augustana Book Concern, 1903.

Sandzén, Margaret. "John the Baptist of Art: A Short Biographical Sketch of Carl J. Smalley." *Kansas Magazine 1939,* pp. 7–10. Manhattan: Kansas State College Press, 1939.

Schön, Anders. "Den första stora Svensk-Amerikansk konstutställning." In *Prärieblomman kalender för 1912,* pp. 123–42. Rock Island, Ill.: Augustana Book Concern, 1911.

Seward, C. A. "Annual Report of the Prairie Print Makers for the Season 1936–37."

———. "Bulletin of the Prairie Print Makers" 5 (Wichita, Kans.: December 1930).

*Stawski, Nina. "The Drawings and Sketchbooks of Kansas Art Patriarch Birger Sandzén." Master's thesis, University of Missouri, Columbia, 1982.

*Swanson, Mary Towley. *The Divided Heart: Scandinavian Immigrant Artists, 1850–1950.* Minneapolis: University Gallery, University of Minnesota, 1982.

Whittemore, Margaret. "Notes on Some Kansas Artists." *Kansas Magazine 1935,* pp. 41–45. Manhattan: Kansas State College Press, 1935.

NEWSPAPER ARTICLES
(In chronological order)

"E. W." [Evert Wrangel]. "Birger Sandzén." *Sydsvensk Dagbladet Snällposten* (Malmö), March 2, 1912.

Oliver, M. T. "Exhibition of Sandzén's Paintings and Prints." *Chicago Sunday Record-Herald,* April 27, 1913.

"R. J. B." "Birger Sandzén Quoted on His Own Work," *Kansas City Star,* January 21, 1916.

"R. J. B." "News of the Fine Arts." *Kansas City Star,* April 7, 1916.

"R. J. B." "The McPherson Art Show." *Kansas City Star,* May 6, 1916.

"R. J. B." "The McPherson Art Show." *Kansas City Star,* October 18, 1916.

McCauley, Lena May. "Prints by Birger Sandzén," *Chicago Evening Post,* May 21, 1918.

"An Age of Freedom in Art." *Kansas City Times,* January 3, 1920.

Abbott, Yarnall. "Comment on Art and Artists." *Philadelphia Sunday Press,* January 11, 1920.

Powers, Laura Bride. "Birger Sandzén's Show

Glowing with Vitality." *Oakland Tribune,* February 1, 1920.

"Den Svenska-Amerikanska utställning i Malmö." *Sydsvensk Dagbladet Snällposten* (Malmö), July 28, 1920.

"Svenska-Amerikanska utställning i Göteborg konstförening." *Göteborgs Handelstidning,* August 23, 1920.

Boswell, Peyton. "Sandzén's Bow to the East Is Great Success." *New York American,* February 5, 1922.

Cortissoz, Royal. "Paintings, Examples of the Old School and the New." *New York Tribune,* February 5, 1922.

Field, Hamilton Easter. "Birger Sandzén's Exhibition of Paintings and Prints." *Brooklyn Eagle,* February 5, 1922.

McBride, Henry. "Paintings of the West by Sandzén." *New York Herald,* February 5, 1922.

Merrick, Lula. "Sandzén's Paintings and Prints." *New York Morning Telegraph,* February 5, 1922.

"Western Studies, Birger Sandzén." *New York Times,* February 5, 1922.

"Sandzén's Work Has Brought Breeze from West Not Felt Before." *Christian Science Monitor,* February 6, 1922.

Bowdoin, W. G. "Distinguished Interpreter of Colorado Scenes." *Rocky Mountain News* (Denver), February 20, 1922.

Bowdoin, W. G. "Notable Work by Swedish Artist." *Rocky Mountain News* (Denver), February 22, 1922.

McCauley, Lena M. "Federation of Arts Gives Inspiration." *Chicago Evening Post,* June 6, 1922.

"H. P." "A River and an Artist." *Boston Evening Transcript,* March 23, 1923.

"G. T." *Skånska Dagbladet* (Malmö), August 1, 1923.

"Western Studies." *New York Times,* February 3, 1924.

"Birger Sandzén's utställning." *Skara Posten,* June 21, 1924.

McCauley, Lena M. *Chicago Evening Post, Magazine of the Art World,* October 13, 1925.

Bonte, C. H. "Birger Sandzén Exhibition at Art Alliance." *Philadelphia Inquirer,* December 19, 1926.

Ziegler, Francis J. "Sandzén in Philadelphia." *Philadelphia Record,* January 1, 1927.

Powell, M. K. "Birger Sandzén." *Kansas City Star,* April 4, 1928.

"Carl Milles upptäcker en stor svensk konstnär."
Svenska Dagbladet (Stockholm), April 19, 1930. Interview with Carl Milles.

"Sandzén länge bekant i Lund som stormålare." *Stockholm Tidning,* April 22, 1930.

"G. T." "Birger Sandzén: En Svensk-Amerikansk mästare." *Skånska Dagbladet* (Malmö), February 4, 1931.

"Sandzén's Art as a Call for Courage." *Detroit Sunday News,* December 6, 1931.

Whittemore, Margaret. *Topeka Capital,* December 6, 1931.

Powell, M. K. "In Gallery and Studio." *Kansas City Star,* January 14, 1933.

"Sandzén of Kansas." *Kansas City Star,* March 10, 1933. Editorial.

"Svensken som blev pioniär i Amerikas konst [Birger Sandzén]." *Svenska Dagbladet Söndagsbilagan,* April 25, 1937.

"Lördags vernissage i Gummesons konsthall [Birger Sandzén]." *Stockholm Dagens Nyheter,* May 2, 1937.

"Två maj vernissage." *Stockholm Tidning,* May 3, 1937.

"Birger Sandzén's utställning i Gummesons konsthall." *Svenska Dagbladet* (Stockholm), May 5, 1937.

*Wåhlin, Hans. "Konstutställning: Birger Sandzén." *Nya Dagliga Allehanda* (Stockholm), May 14, 1937.

"Sandzén and Curry of Kansas, Pioneers of Art in the West." *Kansas City Times,* January 3, 1938.

"Art Gift to Gallery." *Kansas City Times,* March 7, 1938. Dedication of Sandzén's *Long's Peak, Colorado,* at the Nelson-Atkins Museum of Art.

"Sandzén Art Is Displayed at Museum." *Philadelphia Inquirer,* June 2, 1940.

"Water Colors of Birger Sandzén, Lindsborg Artist, Are Shown." *Kansas City Star,* July 4, 1947.

"Sandzén Exhibition." *Santa Fe New Mexican,* October 8, 1947.

Berryman, Florence. "Exhibition of Birger Sandzén's Works Inaugurates New Art Gallery Here." *Washington Star,* October 28, 1947.

"Sandzén Exhibition at Museum of Art." *Santa Barbara News-Press,* May 9, 23, 1948.

Carlson, Anna. "New Book Depicts Art Career of the Noted Birger Sandzén." *Kansas City Times,* May 1, 1952.

Yarber, Ken. "Challenge in Youth Gave Birger Sandzén to Kansas." *Wichita Eagle Sunday Magazine,* February 14, 1954.

"Birger Sandzén Obituary." *New York Times,* June 20, 1954.

Carlson, Anna. "Death of Birger Sandzén." *Kansas City Times,* June 26, 1954.

Murphy, Paul. "Birger Sandzén Left Behind a Treasure of Beauty on Canvas." *Hutchinson News-Herald,* August 8, 1954.

*Wood, Dorothy. "Sandzén Exhibit Shown." *Wichita Eagle-Beacon,* September 15, 1974.

"BC." "84 verk av Sandzén i unikutställning." *Ulricehamns Tidning,* March 16, 1985.

Andren, Bertil. "Från Ulricehamn till Klippiga Bergen." *Tidningen Västgöta Demokraten* (Lidköping), March 22, 1985.

Sturm, Claes. "Profet i USA—Okänd i Sverige." *Stockholm Dagens Nyheter,* March 30, 1985.

Menzing, Hans. "Skarautställning om djäknen som blev mästare på västernskildring." *Skaraborgs Läns Tidning,* April 4, 1985.

Pate, Nancy. "Birger Sandzén: A Man and His Art." *Wichita Eagle-Beacon,* May 5, 1985.

"Sandzén Exhibitions in Sweden." *Lindsborg News-Record,* June 6, 1985.

Index

Note: This index follows the Swedish alphabetizing method for twenty-nine letters, which include å, ä, and ö.